Barbara Hepworth

A Retrospective

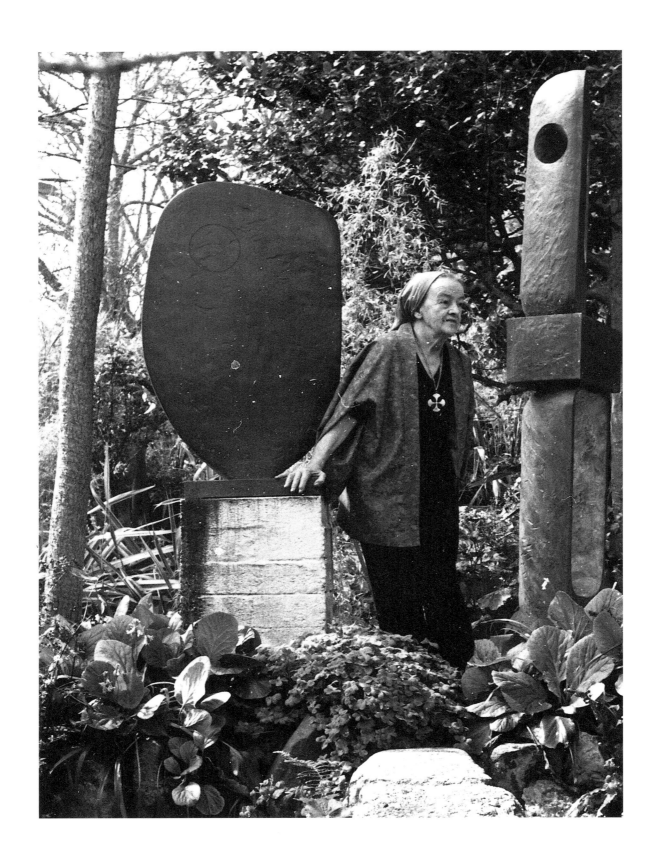

Barbara Hepworth,
Trewyn Studio Garden, April 1973

Barbara Hepworth

A Retrospective

Penelope Curtis Alan G. Wilkinson

An exhibition organised by Tate Gallery Liverpool
and the Art Gallery of Ontario, Toronto

Tate Gallery Liverpool
14 September – 4 December 1994

Yale Center for British Art, New Haven
4 February – 9 April 1995

Art Gallery of Ontario, Toronto
19 May – 7 August 1995

Published by Tate Gallery Publications

Contents

Preface

This exhibition is the first large retrospective of Barbara Hepworth's sculpture and drawing since that held at the Tate Gallery, London in 1968 and it takes place very nearly twenty years after her death. In these twenty years it seems that Barbara Hepworth and her work have become less well known to the general public. It is not unusual for artists' stars to wane after their death, but in Hepworth's case the situation is the more surprising given the growth of a critical awareness of the contribution of women artists. A new generation of art historians now seems poised to make good that neglect.

It is against this background that we considered it timely to re-introduce Hepworth to a wider audience. The Tate Gallery has the largest public collection of Hepworth's work, in part because of her long association with the Gallery and her generosity to the national collection. The collection of the Art Gallery of Ontario reflects the increasing support from North American collectors which Hepworth enjoyed towards the end of her career. We are delighted to collaborate on this major Hepworth exhibition which, after its British showing at Tate Gallery Liverpool, will travel to the Yale Center for British Art, New Haven before its display at the Art Gallery of Ontario, Toronto. We are indebted to Duncan Robinson, Director of the Yale Centre for British Art, for his support.

Hepworth's output was large, but not unmanageably so, and it has seemed reasonable to make a selection that represents over a tenth of her total output of around 600 sculptures. Hepworth is an artist whose work is known but not known. Many people have a mental image of what they consider to be a typical 'Hepworth', and while this exhibition seeks to consolidate that reputation for consistency, it also hopes to disclose the great variety within her oeuvre.

The initial suggestion for the exhibition came from Alan Wilkinson, Curator of Twentieth-Century Art at the Art Gallery of Ontario. He and Penelope Curtis made the selection together and have each contributed two essays to this catalogue. The research needed to bring the exhibition together was undertaken by Penelope Curtis, Head of the Henry Moore Centre for the Study of Sculpture and formerly Exhibitions Curator at Tate Gallery Liverpool, and the administration of the exhibition was undertaken by Roy Atherton, Jemima Pyne and Helen Ruscoe at Tate Gallery Liverpool. Meg Duff of the Tate Gallery Library carried out extensive bibliographical research. Some of Hepworth's sculptures are well known, others hardly at all. Some have never been exhibited since they were bought from the artist. Hepworth's own papers will shortly be in the public domain and this exhibition should therefore be seen as a prelude to the further research and reflection which is undoubtedly due to the artist. We hope that it will succeed in inspiring such an interest in old and new audiences alike.

We are grateful to the Henry Moore Foundation for enabling us to publish this catalogue at a subsidised price. We are greatly indebted to all our lenders – public and private – who have sacrificed what is often a particularly cherished piece within a collection for this extremely exciting exhibition. We are very pleased to acknowledge the generous support of Sir Alan and Lady Bowness who have made it possible for us to exhibit work from the artist's Estate.

Glenn D Lowry
Director
Art Gallery of Ontario

Nicholas Serota
Director
Tate Gallery

Lenders to the Exhibition

City of Aberdeen Art Gallery and Museums Collections
The Art Gallery of Ontario, Toronto
Arts Council Collection, The South Bank Centre, London
Art Gallery of Hamilton, Ontario
The Art Institute of Chicago
Priscilla Beckett
Birmingham Museums and Art Galleries
Ivor Braka Ltd, London
The British Council
Alejandro Freites Collection, Caracas
Gimpel Fils, London
Government Art Collection of the United Kingdom
Trustees of the Barbara Hepworth Estate
Hirshhorn Museum and Sculpture Garden
Hiscox Holdings Ltd
Kettle's Yard, University of Cambridge
Kröller-Müller Museum, Otterlo

Leeds City Art Galleries
Leicestershire Museums, Arts and Records Service
Manchester City Art Galleries
Marlborough Fine Art (London) Ltd
The Museum of Modern Art, New York
National Portrait Gallery, London
The Pier Gallery, Stromness
Sheldon Memorial Art Gallery, University of Nebraska
The Tate Gallery, London
The Board of Trustees of the Victoria and Albert Museum
Wakefield Museums, Galleries and Castles
Walker Art Center, Minneapolis
Lady Zuckerman
and several private collectors

Photographs of Barbara Hepworth's work and quotations from the artist are copyright Sir Alan Bowness.

Sponsor's Foreword

Manchester Airport is proud to sponsor the Barbara Hepworth exhibition at Tate Gallery Liverpool. As the largest sponsors of the arts in the North West we have given over £1.5 million to arts projects in the region over the past two years.

Our investment in projects such as the Barbara Hepworth exhibition is partly altruistic and partly good business sense. We believe in investing in those who invest in us and we value our customers from Merseyside as we value our customers from the entire north of Britain. We also recognise however that by contributing to the development of the North West as a centre of excellence for arts and culture, we are helping to make the region more attractive as a destination for inbound tourism – something which benefits us all.

On behalf of Manchester Airport and of The Henry Moore Foundation who are also supporting the exhibition I would like to welcome you to Tate Gallery Liverpool and to the work of Barbara Hepworth and I hope that you enjoy your visit.

Geoff Muirhead
Chief Executive
Manchester Airport

Supported by
THE HENRY MOORE FOUNDATION

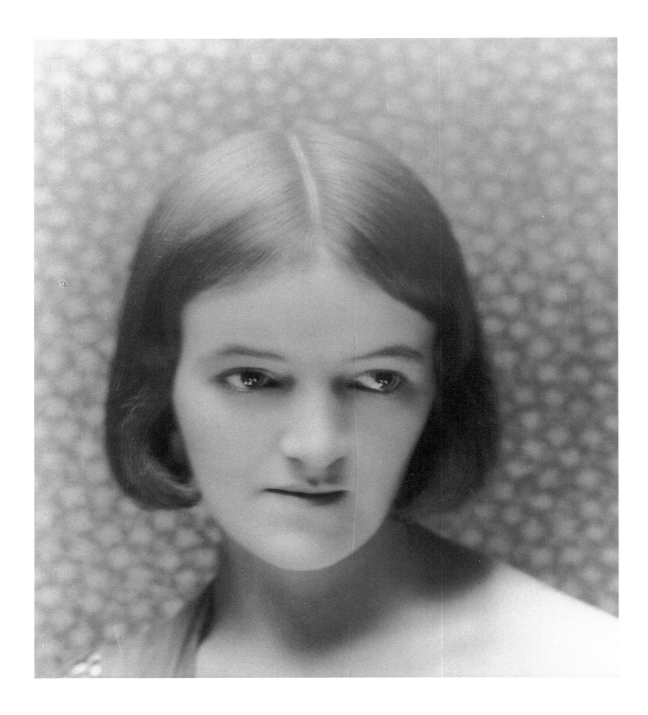

Barbara Hepworth c.1925

Barbara Hepworth and the Avant Garde of the 1920s

Penelope Curtis

Barbara Hepworth's early work tends to be situated alongside English modernism of the 1930s and defined by the writings of Herbert Read. But this characterisation, arising out of the time when she lived with Ben Nicholson alongside other English and continental modernist artists in Hampstead, comes a good decade into her career. Though concepts integral to the artistic creeds of modernism may have crystallised at this time, many of these concepts – notably truth to material and direct carving – had already been taken up by critics and sculptors in the previous decade. Before she met Nicholson, and before her work had been described by Read and Adrian Stokes, Hepworth, with her first husband, the sculptor John Skeaping, was already part of another avant garde with its own champions and critics.[1] This avant garde can equally well be defined by its interest in carving.

It is important for our understanding of the position which Barbara Hepworth had reached by the early 1930s to recognise that the discussion of direct carving during the 1920s was not only alive but was also well developed. It was, however, a discussion which can be clearly distinguished from that of the 1930s. This essay looks at Hepworth's introduction to carving within this context, which can be characterised by its presentation within the non-Western tradition, with a focus on technical skill and exotic material. Modern pieces were exhibited alongside ethnological examples, and both were bought by the same collectors. At this point the subjects of the modern carver were still based on the human or the animal, with a preference for the animal world because it allowed more room for experiment. The promotion of small-scale experimental carvings – form for form's sake – was couched within a new market for domestic, semi-decorative/semi-abstract sculpture. As modern carving was to be explained in the 1930s by analogy with biology or geology, so in the 1920s its apologists made comparisons with the archaic or non-classical traditions of the craftsman working direct with his chosen material. Such a positioning gave critics the tools with which to establish modern carving, and provided artists with the grounding in which to make and to describe their work.

• • •

Hepworth entered Leeds School of Art in 1920, and followed a drawing course there as the quickest way into the Royal College in London. It is unclear from the few records which survive to what extent sculpture was practised at Leeds at that time. There were certainly craft teachers, including one in carving, but Henry Moore has given the impression that there was no academic sculpture department, and that one was set up especially for his use. However, in

a letter home he asks, 'And how is the casting going on in the bottom modelling room in Leeds? … I think of Leeds and the top modelling room and when we all sat round the throne on the concrete floor modelling detail'.[2] At any rate, what this makes clear is that the world of the student who drew from life and modelled detail was completely separate from that of the student who followed a vocational course in carving.

In the 1920s carving was not understood to be part of a Fine Art training. It was taught, but to craftsmen and artisans rather than to artists. Even at the Royal College, which during Hepworth's time was being transformed by its new Head, William Rothenstein, from a teacher training college to a modern day art school, carving was only integrated into the sculpture department proper in 1932.[3] Those artists who, during the 1920s, developed their use of carving as integral to the meaning of their art evolved their practice on the margins of the academy.

At the College Hepworth was part of the 'Leeds table' (as it was known) which included Henry Moore, Raymond Coxon and Edna Ginesi. She accompanied them on at least one trip to Paris (it was cheaper to go to Paris than to go home to Yorkshire) between 1921 and 1923. Coxon has described these trips as comprising morning visits to private and public galleries, with afternoons and evenings spent drawing at Colarossi's atelier.[4]

To develop an interest in carved work, and particularly in direct carving, within the milieu of contemporary art at this time would have required some deliberation. It is questionable whether Hepworth did any direct carving at college. Though Hart taught stone carving, direct carving as an end in itself would not have played a prominent role. There was little modern carving to see in the galleries, and apart from Epstein's occasional shows, the historic collections in the British Museum and the Victoria and Albert Museum would have been the most relevant source.[5] The Victoria and Albert also displayed some contemporary works: in 1922, their carved Modigliani head was on show.

In April 1923 the stipulations for the 1924 Rome Scholarship were published. Hepworth sat the Open Examination in October 1923 and proceeded, with Skeaping, Pamela Harris and Emile Jacot, to the Final Competition.[6] In April 1924 the Faculty decided on the following subject: 'a panel in high relief 5′ x 3′ for the main exterior entrance to a hospital.' Hepworth executed this in the summer of 1924, and the Prize was judged in October. Newspaper reproductions of Hepworth's two submissions survive, one must date from January 1924, and one from the following summer.[7] These are rare visual records of the period between the Royal College (and Hepworth's first Italian trip) and her connection with Skeaping. It remains open to question how far we can judge Hepworth by these submissions. One is stylistically close to a bas-relief modelled by Skeaping in Rome, and is very fluid, its dance motif relating to German symbolic expressionism.

When Moore undertook the task of 'scout' to assess the nature of Hepworth's competition in the Prix, it would appear that he and Hepworth were surprised to find in Skeaping an 'ally' whose work could be respected. Hepworth wrote that she shared with Skeaping 'the same

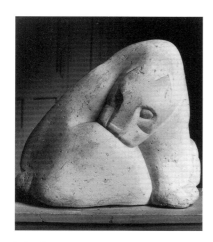

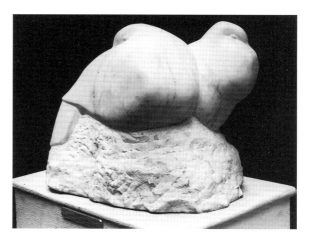

John Skeaping, 'Cat' ?exh 1928 Green
serpentine marble

I 'Doves' 1927

philosophy of life and art'.[8] Moore later wrote that 'Skeaping had the most wonderful facility with his hands as a carver, and Barbara Hepworth learnt a great deal from him technically'.[9] Skeaping won the Scholarship, and Hepworth was runner-up. However, a West Riding Scholarship enabled her to go to Italy as well, and in May 1925 she and Skeaping were married in Florence.

Hepworth's time in Italy has often been presented (not least by Hepworth herself) as her real introduction to carving. Although this is in a sense indisputable, it must have been John Skeaping's influence there which was really important. Hepworth first visited Italy alone, and although she has given the impression that she went with an experienced eye and a wish to seek out the early Italian art which complemented the vision of English modernism, conversation with the family with whom she lodged suggests a lack of real engagement with the country. She did no travelling alone, and was engaged in modelling in plaster a bust of her host Mrs A.R.T. Richards ('Quita') throughout her visit.

Skeaping had already been in Italy on the R.A. 'Traveller' bursary for a period between mid-1920 and mid-1922. He had been apprentice to Ardini, the *marmista* (marble blocker) for the Slovenian sculptor Mestrovic, for six months, and also worked in Carrara making statues for English cemeteries. It is almost certain that the stimulus of Ardini of which Hepworth writes was actually transmitted through Skeaping, as she spoke little Italian.[10] It is clear that Skeaping's knowledge of stone-carving must have been far in advance of Hepworth's. Her first known carved work ('Dove', now destroyed) is said to date from 1925. In any case, it is certain that Skeaping and the British School were catalytic in introducing Hepworth to carving. Skeaping recalls that he also taught his wife to carve wood, a skill that he had acquired from John Grierson, Registrar at Armstrong College, Newcastle, where Skeaping taught between Parts I and II of the Scholarship competition.[11] To judge by the quality of his article on the Skeapings in *Apollo* of 1930, Grierson may well have been an important formative influence.

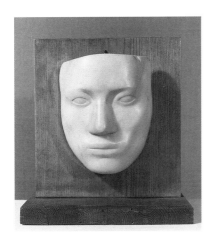

3 'Mask' 1928

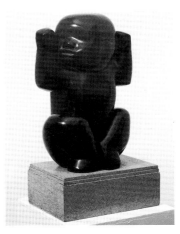

6 'Infant' 1929

Hepworth was fortunate that the new Director of the British School, Bernard Ashmole, had only that year ended the regulation against wives living in. Thus the Skeapings were able to share a large studio. Ashmole must have been of great value; he had a profound knowledge of Greek and Roman marbles, and has stressed Skeaping's passion for direct carving.[12] The masons whom Ashmole summoned from Roman yards to help with the identification of stones may well have stimulated the Skeapings. Certainly Italy cannot but have been revelatory with respect to materials. Skeaping used red sandstone, Carrara, Serravezza and Greek marbles there, and his work in stone outweighed his modelled work. His time there is recorded by the fountain which he carved for the School's central courtyard.

The Skeapings continued to carve when they returned from Rome. They were not well off, but even in the cold and relative dicomfort of their houses in London's Primrose Hill and St. John's Wood (1926–7) Hepworth made a point of carving outdoors. 1927 was a prolific year, with seven works in comparison to only one known from the preceding year. The years immediately after the return from Italy are marked by a use of Italian marbles which they showed at their joint exhibition of 1928. Though by 1930 Hepworth had moved on to English limestones, sandstones and alabaster, the late 20s are remarkable for the Skeapings' common interest in exotic stones, and reviews of this period begin to focus on the extraordinary range and hardness of their materials. Though Skeaping went further than Hepworth, towards both hardness (in carving chert) and preciousness (lapis lazuli and malachite), both were interested in the resistance of hard materials. Ironically, the artists' focus on material leads towards sensationalism and away from the true 'truth to materials', which actually requires a kind of indifference to material. Both doctrines – of truth to materials and of direct carving – should be carefully defined in relation to Hepworth's work. They are frequently associated with finding the image in the block, but everything that Hepworth says about carving should warn us against seeing her work in this way. She talks of knowing what she

Collection of G. Eumorfopoulos at his home

wants to carve before she starts, and acquiring the knowledge of which material to carve it in: 'An idea for carving must be clearly formed before starting and sustained during the long process of working.'[13] Her account of the seemingly pebble–like 'Toad' to its current owner seems to confirm this: 'The material was a green onyx and was a simple block which I bought at the time when I was carving some semi-precious stones.'[14]

The Skeapings had returned prematurely from Italy, on account of John's ill-health, in October 1926.[15] They lived first in Primrose Hill next to the Nevinsons, and moved to St Ann's Terrace in St John's Wood in April 1927. Their return was cushioned by some of the contacts they had made through the British School in Rome, and the common background of their new supporters is an interesting one. They had an entrée into a circle of support connected to the London museums through George Hill of the Coins Department of the British Museum. Hill was a trustee of the British School and had bought some of Skeaping's sketches out there. Hill then bought Hepworth's 1928 'Mask' and 1929 'Infant', and recommended his colleague, Lawrence Binyon, of the Oriental Collection at the Museum, to engage Skeaping to sculpt his daughter. This may well have been Skeaping's first work after his return.[16]

Other early pieces were bought by George Eumorfopoulos and Professor Charles G. Seligman, also Orientalists. Eumorfopoulos came late to modern art, which he began to collect in 1917. He owned sculptures by Richard Bedford, Frank Dobson, Henri Gaudier-Brzeska, Dora Gordine and Leon Underwood. He bought Hepworth's 1927 'Seated Figure' soon after completion, her 1927 'Doves' (p. 13) and her 'Mother and Child' as well as Skeaping's bust of Hepworth and a sacred group in terracotta. His collection was catalogued by Binyon in 1927. Eumorfopoulos was adviser to the Seligmans in building up their oriental collection; Seligman also owned a Hepworth, the 1928 'Toad'. A 1933 sculpture was bought by another Orientalist, Henri Frankfort.

It is tempting to see a connection between these Orientalists and their interest in Hepworth

and other modern sculpture. Such a connection prompts two questions: whether it is more than fortuitous, and whether it influenced Hepworth? Was she in regular contact with a circle of museum-based Orientalists? Eumorfopoulos did hold weekly open-house, but, although Hepworth certainly visited, any regular attendance is unlikely. Binyon had apparently lost interest in modern art by the 1920s, and although he continued to lecture at the Royal College and elsewhere, he viewed the 'taboos' and 'fanaticism' of the 'modern movement' as ridiculous.[17] Despite this, it is hard to relinquish the idea that such modern sensibility to form as is displayed by Binyon (notably in *The Flight of the Dragon* of 1911) was important. Its importance most plausibly rests in the connection between the appreciation of non-western art and of modern sculpture. This takes us beyond Orientalism into the wider field of comparative cultures; exemplified by the writings of Binyon and the collection of Sir Michael Sadler.[18]

It does seem likely that an appreciation of modern sculpture was easier for curators with prior academic interest in non-western form. Familiarity with three-dimensional abstraction must have helped, and abstraction in the three-dimensional was accepted earlier than in the two-dimensional. It seems plausible that the sculptural slant in the interpretation of modern art must be due to the amount of new non-western art forms revealed in the first decades of the century; art which was very much more often three-dimensional than two-dimensional. The discussion of modern art in terms of other cultures seems to prefigure its discussion in terms of science in the 1930s; both make use of a lay-man-like approach towards one discipline to explain and defend another.

This comparative approach was not unacceptable to Hepworth; she participated in exhibitions of comparative cultural artefacts in Sydney Burney's Gallery in 1928, and again as late as 1932. The exhibition, entitled *Sculpture considered apart from Time and Place*, exemplified the connection, and its two themes, the 'Dance and the Repose Motives' expressed the contemporary approach to a comparative appreciation of form. This exhibition inspired Michael Sadler to buy Hepworth, Skeaping, Moore and Zadkine. Though some have looked to Sadler as an influence on Hepworth, a much more likely source for the appreciation of the analogies between modern and non-Western art was Richard Bedford, of whom Skeaping said: 'It was Eddie Marsh who, with Richard Bedford of the Sculpture Department of the Victoria & Albert Museum really gave me my start in life on returning to England from the Rome Scholarship.'[19]

Bedford, twenty years older than Hepworth, had entered the department in 1911, having previously been a technical assistant in the museum for seven years. Both an academic and a carver, he combined these approaches in his comprehensive historical interest in carving technique. Bedford made explicit the relationship between forms of different cultures, and recognized 'the extreme value of primitive sculpture as evidence of the working mind when unhampered by restrictions imposed from without, and as possible sources of inspiration for modern artists'.[20] Bedford was representative of the Victoria and Albert Museum policy at the time: curators were technically knowledgeable and presented the collections very much as

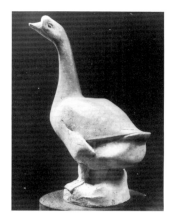
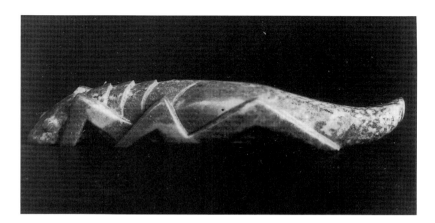

Barbara Hepworth, 'Goose'
1927–28 Terracotta

Richard Bedford, 'Cricket' 1931 Swedish green marble

teaching resources illustrative of craft techniques. The museum remained an adjunct to the former South Kensington training college. In a manner deriving from the late 19th century, rather than from new thinking, craft and material were presented as symbiotic.

Bedford was the author of articles on oriental, architectural and medieval carving, and had some kind of a circle around him. He had earlier known Gaudier, and while Hepworth's biographer A.M. Hammacher defines his circle as Moore, Hepworth, Alan Durst and Maurice Lambert, newspaper reports single out Moore, Sir Charles Wheeler and mention the others, excepting Durst. Bedford was undoubtedly important to young sculptors, and not only in obtaining stone for them. His stylistic similarity with Skeaping is apparent in their use of animal form. In their *animalier*, essentially pocketable pieces (p. 13 and 17), both approach Chinese animal sculpture and *netsuke* (carved button-like ornaments). Hepworth's series of small animal sculptures 1927 to 1930 reminds us that she cannot be placed outside this capricious *animalier* strain. Her surviving 'Toad' is in line with Skeaping's fondness for small, caressable objects. Her lost 'Goose', 'Dying Bird' and 'Dog' (reproduced in *Apollo*, November 1930, p. 351) of 1927–29 probably shared this quality. The 1930 'Fish' and 'Marten', in iron-stone and alabaster, were her last animal and bird works. Hepworth made small-scale work which had an intimacy and talisman-like quality which prompted associations with the supernatural. This was something very new to European sculpture. This feel for form is well described by Bedford in the same article:

> In its treatment of animal forms the Chinese genius reaches its greatest heights. Here the feeling for rhythm – for a ceaseless flow of line within the mass – and the tendency towards abstraction which are so essential to great sculpture are allowed full play.

Although her work was so close to Skeaping's in these years, in material, scale and theme, it is perhaps significant that Hepworth did not exhibit with him at the Imperial Gallery in 1927

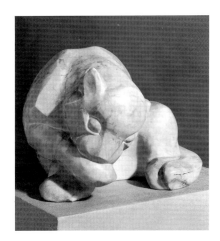 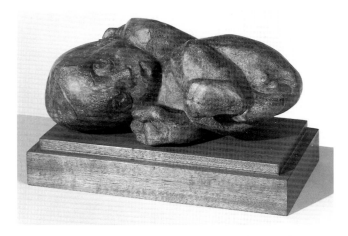

Alan L. Durst, 'Feline' 1930 Siena marble

Gertrude Hermes, 'Baby' 1932 Bronze, cast from chalk carving

and 1928. This gallery was colonialist in spirit, and colonialism worked in tandem with the Arts Décoratifs style, and its use of colonial woods and animals.[21] The *animalier* trend around 1930 helps to illuminate other areas. The notable growth in small sculpture (in itself a significant innovation) can be set within the promotion of sculpture for the flat-dweller, easy to display and afford. There was a new concern for interior design which resulted in a genre of trinket-sculpture, frequently Art Deco. Examples by Maurice Lambert, Gertrude Hermes, Eric Kennington and Moore are in Aumonier's *Modern Architectural Sculpture* (1930). Hepworth was herself involved with interiors, designing a number of household items with Nicholson. They both had their prints made up as curtains for each other[22] and Hepworth exhibited designs for both curtains (Lefevre 1933) and tableware (Harrods 1933). These may be regarded as breadwinners, but also had a serious status, linked to Hepworth's interest in the all-encompassing design concerns of Mondrian's atelier.

In 1927 the Skeapings held an exhibition in their studio in St John's Wood, and the following year they exhibited together three times. They had a joint show at the Beaux Arts Gallery, and contributed to *Modern and African Sculpture* at the Sydney Burney Gallery and to *French and English Decorative Art* at the Claridge Gallery. Both exhibitions suggest a certain underestimation of modern sculpture, and an 'oiling' of its sticky path by revealing it in comparative and functional modes. Nevertheless, Hepworth clearly found it acceptable to exhibit with Bedford, Durst, Dobson, Epstein and Gordine, in juxtaposition with African masks and furniture. There is certainly evidence that Hepworth was excited by African carving around this time.[23]

It is clear from a number of sources that by the end of the decade the Skeapings were in a position that demanded recognition. An article devoted exclusively to their sculpture by Grierson, Skeaping's Newcastle friend, appeared in *Apollo* in November 1930. They were selected for exhibitions abroad: in 1930 for *Modern Sculpture* in Stockholm, and in 1932 for

Neue Englische Kunst at the Hamburg Kunstverein. The 1932 exhibition can be considered within the context of the late 1920s for it is work by the prominent members of the 1920s avant garde that was selected. Among the other exhibitors – Bedford, Lambert, Moore and Underwood – Skeaping was, according to a local critic, awarded pride of place.[24]

It is with the 1928 exhibitions that we have our first chance to see how the press greeted the Skeapings. The *Times* critic singled them out at each exhibition. Although they did not exhibit in 1929, their absence was noted.[25] Their second joint exhibition was at Tooth's in 1930, where archives survive which allow an assessment of a representative cross-section of criticism. The 1930 Tooth's exhibition received more, and more in-depth, reviews than Hepworth and Nicholson's show there in 1932. At least eleven newspapers reviewed it, eight national. All except *The Manchester Guardian* were laudatory, and indeed approach complacency in their ready acceptance of the exhibition's importance. There is an excitement in the verbal control offered to the critic with the use of the motifs of 'direct carving' and 'discovery'. The easy comprehensibility of these motifs offered a critical key and suggests the same sense of illumination that is later identified as informing the writing of not only Read and Stokes, but also of the artists themselves.

The *Times* critic wrote of the 1928 Beaux Arts show: 'Both Mr. Skeaping and Miss Hepworth are of the satisfying kind [of artists] that allow their formal intentions to be regulated by the materials.' He considered Hepworth 'the more conscious of the characteristic form, as distinct from the substance, of the material. Most of her carvings are designed within the cubical as if they had been "found" in it'.[26] That such critical language is used in *The Times* at this date seems striking. But then, Hepworth was not unduly isolated nor avant garde in her personal development of direct carving and truth to material. The terms had been current among critics for at least a decade, with Charles Marriot (*Times* critic from 1924 and probable author of this uncredited article) asserting in 1918 that 'the question asked will not be "is it true to nature?" but "is it true to stone or wood or iron or paint as we know it"?'.

Direct carving had already been thoroughly discussed well before Read and Stokes took it up in the 1930s. As early as 1921 the critic Kineton Parkes labelled Gill, Turner, Parker and Cole as direct carvers for their love of tools and of the surface. However, he pointed out that 'it is no [sic] essential that the sculptor himself shall work direct upon these materials', and we sense an early suspicion of the new fashion. Within a decade one generation of writers had been through the notions of 'direct carving' and 'truth to materials' and had wearied of them.[27] Stanley Casson had welcomed the discipline which the love of stone provoked. The co-existence of love and discipline was central to the 'truth to materials'. The shift in Casson's tone from 1928 to 1939 is clear. His early faith in stone – 'All sculptors who love the material they use, who bring it under their hands at every stage, can today be called as leaders' – has become much more reserved a decade later: 'This new emphasis on the beauty of material as such has led, in some cases, to a curious exaggeration of the truth implicit in the view itself.'[28] Similarly in his chapter on 'Carving for its own sake' in his 1933 book on *Modern Sculpture*, Herbert

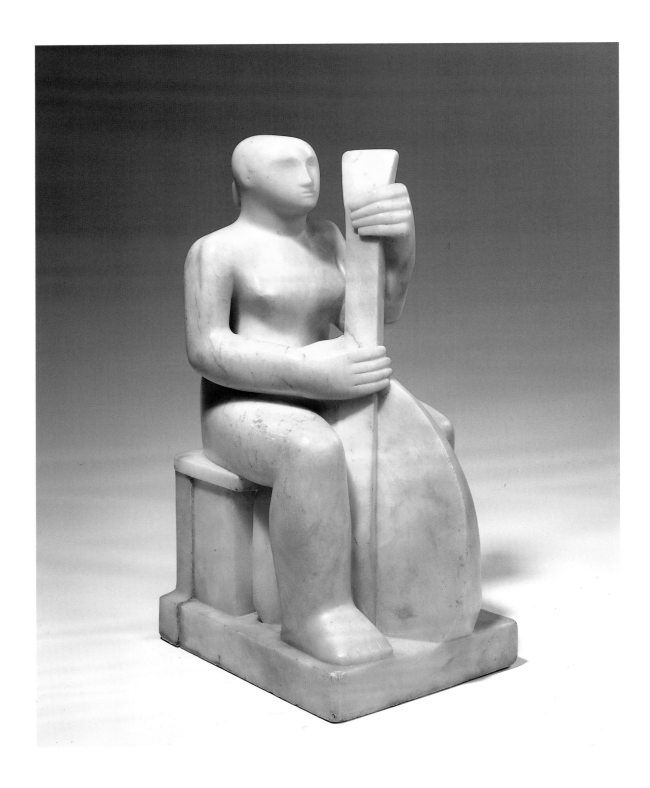

5　'Musician' 1929

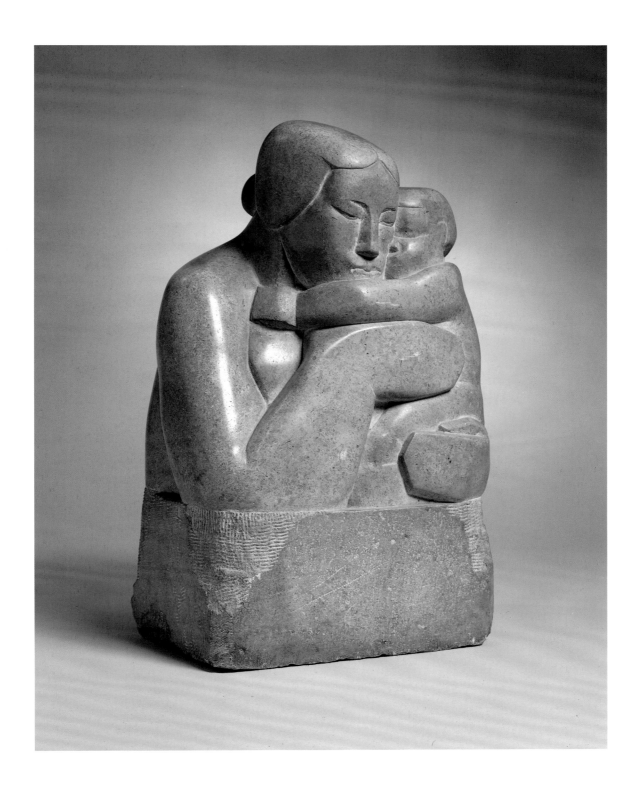

2 'Mother and Child' 1927

11 'Torso' 1932 9 'Head' 1930

Maryon (Master of Sculpture at Armstrong College) located all the 'obsessions' within a central obsession with stoniness:

> The most notable development within the realm of sculpture in recent years is the remarkable increase of interest, on the part of sculptors, critics and the public alike, in the actual carving of stone, marble and wood. It would seem, however, that many of our present day writers are so obsessed by stone, stonecarving, 'direct carving' and all that is of the stone – stony, that they sometimes compel us to wonder whether what is presented, and how it is presented, matters at all if only it is presented in stone.[29]

Many of the verbal tools used to describe sculpture in the 1930s are prefigured by the language of the 1920s. There is at once a striking proximity and a striking distance. The writers of the 1920s were unable to accept that the ideas which had excited them led to the kind of work that was to appear in the 1930s. The doctrine of 'truth to materials' had been taken up with a readiness which turned sour as writers perceived it becoming another academicism. This sourness must have been due, in part, to the 'second wind' which the doctrine enjoyed in the 1930s (when it was lauded at the expense of much else), and in part to the cultivation of form and material by sculptors such as Moore and Hepworth, whose repetitions seemed, to the conservative writers, to leave out much of 'life'. The 'heresy' in art condemned by conservative writers – that the part became the whole – was embodied by the 1930s avant garde. Frank Rutter's shift in position typifies the shift on the part of an earlier generation of critics. In 1930 he had praised Hepworth's work enthusiastically; in 1933 he classes her among the 'fashioners of monstrosities in stone'.[30]

The spate of textbooks[31] that suddenly appeared at the end of the decade put Hepworth into a 1920s context. In Casson she is seen as of 'even greater promise' than Skeaping. Wilenski cites Moore, Underwood and Bedford as the new 'poet-sculptors', and includes

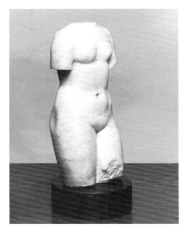

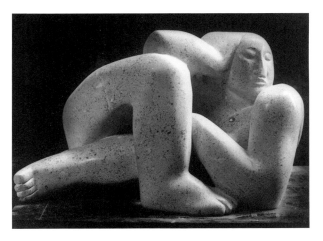

4 'Torso' 1928

John Skeaping, 'Reclining Woman' exh 1930
Hopton wood stone

Hepworth in the plates. In 1933 Eric Underwood can still class her with Lambert, Skeaping and William Simmonds. These surveys take us back to an avant garde that was soon to be completely overshadowed. While for some writers she was now established, for others she had hardly begun.

Skeaping was very much part of this avant garde. It is therefore striking how quickly in the 1930s the avant garde is disassociated from him. It seems plausible to suggest that, had Skeaping chosen, he might have had his place in it. He continued to be friendly with Moore, who indeed had attempted to keep alive his marriage with Hepworth, and was a member of the Seven and Five Society as late as 1932 (although dating his retreat in his autobiography to the late 1920s). In 1931 the only sculptures exhibited in the Society's 10th exhibition were by Skeaping and Kanty Cooper. In 1932 both he and Hepworth were members; in 1933 Moore replaced Skeaping as sculptor-member, Skeaping having resigned during the year following February 1932. Seeking a milieu now at one remove from the avant garde, Skeaping joined the circle of Edward Marsh, who supported the Nashes, Spencer, Wadsworth, Christopher Wood, Lett Haynes and Cedric Morris. He met the Sitwells and Ottoline Morrell, and collaborated with Duncan Grant and Vanessa Bell for an *Architectural Review* competition. It would seem that a new 'avant garde' had by now been identified, and Skeaping chose its opposite in opting for Bloomsbury. He preferred this 'less serious world' to the 'back-scratching operation' of the 'modern movement'.

In the light of this evidence it is possible to suggest that it was only when Moore and Hepworth detached themselves from the 1920s context for carving that the avant garde of the 1930s could take off. Hepworth's critical supporters from the 1920s were alienated both by the change in her work, and by those who were now associated with it. They disliked what they saw as the exaggerated self-importance of Read and Stokes. The reviews of the 1932 show pay much more attention to the artists to whom she was connected, rather than to what

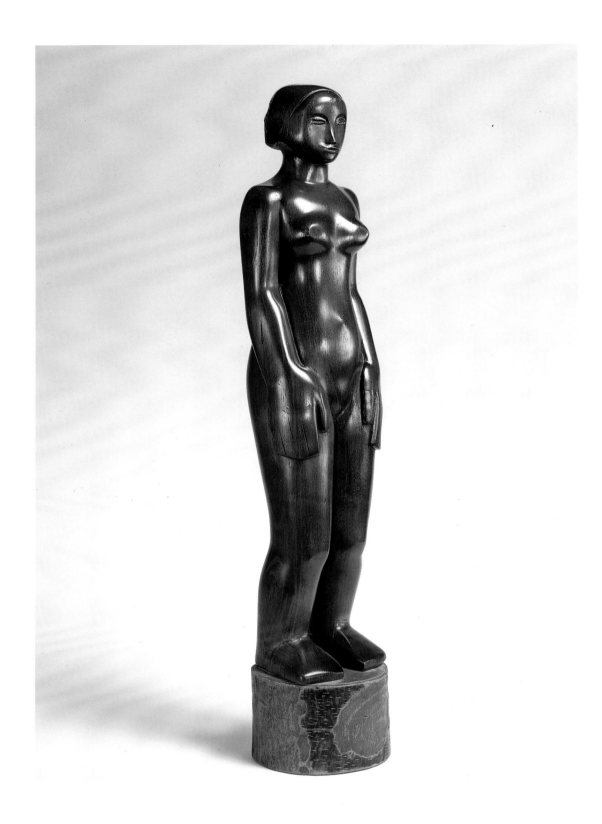

7 'Standing Figure' 1930

she was making. Certainly she was now, as she had not been previously, placed alongside Moore. The initial advocates of a return to direct and truthful treatment of material were unable to countenance its eventual alienation from representation.

That Hepworth's output and confidence flowered in the years 1929–33 is clear. In 1929, she produced eleven works, ceased working with *animalier* subjects, and began to work on a larger scale, in wood. Abstraction might be interpreted as appearing in her work when Hepworth felt that she had mastered materials and could thus, in a sense, break free of them. Her forms before 1930 had tended to conform to the block and be contained by it. Wood helped to free her from the block: 'By 1930, I felt sure that I could respond to all the varieties of wood growth or stone structure or texture. The 'Head' (p. 22) carved in 1930 expressed that feeling of freedom, and a new period began in which my idea formed independently of the block.'[32] Her new found freedom in releasing her sculpture from the 'block' may be marked by her first piercing of the form. The fact that her 'Pierced Form' of 1931 (p. 37) is isolated in her œuvre at this time makes it difficult to know how to interpret this innovation. What is clear is that this particularly creative period began while Hepworth was with Skeaping (with whom she continued to exhibit until 1932), and even the piercing – a trademark of modernism – may well have been initiated by him. In November 1930 John Grierson had noted in his article, 'I like Skeaping's new method of boring holes through the block. It gives air and intimacy, and a sort of stereoscopic quality to the composition'. Grierson particularly welcomed the tendency 'to get compositions into the air'.[33]

In shedding the block Hepworth also lifted her work off the ground plane. As she explored the effects of piercing she came to employ greater depth, so that she could burrow into rather than just cut out. She aimed at a 'greater co-ordination between head and hand', and this is suggestive of her co-ordination of two opposing disciplines: imposition of her will on the material and obedience to it. The searching for this meeting point is, perhaps, what led to abstract form; a mixture of the physical and the mental. This also reminds us of what Hepworth called her 'stereoscopic' device, and how the pierced form permits a deeper knowledge of its solidity by presenting a shifting image, as if from each eye separately. Carving is seen as autograph, as medium and sign. The haptic quality of sculpture was an important one to this period, revealed most strikingly in Stokes' belief that our awareness of space derives from our sense of touch. This is reminiscent of Hepworth's later use of the notion of the stereognostic: the mental apprehension of solid forms by touch.

It is indisputable that there was a significant change in Hepworth's own writing, as well as in the terms of critical discourse, from the early 1930s. But the fact that Hepworth's art and its language appear to come together with the advent of Read and Stokes may well be due, in part, to quite another factor altogether. Her new relationship with Nicholson confirmed an important component in her make-up: that of Christian Science. Nicholson's wife Winifred was strongly committed to Christian Science and influenced both Nicholson and Hepworth, who consulted a Christian Scientist, a Mrs Ferguson, for advice over their complicated

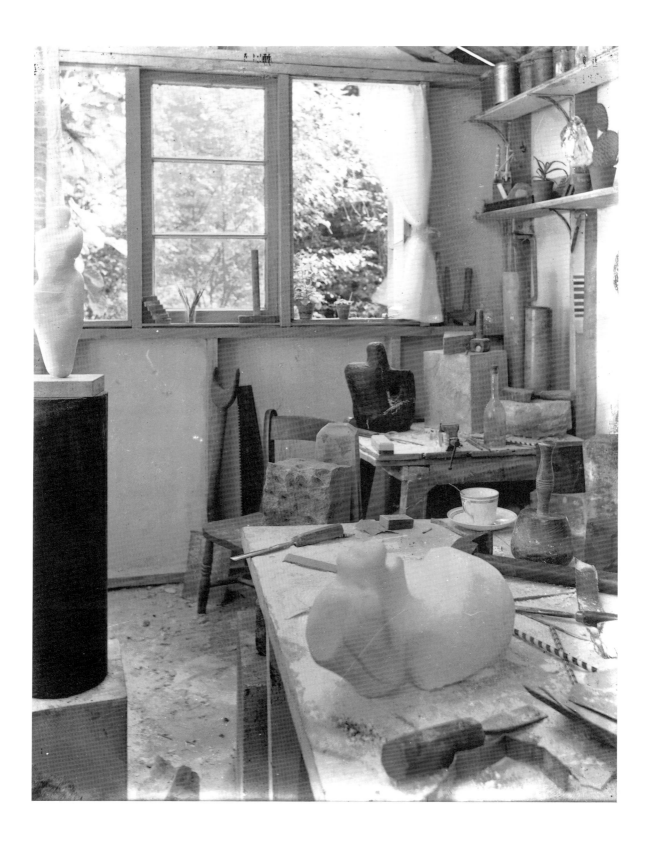

Barbara Hepworth's studio at the Mall, Hampstead c.1933

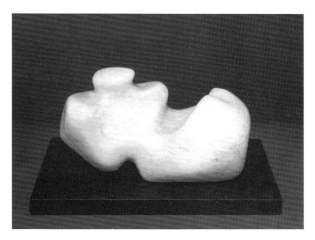

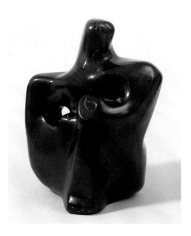

12 'Reclining Figure' 1933 13 'Seated Figure' 1932–33

ménage à trois. Early in their correspondence Hepworth told Nicholson, 'You know that science thought as I know it is the very core of my being – the lovely Genesis of perfect creation – & unfolding of spiritual ideas'.[34] The idiom and language of her sculpture was to reflect her continuing interest in Christian Science throughout the rest of her career: 'one has to learn to hold the clear thought so that it destroys the veil'.[35]

As is clear from her published writings, Hepworth was very concerned about language. When she met Read and Stokes she not only welcomed their ability to write about her art, but also asked them to help her in putting texts together, and was a careful and critical reader of their pieces. Her description of Stokes is reminiscent of Christian Science: 'his thought is not of limitation but of this: "Identity is the reflection of spirit, the reflection in the multifarious forms of the living principle – love"'.[36] Hepworth took her writing very seriously and defended it in a letter to Ben Nicholson, 'Yes my article is very solemn and serious – carving is you know compared with ptg'. As Hepworth adopted the poetic language of Read and Stokes, her words came to stand for her art, but they do not necessarily help us to enter in. The language of the 1920s is less watertight, but nevertheless prefigured that of the 1930s, and Hepworth's introduction to the discussion of direct carving has to be located within the earlier critical approbation accorded to the doctrine. This pre-existed the second wave which, despite its clarity and dogmatism, was not seen to have been, formative for Hepworth. It was the openness of the 1920s discourse which had enabled Hepworth to absorb its concepts and move on to achieve personal creative freedom in her carving by the end of the 1920s.

Much of the material for this essay derives from the author's own M.A. report, submitted to the Courtauld Institute in 1985.
Additional material is drawn from the Ben Nicholson Papers in the Tate Gallery Archive (TGA 8717).

Abbreviations used in this essay are as follows:
TGA – Tate Gallery Archive;
HMCSS – Henry Moore Centre for the Study of Sculpture, Leeds.

1 The established critical reception of Hepworth's work dates from 1932–3, when Read prefaced her Tooth's exhibition with Nicholson (Nov–Dec 1932), when Stokes first reviewed her work (in *The Spectator*, 3 November 1933), and when Unit One was formed. Hepworth's correspondence with Nicholson dates from August 1931. She and Skeaping separated at the beginning of October (TGA 2 and 4/10/31) and by March 1932 Ben had begun to share her studio; a situation which was to continue intermittently through the early 1930s. Hepworth made 65 works in the years 1920–1934, of which fifteen appear to be lost and two destroyed.

2 Letter of c.1920 to Jocelyn Horner, HMCSS, Leeds. Raymond Coxon's recollections (tape, TGA) of modelling with Moore similarly give the lie to his isolation. The *Yorkshire Evening News* of 8 October 1923 shows a photograph of the modelling department of the School. Of surviving prospectuses, that closest to Hepworth's time there, for 1924–5, postdates it by five years, but Cotterill, the Head of Sculpture & Modelling, is listed as having been at the School since around 1920.

3 The 1921–2 syllabus for the School of Sculpture shows that one of the four sections in the Upper Division was stone carving. In 1925–6, Hart joined the School of Sculpture, and wood-carving was added to the syllabus. By 1932, 'Carving is looked upon as an integral part of the course, and various kinds of stone, marble and wood suitable for sculpture are considered'.

4 Raymond Coxon, taped interview, TGA.

5 Epstein showed at the Leicester Galleries in 1917, 1920, and 1924.

6 The Sculptor Members of the Faculty of Sculpture for the British School at Rome present at the January meeting which decided the shortlist were Frampton, Goscombe John, Reid Dick, Jagger, Ledward and Pomeroy; these names remind us of the endurance of the 'New Sculpture' of the turn of the century.

7 Reproduced *Daily Chronicle*, 7 March 1925.

8 Letter to Claire Walmsley, quoted in Leo Walmsley, *So Many Loves*, London 1944, p.247. Hepworth abhorred Walmsley's book.

9 Henry Moore, *The Sunday Times*, 25 March 1975.

10 Bernard Ashmole, in a letter to the author, 11 March 1985. Information from first visit through discussions between the Richards family and the author, 18/3/85.

11 J. Skeaping in *Drawn from Life*. London 1977, p.72.

12 Ashmole's recollections in conversation with the author, 19/3/85.

13 Barbara Hepworth, *The Studio*, 1932, p. 332.

14 May 1963.

15 Skeaping spent his convalescence sketching in London Zoo where he may have met Solly Zuckerman, soon to be a patron, and who may already have been in position as prosector there. (A prosector dissects corpses in preparation for anatomical study). See S. Zuckerman, *From Apes to Warlords*, London 1978, pp. 28 and 57.

16 Binyon's daughter is Nicolete Gray, who was to arrange the exhibition *Abstract & Concrete* which was mounted in Oxford, Cambridge, Liverpool and at the Lefevre Gallery in London in 1936. (Hepworth strongly disliked the title and the printed material for the exhibition.)

17 L. Binyon, *Art & Modern Life*, Lecture to the University of Bristol, 1929, pp. 7 ff.

18 Sir Michael Sadler, 1911–23 Vice Chancellor at the University of Leeds, with an absence 1917–9 in Calcutta. Until the late 1920s Sadler was principally collecting English watercolours, especially the Norwich school and late 19th-century French works. Sadler's 'comparative' collection is said to have influenced Hepworth. Although she probably did visit it while she was at Leeds, at this stage it contained no modern art.

19 J. Skeaping, *A Tribute to Edward Marsh*, Liverpool, Bluecoat Galleries, 1975, p. 35. Sir Edward Marsh collected in the same vein as Binyon. His own contemporary tastes were cautious, but he encouraged Sadler to look at contemporary art. Though he never bought any Hepworths, he owned three or four carvings by Skeaping, and was the first English patron to buy one of his animal drawings. (E. Marsh, *A Number of People*, London 1939, pp. 351 f.).

20 Richard Bedford, 'Chinese Animal Sculpture', *Old Furniture IV*, August 1928, p. 223.

21 Skeaping also wrote the foreword to the exhibition *Six Colonial Artists* at the Cooling Galleries in 1934.

22 TGA 16/12/32. In 1928 Skeaping designed around half a dozen small animal pieces for Wedgwood to reproduce in ceramic.

23 There is some evidence in Hepworth's letters to Nicholson that she was excited by Burney's African pieces (TGA 30/12/32). Certainly one of her few stated concerns about Christian Science was that 'it cuts out all the warmth, creativeness humanness of the negro carvings' because (Christian) 'science will not admit the necessity of sex harmony' (TGA 2/7/32).

24 Gustav Bauli, *Frankfurter Zeitung*, 8 July 1932. The Hamburg show was the first German exchange exhibition since the war, and was selected by the Director of the Hamburg Kunstverein. Forestalled by the next war, the German selection never came to London.

25 The *Studio* in July 1929 and the *Daily Express* in March 1930 lamented the absence of younger sculptors at the Royal Academy summer exhibition, including both Skeapings in their lists, along with Epstein, Gill, Dobson, Moore, Maurice Lambert, Richard Bedford, Betty Muntz and Arnrid Johnstone.

26 *The Times*, 7 December 1928 and 13 June 1928.

27 W. Kineton Parkes *Sculpture of To-day*, Vol 1, London 1921, p.32. In 1932 R.H. Wilenski noted the preference for direct carving in his *The Meaning of Modern Sculpture*, London 1932, p. 92, and Stanley Casson noted that, 'sculptors spoke of this strange new custom as if it were an invention of the 20th century'. (*Sculpture of Today*, London 1939).

28 S. Casson, *Some Modern Sculptors*, London 1928, p. 73 and *Sculpture of Today*, London 1939, p. 22.

29 H. Maryon, *Modern Sculpture*, London 1933, p. 33.

30 Frank Rutter, *The Sunday Times*, 26 October 1930 and in *Art in My Time*, 1933. Rutter's change in position is unusual in that it appears to arise from a recognition of the change in Hepworth's own work between these years.

31 The textbooks: S. Casson, *XXth Century Sculptors*, London 1930; R.H. Wilenski, *The Meaning of Modern Sculpture*, London 1932; E. Underwood, *A Short History of English Sculpture*, London 1933; F. Rutter, *Art in my Time*, London 1933. Skeaping appeared in all these books, and also in M. Sadler's *Modern Art & Revolution*, London 1932; J.E. Barton's *Modern Art*, London 1932 and Casson's *Sculpture of Today*, London 1939.

32 *Carvings & Drawings*, London 1952, facing plate 1. In October 1931 she talked to Dudley Tooth about having a contract separate from Skeaping, recognising that her work was 'tending to become more abstract' (TGA 2/10/31) p.17.

33 J. Grierson, 'The New Generation in Sculpture', *Apollo*, November 1930, p. 351.

34 TGA 15/5/32.

35 TGA 23/7/32. Christian Science was of enduring support to Hepworth and was to inform her approach to her own and her children's illnesses.

36 TGA 6/12/33. In December Hepworth wrote 'Adrian – we are collaborating over my Unit One thing. That is he is going to help me!' (8/12/33) and three days later, 'Adrian spent 3 hours last night on my Unit One thing. It evolves slowly and … will take a week to do at least.'

14 'Figure' 1933

8 'Figure of a Woman' 1929–30

The 1930s: 'Constructive Forms and Poetic Structure'

Alan G. Wilkinson

> Decades, like centuries, are arbitrary divisions of the flow of time, but now that we can look back on the years 1930–40 we can have no doubt that they were decisive in the history of art in England.[1]
>
> Herbert Read

'By 1930', Barbara Hepworth wrote, 'I felt sure I could respond to all the varieties of wood growth or stone structure and texture.'[2] Indeed, if one compares the massive, block-like 1927 'Mother and Child' (p. 21) with the 1929–30 'Figure of a Woman' (p. 30), it is abundantly clear how far the sculptor had progressed in her ability and confidence to free the forms from the original block, to pierce the stone and open out the spaces between the arms and the torso. For Hepworth, as for Henry Moore, the 1920s were a period of struggle with the technical problem of carving, and of creating fully three-dimensional shapes, as opposed to the definition of forms by surface cutting in relief. The artist herself, in Herbert Read's 1952 monograph *Barbara Hepworth: Carvings and Drawings*, characterised the first of six periods of her work in terms of direct carving: 'the excitement of discovering the nature of carving 1903–1930.' The next two periods, which completed her London years, she summed up as: 'the breaking up of the acceptable structural order, and the poetry of the figure in landscape 1931–1934' and 'constructive forms and poetic structure 1934–1939.'[3]

Two carvings, both dated 1929–30, represent the culmination of the decade of the 1920s rather than announce or even hint at future directions. The teak 'Standing Figure' (p. 24) has much in common with what might be called the English figurative style of the 1920s found in the work of sculptors such as Dobson, Gill, Moore and Skeaping. In the head, the distinct, if generalised, echoes of African tribal sculpture are an atypical feature of Hepworth's early work. In her formative years, Hepworth drew inspiration from ancient Egyptian, archaic Greek and Cycladic sources rather than, as did Moore, from pre-Columbian and African art. Although their sculpture from the late 1920s to the mid 1930s shares common formal and stylistic characteristics, the differences in what might be called the 'personality' of their work are readily apparent. Compare Hepworth's 1929–30 'Figure of a Woman' with Moore's 1930 'Girl with Clasped Hands' (p. 32). Hepworth's figure radiates a sense of calmness and serenity. She herself best summed up this decidedly passive, inward-looking spirit found in much of her early figurative work in the title 'Contemplative Figure' (BH 15), a carving of 1928. By comparison, Moore's 'Girl with Clasped Hands' is alert and tense, with a pent-up energy and a forceful, somewhat disturbing personality. Hepworth's sculpture reflects her interest in the

Henry Moore, 'Mother and Child'
1930 Ancaster stone

Henry Moore, 'Girl with Clasped Hands'
1930 Cumberland alabaster

timeless spirit of classical art; Moore's work echoes the alertness and vitality he found in pre-Columbian sculpture and in tribal art.

Henry Moore was undoubtedly the most important formative influence on Barbara Hepworth. Both Yorkshire-born – Moore in Castleford in 1898, Hepworth in Wakefield in 1903 – they met at the Leeds School of Art in 1920. From 1921–24 they were fellow students in the School of Sculpture at the Royal College of Art in London. In 1928 they both exhibited publicly for the first time. Moore had a one-man show at the Warren Gallery, Hepworth and her husband John Skeaping exhibited together at the Beaux Arts Gallery. By 1929 the three sculptors were living and working together in close proximity in Hampstead.

For Hepworth, Henry Moore, four and a half years older than she, was something of a mentor and older brother. In the early years in Leeds and London they were obviously very fond of one another. Moore once said in conversation with the author that they had had 'a bit of an affair' and left it at that. But it is clear that it was their artistic relationship that mattered most to both of them. Between 1929, when Moore and his wife Irina moved to 11A Parkhill Road, close to Hepworth and Skeaping at 7 The Mall Studios, Parkhill Road, and 1939 when Hepworth left London for Cornwall, Henry and Barbara were seeing each other often, discussing ideas and following each other's work closely.

Moore, unlike Hepworth, taught regularly throughout this period and he also formulated many of the ideas that he and Hepworth had explored together. In 1930 he set these out in a statement under the title 'the nature of sculpture' in the *Architectural Association Journal* for that year. He commented that European sculpture had been dominated by the Greek ideal since its revival in the Renaissance. With the present day knowledge of the great non-European traditions, Moore wrote, 'the few sculptors of a hundred years or so of Greece no longer blot our eyes to the sculptural achievements of the rest of mankind.' Removing the

18 Single Form 1934

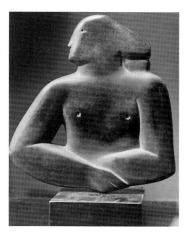

Barbara Hepworth, 'Carving' 1930
Iron-stone

Greek spectacles has helped the modern sculptor 'to realise again the intrinsic emotional significance of shapes instead of seeing mainly a representation value'.[4] He stressed the importance of direct carving and of understanding the potentials and limitations of each material. Stone should look like stone, rather than trying to imitate flesh. The sculpture which Moore most admired was fully three-dimensional, rather than surface cutting in relief, with its component forms working as masses in opposition. Sculpture, he felt, should not be perfectly symmetrical. It should be strong and vital and have a life of its own independent of the objects it represents. Hepworth's own published statements about the nature of sculpture, particularly those that appeared in *Unit One* (1934) and *Circle* (1937), reflect similar aims as well as fundamental differences in her vision of sculpture.

In 1930, Hepworth, Skeaping and their year-old son Paul, spent a summer holiday on the Norfolk coast with Henry and Irina Moore and the painter Ivon Hitchens. Barbara and Henry collected iron-stone pebbles on the beach which they transformed into small sculptures. Presumably it was in Norfolk that Hepworth carved two iron-stone pebbles, one of which was a half-figure entitled simply 'Carving' (BH 30, also known as 'Sculpture', above). In the same year Moore, always far more prolific in his output than Hepworth, carved four works in iron-stone. Nowhere are the close formal and stylistic ties between Hepworth and Moore at this period better illustrated than in two works of 1930 – Hepworth's iron-stone 'Carving' and Moore's Ancaster stone 'Mother and Child' (p. 32). The most obvious similarities are to be found in the shapes of the heads, both in profile, in the continuous, uninterrupted line of the nose and forehead, in the broad shoulders and weighty arms, and the inverted nipples. In Hepworth's 'Carving', the large protuberance of hair, supported by a rectangular block on the left shoulder, was almost certainly inspired by the cube-like buns of hair found in a number of Moore's pre-Columbian inspired carvings of 1929–30, such as the well-known

1929 'Reclining Figure' in Leeds City Art Gallery (LH 59). 'Carving', however, differs from Moore's work of the period in the way in which the arms form an obtuse angle, thereby lifting the figure from the base, rather than having the entire circumference of the torso, as in Moore's 'Mother and Child', firmly anchored to the base. In Hepworth's carving, the rectangular space between the torso and the right arm is indicative of the sculptor's new found freedom. This 'naturalistic' space is created by the position of the right arm in relation to the torso, but it is a 'hole' carved through the stone nevertheless. By 1930, the original shape of the stone, wood or pebble no longer had the upper hand. Hepworth herself says as much in the last paragraph of her notes on the first period of her life and work (1903–1930), in which she mentions this turning point in her career represented by the 1930 Cumberland alabaster 'Head' (p. 22): 'The 'Head' carved in 1930 expressed the feeling of freedom, and a new period began in which my idea formed independently of the block. I wanted to break down the accepted order and rebuild and make my new order'.[5]

From 15 October to 15 November 1930 Hepworth and Skeaping held a joint exhibition of sculpture and drawings at Arthur Tooth and Sons' Galleries, New Bond Street, London. This was to be their last show together. In the three years since they had organized the first exhibition of carvings in their St. John's Wood studio, Hepworth had worked through and absorbed the influences that shaped her formative years – Gaudier-Brzeska, Epstein, Skeaping and Moore. Symbolically, if not chronologically, the exhibition at Tooth's in the autumn of 1930 ended the six year Hepworth/Skeaping partnership. Their marriage was beginning to falter, although at the time, as she wrote in her book *Barbara Hepworth: A Pictorial Autobiography* (1972), 'I did not see what was happening to us after our second show together at Tooth's in New Bond Street. Quite suddenly we were out of orbit.'[6]

In April 1931 Barbara Hepworth shared an exhibition (in fact she showed only one sculpture) with the painter Ben Nicholson and the potter William Staite Murray at the Bloomsbury Gallery, London. It was probably then that she met Nicholson for the first time, although there had been a number of opportunities when she could well have met him and seen his work in the previous two or three years[7]. She has described the exhilaration of seeing the work of a painter with aims parallel to her own, and of the way in which his landscapes and still lives profoundly altered her vision of form, colour and perspective:

> To find an equivalent movement in painting to the one of which I was a part in sculpture was very exciting, and the impact of Ben Nicholson's work had a deep effect on me, opening up a new and imaginative approach to the object in landscape, or group in space, and a free conception of colour and form. It often happens that one can obtain special revelations through a similar idea in a different medium. The first exhibition which I saw of his work revealed a freedom of approach to colour and perspective which was new to me. The experience helped to release all my energies for an exploration of free sculptural form ...[8]

Nicholson, who was nine years older than Hepworth, was recognised as one of the leading figures in modern British art. The son of a distinguished artist, he had, by 1930, begun to establish contacts in Paris with artists, collectors and dealers. Hepworth and Nicholson had been exhibiting separately with the same London galleries for the previous three years. In February and March 1928 Nicholson had shown with the Seven and Five Society at the Beaux Arts Gallery, where Hepworth and Skeaping were to hold their first public exhibition in June that year. In March 1929 he had exhibited again with the Seven and Five Society, this time at Arthur Tooth and Sons', the gallery which was to give Hepworth and Skeaping a joint show in October of the following year. In March 1930 Nicholson had a one-man show at the Lefevre Gallery, and the following January exhibited again with the Seven and Five Society, this time at the Leicester Galleries. If Hepworth had seen Nicholson's work at one or more of these exhibitions – it is hard to believe that anyone interested in 19th century French art, and contemporary French and British painting and sculpture would not have frequented the Beaux Arts, Lefevre and Leicester galleries – she does not appear to have responded to it immediately.

Hepworth herself recalled that it was 'In 1930 I saw the paintings of Ben Nicholson ... and Frances Hodgkins for the first time'.[9] She was probably in fact referring to the January 1931 exhibition at the Leicester Gallery of the Seven and Five Society in which both Nicholson and the New Zealand-born Hodgkins were showing. As Hepworth's husband John Skeaping was exhibiting as a non-member, it is inconceivable that Hepworth would not have seen the show. (Later that year, Hepworth, Skeaping and Moore were elected members of the Seven and Five Society.)

Nonetheless, it was almost certainly at the April 1931 exhibition at the Bloomsbury Gallery that Hepworth met Nicholson for the first time and responded to his work. In that same month Nicholson and his wife Winifred spent an evening with Hepworth and Skeaping at 7 The Mall Studios in Hampstead. Barbara's interest in Ben's work was such that she arranged to borrow several of his paintings. In the spring their relationship had developed into a friendship, stimulated by a mutual respect and excitement about each other's work. That September Hepworth was planning to spend her second consecutive holiday on the Norfolk coast, where she had rented Church Farm at Happisburgh. Again she was joined by Henry and Irina Moore, and Ivon Hitchens. This year Ben and Winifred Nicholson were also invited. Ben arrived on his own on September 12, leaving his wife and their three young children at their house near the village of Banks, Cumberland. Ben, writing to Winifred (?20 September 1931), captures the spontaneous, contagious charm of Moore, the breadth of his knowledge and the clarity of his thinking – qualities that would certainly have engaged Barbara: 'Harry [Moore] seems to know all about everything I should say & in the most lively quiet & humorous way – of course it is all in his sculpture but it is fun to see it every day in him'.[10]

By September 26, when Nicholson left Happisburgh and returned to Banks Head, he had spent a fortnight with Hepworth and her friends. Both Henry and Irina Moore and John

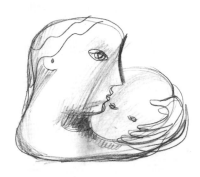

93 'Two Heads (Mother and Child)'
c. 1932

10 'Two Heads' 1932

Skeaping had departed before Nicholson, leaving Ben and Barbara more or less on their own. If the initial friendship had begun for Nicholson out of compassion for Hepworth's marital difficulties[11], by the end of the Happisburgh holiday one assumes the relationship had reached a greater level of intimacy.

Hepworth made only three sculptures in 1931, the smallest annual production since the mid 1920s. Having mastered the technique of carving, she could concentrate on formal considerations and begin to explore a new poetic structure that was no longer regulated by the constraints of representation closely tied to human anatomy. Hepworth described her new approach and emphasized the special bond between the sculptor and her materials:

> In trying to find a new way of composing forms other than by the accepted order of human anatomy or by my own experience of the special forms induced by carving direct into the material, and feeling in harmony with the properties of wood or stone, I discovered a new approach which would allow me to build my own sculptural anatomy dictated only by my poetic demands from the material.[12]

The alabaster 'Figure (Woman with Folded Hands)' (BH 33), is, in the extreme exaggerations and distortions of the human figure, unlike any of Hepworth's previous work. The gigantic proportions of the arms and hands, the most powerful sculptural element when the half-figure is viewed from the front, are reminiscent of the ponderous figure style of Picasso's women from his neo-classical works of 1921–22, such as 'The Race' 1922, on which the curtain for the ballet *Le Train Bleu* was based. Henry Moore greatly admired the Picasso curtain and is likely to have discussed it with Hepworth.

In the 1931 alabaster 'Pierced Form' (also known as 'Abstraction') (p. 37), Hepworth carved through the centre of the sculpture, thereby creating for the first time in her work an

Barbara Hepworth, 'Pierced Form'
1931 Alabaster

90 'Form with Hole' c. 1932

abstract hole that has no reference to the logic of human anatomy. The title itself refers to the physical act of cutting into and through the stone. By creating this *abstract*, negative space, Hepworth had inaugurated what was to become for her and for Moore one of the most important formal features of their work. This breakthrough was of such significance that 'Pierced Form' was one of only two sculptures that Hepworth discussed in her notes on the years 1931–1934:

> ...in the 'Pierced Form' I had felt the most intense pleasure in piercing the stone in order to make an abstract form and space; quite a different sensation from that of doing it for the purpose of realism. I was, therefore, looking for some sort of ratification of an idea which had germinated during the last two years and which has been the basis of my work ever since.[13]

Hepworth has recorded how impressed Moore was when he saw 'Pierced Form' in her studio.[14] The question as to which of the two sculptors first created 'the hole' should be discussed in the context of their earlier work. By 1929 both artists, no longer intimidated by the material, had carved through the stone, but these opened out areas simply define the 'naturalistic' space between the arms and the body (p. 30 and p. 32). In Moore's Picasso-esque 1931 'Composition' (LH 99), for example, the opening at the top of the figure still represents the space between the arched arm-like form and the head. The significance of the hole in Hepworth's 'Pierced Form' is the way in which it has been carved more or less through the centre of the alabaster, thus opening out a totally abstract space that has a life of its own, without representational references. The hole has become an integral sculptural element as important as the solid stone that surrounds and defines it. Since the abstract hole does not appear in Moore's work until 1933, in carvings such as 'Composition' (LH 131), Hepworth

should be credited with having initiated this formal device which was to be arguably the most significant recurring theme of her career. But in the last analysis who got there first is of little consequence. In fact, the abstract hole in modern sculpture pre-dates its appearance in Hepworth and Moore's work by nearly two decades. By 1912 it was a dominant feature in Archipenko's sculpture, and is also found in Gaudier-Brzeska's 1914 'Ornament Torpille', one of his last works. The close working relationship between Hepworth and Moore is reminiscent of the constant borrowings and exchange of ideas between Braque and Picasso during the great early Cubist years from 1907–14. For example, in September 1912 Braque created the first *papier collé* by pasting pieces of wallpaper onto the surface of a drawing, entitled 'Compotier et Verre'. When Picasso saw Braque's revolutionary new technique several weeks later, he appropriated the medium almost at once. When artists are working as closely together as Monet and Renoir in the early 1870s, Picasso and Braque 1907–14, and Moore and Hepworth in the late 1920s and the 1930s, the relationship is symbiotic in nature.

In the autumn of 1931, following the summer holidays on the Norfolk coast, the relationship between Hepworth and Nicholson continued to blossom. In early October, he left Banks Head for London and began to see her regularly. By November Nicholson had moved from Chelsea to rented rooms at 53 Parkhill Road, Hampstead, very close to where Hepworth was living. Hepworth and Skeaping had been living at 7 The Mall Studios since 1928. In 1929 Barbara had been responsible for finding a studio flat nearby for Henry and Irina Moore. Nicholson's reasons for moving to Hampstead were two-fold: the potential of a new relationship with Hepworth, and his friendship with and interest in the work and ideas of Moore. Hepworth had been responsible for attracting Nicholson and Moore to Hampstead, thus establishing this area of London as the artistic centre of the avant garde. As Herbert Read has written, '... Henry Moore, Ben Nicholson, Barbara Hepworth and several other artists were living and working together in Hampstead, as closely and intimately as the artists of Florence and Siena had lived and worked in the Quattrocento'.[15] Subsequently, it was largely through the friendships and contacts of Nicholson, Hepworth and Moore that other English and European painters, sculptors, architects, poets and critics gravitated to Hampstead. By the end of the decade, this 'nest of gentle artists',[16] to use Herbert Read's delightful and affectionate phrase, included Paul Nash, Roland Penrose, Piet Mondrian, Naum Gabo, Marcel Breuer, Walter Gropius, Herbert Read, Adrian Stokes and Geoffrey Grigson. It was not only the artists who played an influential role in Hepworth's life and work. The critics Read, Stokes and Grigson provided much needed moral support with their perceptive and sympathetic reviews of her sculpture.

By 19 March 1932 Hepworth and Nicholson were sharing 7 The Mall Studios, although Ben continued also to rent rooms at 53 Parkhill Road. For the rest of the decade, the work of both artists was enriched by the cross-fertilization of ideas from sculpture to painting and from painting to sculpture. That Hepworth and her sculpture are depicted in a number of Nicholson's paintings and drawings of 1932–33 attests to his excitement about his new found

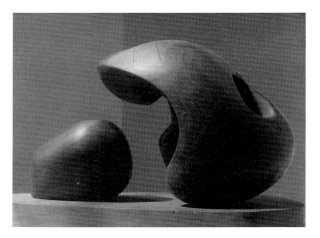

Ben Nicholson, '1932 (girl in a mirror, drawing)' Pencil on paper

Henry Moore, 'Two Forms' 1934 Pinkardo wood

love, and his intense interest in her work. The bust on the table in his painting '1932 (head with guitar)', seems to combine a likeness of Hepworth with echoes of the 1930 Cumberland alabaster 'Head'.[21] The sculptor was also the subject of a number of life drawings made in 1932, of which '1932 (girl in a mirror, drawing)' (above), is one of the most haunting and beautiful. In Hepworth's carvings of the period, the most obvious influence of Nicholson's work is the appearance for the first time of lines incised on the surface of the stone or wood. In the 1932 alabaster 'Two Heads' (p. 36), representing the tender bond between mother and child, incised lines define the right eye of the mother, the nose (or mouth) of the child, and the mother's hand at the back of the infant's head. While the simplified, almost featureless head of the child is reminiscent of the work of Brancusi, such as the 1911 marble 'Prometheus' (Philadelphia Museum of Art), the subject itself could be distantly related to Epstein's 1913–14 marble 'Mother and Child' (Museum of Modern Art, New York). In Hepworth's 1932 green marble 'Profile' (BH 40), the head incised at the top of the carving closely resembles the features of the sculptor. Linear profiles of Hepworth's head also appear in a number of Nicholson's paintings and prints of 1932–33.[17] The 1933 alabaster 'Reclining Figure' (p. 27) represents a radically new treatment of the human figure which would characterize Hepworth's sculpture for the next two years. The flowing, curving rhythms of the figure, which echo elements of landscape as much as the human body, may owe a debt to Arp's first three-dimensional sculptures made in the early 1930s (p. 45). Although Hepworth did not visit Arp's studio until the spring of 1933, she could possibly have seen his sculpture reproduced in *Cahiers d'art* 6, nos. 7–8, 9–10 (1931). A source closer to home is the work of Nicholson, such as '1932 (painting)'. As Jeremy Lewison has commented: 'Some have seen in this painting the outline of a reclining nude, and a mountainscape may also be implied ... The free-flowing line is suggestive of Nicholson's interest in certain aspects of Surrealism,

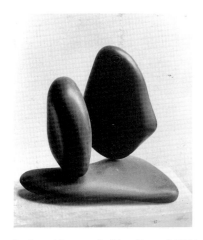

Barbara Hepworth, 'Two Forms' 1934
Iron-stone

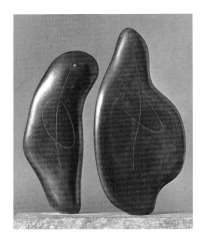

Henry Moore, 'Two Forms' 1934
cast into bronze, 1967

particularly the organic or biomorphic ones.'[18] In the 1930s it was Nicholson above all who was not only responsible for championing the cause of English art abroad, but for making his friends at home aware of the most important developments of the European avant garde.

Hepworth's earliest surviving drawings that relate to her sculpture were executed in 1932. Six of them are exhibited for the first time in this exhibition (cat. nos. 88–93). Although 'Two Heads (Mother and Child)' (p. 36) is clearly associated with the 1932 alabaster 'Two Heads', it should not be seen as the 'definitive' study for the sculpture. Throughout her life Hepworth used drawings as a way of exploring themes that related to her sculptural interests at the time. She did not base her sculptures directly on her drawings. Moore, on the other hand, used drawings as a means to an end – of generating ideas for sculpture. From the early 1920s to the early 1950s, almost all his carvings and bronzes were based directly on preparatory drawings. Hepworth worked in a more conceptual way. Before beginning a sculpture, she would have in her mind the complete conception of the form, which she was able to sustain during the lengthy process of carving.

From 9 November to 3 December 1932 Barbara Hepworth and Ben Nicholson held a joint exhibition at Arthur Tooth and Sons' Galleries, London, where she had exhibited two years before with John Skeaping. The show was an event of great significance on several counts. It announced publicly for the first time her break with Skeaping and her new alliance to Nicholson. The critic Herbert Read, soon to become the champion of the English avant garde, wrote a short foreword to Hepworth's sculpture in the exhibition catalogue (H.S. Ede wrote the foreword to Nicholson's paintings.) Not only was Hepworth exhibiting as an equal partner with the most important English painter of his generation, she had the support of the most influential critic of the modernist movement in England. Read saw the revival of the art of sculpture as the re-establishment of the vital connection between the artist and their

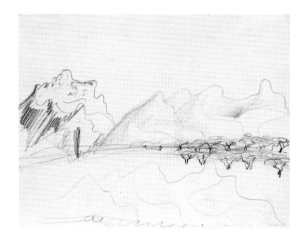

94 'St. Rémy: Tower' 1933

95 'St. Rémy: Mountains and Trees I' 1933

material – in other words direct carving as opposed to modelling clay or plaster and then having the work cast in bronze. Read commented that among the sculptors in England taking part in this revival, 'Barbara Hepworth occupies a leading position'. He found in her work what he believed were the two essential principles of sculpture, 'the organization of masses in expressive relation and the revelation of the potentialities of the sculptural material'. Read may have been the first critic to refer to her sculpture as abstract: 'That some of Miss Hepworth's creative conceptions should recede into a symbolic world of abstractions is not a feature that should deter the disinterested spectator: art is a servant (and a redeeming sanction) in any sphere of the human spirit – and not least in this marginal world between consciousness and unconsciousness from which emerge strange images of universal appeal.'[19] (The 1931 pink alabaster 'Pierced Form' (p. 37) was included in the show as 'Abstraction', catalogue no. 7, and is the sculpture in which the abstract 'hole' first appears in Hepworth's work.) Read in his brief foreword had touched on two concepts which had governed Hepworth's thinking about sculpture since the mid 1920s: direct carving and the inherent qualities of each material. As the artist herself said at the time, in her first published statement 'the Sculptor carves because he must', (*The Studio*, December 1932): 'the idea must be in harmony with the qualities [of wood and stone] of each one carved; that harmony comes with the discovery of the most direct way of carving each material according to its nature.'[20] What was new in Read's foreword reflected what was new in Hepworth's work – her bold step towards 'a symbolic world of abstractions'.

In *The Week-end Review* 19 November 1932, the painter Paul Nash discussed the Hepworth/Nicholson exhibition at Tooth's. Nash not only produced one of the most perceptive and enlightened articles that has ever been written on Hepworth, but also touched on what he called 'a delightful unity' achieved by the complementary juxtaposition of the works of

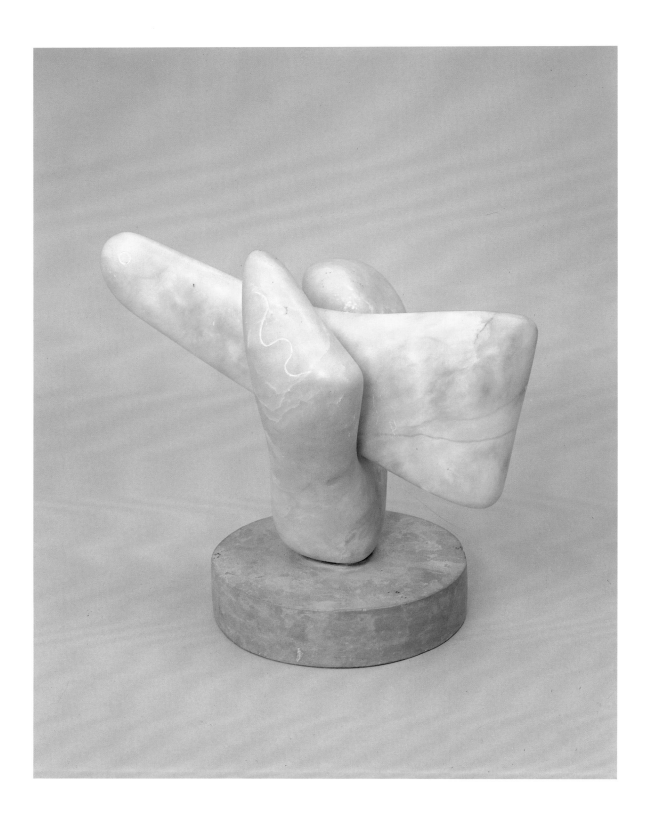

15 'Two Forms' 1933

'A Painter and a Sculptor', the title of his article. 'We are quickly aware', Nash wrote, 'of certain ideals which are shared, certain standards and aims towards which each artist separately directs a determined approach'. 'Both artists', he said, were 'trying to make things which seem to them beautiful in themselves', and he commented on how unusual it is to enter an exhibition and 'be obliged to attend solely to each work, for what it *contains* rather than what it is in reference to...'. In the work of both sculptor and painter Nash remarked on 'the sense of age which many of its objects suggest. Miss Hepworth's carved abstractions seem not to have been fashioned by tools; they have much more the appearance of stone worn by the elements through years of time'. In the following statement, Nash identified an important characteristic of Nicholson's work which was leaning more and more towards the three-dimensional. Whereas with sculpture we expect to enrich our experience of a work by touch, it is unusual, Nash wrote, '...to judge a painting in the same way, yet, in the painting of Ben Nicholson, there is so much actual texture of surface that we are led to feel with our eyes...' Within a year Nicholson was to bridge the gap between painting and sculpture when he embarked on his first carved reliefs. Nash ended his comments on Hepworth's sculpture with a statement that sums up the essential features of her work of 1931–32, which was moving closer to total abstraction. 'Each object is purely sculptural – the embodiment of an idea neither literary, naturalistic, nor philosophical, but simply formal: its meaning is itself, itself the only meaning.'[21] By the time the exhibition at Tooth's Gallery had closed in early December 1932, Hepworth had, with Moore, overtaken Epstein, Gill, Dobson and Skeaping as the leaders of modernistic sculpture in Britain.

When Hepworth joined Nicholson in Paris on 2 April 1933, he had already met Picasso, Braque, Zadkine, Man Ray and possibly Giacometti. The couple spent the Easter holidays at Avignon and St. Rémy de Provence. Hepworth later described her first visit to the south of France and the impact of seeing the interaction of figures in the landscape around the Hellenistic and Roman ruins known as 'Les Antiques' just outside the town of Glanum at St. Rémy (p. 44):

> It was Easter; and after a bus ride we walked up the hill and encountered at the top a sea of olive trees receding behind the ancient arch on the plateau, and human figures sitting, reclining, walking and embracing at the foot of the arch, grouped in rhythmic relation to the far distant undulating hills and mountain rocks ... I made several drawings. These were the last I ever made of actual landscape, because since then, as soon as I sit down to draw the land or sea in front of me, I begin to draw ideas and forms for sculpture.[22]

Two of these unpublished drawings are included in the exhibition. In 'St Rémy: Mountains and Trees' (p. 41), the outline of the hills above the olive trees, known as Les Alpilles, reads like a gigantic reclining figure, with the head and shoulders at the right. With her 1933 'Reclining Figure' (p. 27) and 1934 'Mother and Child' (p. 47), Hepworth employed similar landscape elements as a metaphor for the human figure. In 'St. Rémy: Tower' (p. 41),

Barbara Hepworth at St. Rémy de Provence, Easter 1933

Ben Nicholson, '1933 (St. Rémy, Provence)'
Pencil on paper

Hepworth had drawn on the left 'La Porte monumentale de Glanum' and on the right 'La Mausolée des Jules'. The sketch of the mausoleum includes three figures seated at the base. Above these, greatly enlarged, curvilinear forms are free interpretations of the much smaller and more detailed battle scenes depicted on the sides of the tower. The economic, linear style of Hepworth's drawings is closely related to that of Nicholson, whose drawing '1933 (St. Rémy), Provence' (above), which shows only the Roman arch and the hills in the background, must have been executed at exactly the same time. Nicholson celebrated their holiday in the south of France in his tender and evocative '1933 (St. Rémy, Provence)' (p. 45), with the classically inspired profile heads of the sculptor and painter, and the Picasso-esque, interlocking reflections of the faces in the oval mirror, set against the mountains.

On their return to Paris, Hepworth and Nicholson were invited to join *Abstraction-Création*, the Parisian society of painters and sculptors. Barbara exhibited with the group from 1933 to 1935. Before leaving for London they visited the studios of Arp and Brancusi, two sculptors whose work, in very different ways, profoundly altered Hepworth's formal vocabulary during the following years.

Arp and his wife Sophie Taeuber-Arp lived at Meudon, on the outskirts of Paris. Barbara and Ben were disappointed to find that Arp was not at home, but Sophie Taeuber-Arp showed them around the studio. Although Hepworth disliked the dead white plaster of which many of Arp's first three-dimensional sculptures were made, she delighted in 'the poetic idea in Arp's sculptures, although they lacked these special qualities of material which I cannot do without in my work'.[23] As Hepworth had no first-hand knowledge of the Dadaist or Surrealist movements, she found that 'seeing Jean Arp's work for the first time freed me of many inhibitions and this helped me to see the figure in landscape with new eyes'.[24] That Hepworth responded almost immediately to the stimulus of Arp's multi-piece compositions

Ben Nicholson, '1933 (St. Rémy,
Provence)' Oil and pencil on board

Hans Arp, 'Head with Annoying Objects' 1930–32
Original plaster

(p. 42 and p. 47) reveals the rapport she felt with his sculpture. His work also triggered a response to what was to become a life-long obsession – the almost mystical identification with the human figure and human spirit inhabiting the landscape. As Hepworth wrote of her reaction to seeing Arp's studio, 'I began to imagine the earth rising and becoming human. I speculated as to how I was to find my own identification, as a human being and a sculptor, with the landscape around me'.[25]

Hepworth's visit to Brancusi's studio produced a very different response. Much of his work carved in stone or wood epitomised the doctrine of truth to materials. Whereas her fascination with Arp's sculpture focused on the formal aspects of his work, Brancusi's art combined what she was striving for herself – the harmony between form and material. As she wrote: 'In Brancusi's studio I encountered the miraculous feeling of eternity mixed with beloved stone and stone dust ... The quiet, earthbound shapes of human heads or elliptical fish, soaring forms of birds, or the great eternal column in wood, emphasised this complete unity of form and material.'[26]

On their way back to London towards the end of April, Nicholson arranged a visit with Picasso at the Chateau Boisgeloup, Gisors, where he had installed a sculpture studio in the spring of 1931. Hepworth described 'the afternoon light streaming over roofs and chimney-pots through the window, onto a miraculous succession of large canvases which Picasso brought to show us',[27] but strangely made no mention of Picasso's sculpture. Did he not show them his sculpture, particularly the monumental series of heads and busts of Marie-Thérèse Walter, made at Boisgeloup in 1931–32? Whereas the direct impact of Picasso on Nicholson is much in evidence in his work of 1933, Hepworth's debt was one step removed, as it were, and came via her interest in the sculpture of Arp and, as will be discussed later, Giacometti.

Hans Arp, 'Necktie and
Navel' 1931 Painted wood

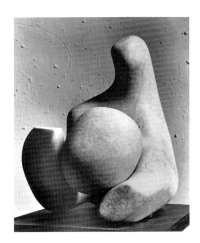

Barbara Hepworth, 'Figure (Mother
and Child)' 1933 Alabaster

From 23 October to 14 November 1933 Hepworth and Nicholson held their second joint exhibition in London within a year, this time at Alex. Reid & Lefevre Ltd. The critic Adrian Stokes reviewed 'Miss Hepworth's Carvings' in *The Spectator* on 3 November. He had written about Nicholson's work the previous week. Hepworth could not have asked for, or found, a writer with such a passionate attachment to the medium of stone. No critic before or since has bettered Stokes' descriptions of stone and of the sculptor's special bond with her material:

> A glance at the carvings shows that their unstressed rounded shapes magnify the equality of radiance so typical of stone ...
> Miss Hepworth is one of the rare living sculptors who deliberately renew stone's essential shapes.
> To the imagination nothing is more solid than stone ...
> Pebbles are such shapes since in accordance with their structures they have responded to the carving of the elements.
> Nothing, it would appear, should be attempted for a time on the mountain and mother-and-child themes in view of what Miss Hepworth has here accomplished (above).
> It is not a matter of a mother and child group represented in stone. Miss Hepworth's stone is a mother, her huge pebble its child.[28]

The progression of Hepworth's carvings of 1933 divides chronologically into two groups: the single form sculptures such as 'Figure' (p. 29), and the multi-part compositions such as 'Two Forms' (p. 42) and 'Figure (Mother and Child)' (above). That the first four carvings of 1933 listed in volume one of the catalogue raisonné of Hepworth's sculpture (BH 47–50) are single figures strongly suggests that they were done prior to the artist's trip to Paris at Easter.

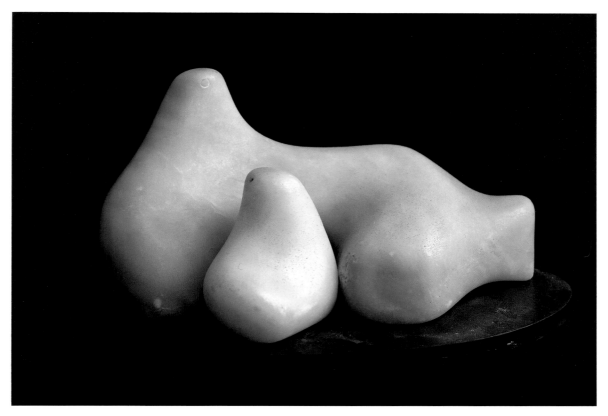

16 'Mother and Child' 1934

While 'Figure', with the 'abstract' hole beneath the small breasts, is a reworking of the seminal 1931 'Pierced Form', 'Two Forms' and 'Figure (Mother and Child)' herald a new departure for Hepworth. They are the earliest in the series of multi-part compositions which became not only the most important motif in her subsequent sculpture of the 1930s, but also a life-long obsession. Undoubtedly the two-piece carvings of 1933 were directly inspired by Arp's first fully three-dimensional sculpture which Hepworth would have seen when she visited his studio in April 1933. Of particular relevance are his transitional sculptures in wood (1926–31), the first plaster sculptures (c.1929–33), and the 'human concretions' (1933–36). 'Two Forms', although more blatantly phallic than any of Arp's early three-dimensional work, does, however, relate to his early plaster sculptures, such as 'Head with Annoying Objects' 1930–32 (p. 45). The 1934 'Mother and Child' (p. 48) is even closer to Arp's multi-part sculptures in which one or more small forms rest or balance on a single larger form. In 'Figure (Mother and Child)', the only carving which Stokes discussed in his 1933 review, the child *is* the simple rounded form whose shape corresponds to the navel forms found in several of Arp's wood sculptures of 1931, such as 'Necktie and Navel' (p. 46). (Arp's multi-part compositions were, in turn, almost certainly inspired by Picasso's series of drawings of upright figures composed

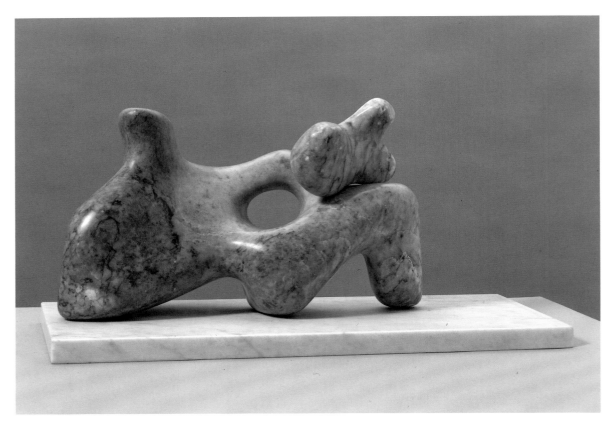

17 'Mother and Child' 1934

of dislocated, balancing forms, made at Dinard in the summer of 1928. By the end of 1933 Hepworth had created at least three multi-part carvings, two of which were based on the mother and child theme.

If in the 1920s Hepworth's work was strongly influenced by Moore, by the early 1930s she had developed a sculptural syntax entirely her own. Historically (as in the debate as to who carved the first abstract hole), it is important to point out that Hepworth's first two-piece compositions were executed in 1933, almost certainly between her return from Paris in April and the end of the year, whereas Moore did not begin his multi-part carvings until some time in 1934. Although by 1934 Moore was certainly aware of the sculpture of Arp and Giacometti, a number of his two-piece carvings are stylistically so closely related to those of Hepworth as to suggest that he was inspired by her work as much as, if not more than, by that of the two Surrealist sculptors. The theme of Hepworth's 1933 'Figure (Mother and Child)' (p. 46) and Moore's 1934 'Two Forms' (p. 39) is the protective relationship between the mother and child. In Hepworth's carving the large, egg-like, foetal form of the child rests on and against the truncated limbs of the mother. As Stokes wrote of this carving in his 1933 review, 'This is the child which the mother owns with all her weight, a child that is of the

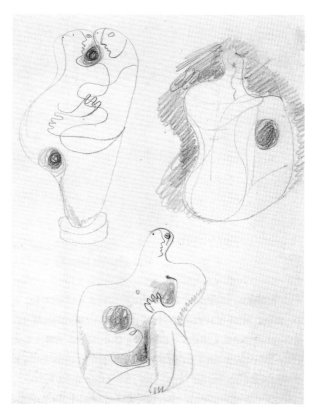

89 'Three Studies for Sculpture' c. 1932

88 'Standing Mother and Child' c. 1932

block yet separate, beyond her womb yet of her being'.[29] In Moore's carving, although the form of the mother arches forward protectively towards the symbolic shape of the child, they are physically isolated and apart.

In early December 1933, while on another trip to Paris, Nicholson took what in retrospect seems like an inevitable step when he made his first carved relief. Although in his earlier work he was very physically involved with rubbing, scraping and drawing incised lines into the surface, his interest in carving was undoubtedly stimulated by his intimate working relationship with Hepworth. As Jeremy Lewison has pointed out, 'Nicholson was encouraged to carve reliefs not only as a result of sharing Hepworth's studio in London, but also by the act of making linocuts which he and Hepworth had been doing quite extensively for the last two years'.[30] Hepworth expressed her excitement in a letter post-marked 8 December 1933: 'I am very interested in your new work idea (carving out) *naturally* – I've been longing for it to happen for ages.'[31] Ben flew back to London on 31 December, and began to concentrate on his carved and painted reliefs. During January and February 1934, Nicholson joined Hepworth and Moore in practising the art of sculpture.

91 'Studies for Sculpture (Standing Figures)' c. 1932

92 'Studies for Sculpture (Profile Heads)' c. 1932

In the early months of 1934, Hepworth and Nicholson learned that they were expecting a baby in the autumn. It is not surprising that the first five carvings that Hepworth made in 1934 focus on the mother and child theme. In 'Mother and Child' (BH 56) the child rests on the lap of the mother and leans against her body. In 'Mother and Child' (p. 47) the pebble-like form of the child nestles close to the mother and shares the same base. In 'Mother and Child' (p. 48) and in the closely related 'Large and Small Form' (BH 59), the way the child balances on the legs of the reclining mother relates directly to the balancing forms found in Arp's sculpture of the early 1930s, such as 'Head with Annoying Objects' 1930–32 and 'Human Concretion' 1933. Whereas Arp's sculptures are rich in poetic associations with the natural processes of growth and transformation with stones, plants, animals and man, Hepworth focuses exclusively on human forms. That four of these mother and child carvings owe an enormous debt to Arp is undeniable, and yet Hepworth shows here as elsewhere a remarkable ability to absorb and adapt ideas and make of them something very much her own.

The iron-stone 'Two Forms' (p. 40) and the white marble 'Standing Figure' (BH 62) followed the five 1934 mother and child carvings. These two transitional works bridge the gap between the figurative mother and child series and the abstract sculptures which Hepworth made at the end of the year. 'Two Forms', with an incised eye supplying a human reference, is a complement to Moore's 1934 iron-stone 'Two Forms' (p. 40). Yet again they represent another 'pair' of carvings by Hepworth and Moore that are stylistically so closely related that the names of the two sculptors are almost interchangeable. By the end of 1934, their work rarely shared such remarkably close stylistic affinities, as Hepworth adopted an abstract vocabulary while Moore continued to create sculptures with tenuous, yet clearly intended figurative associations. The title of Hepworth's 1934 marble 'Standing Figure' is almost the only clue to its human identity and, like 'Two Forms', it is a transitional work. This important carving heralds the beginning of Hepworth's obsession with the upright form, and also the

impact on her work of the sculpture of Brancusi which she had seen at his studio in Paris in April 1933. Like Brancusi's 'Bird in Space', Hepworth's 'Standing Figure' teeters on the brink of abstraction. By the end of 1934 she would take the crucial step of paring down the rarefied essences of Brancusi's art and move into the realm of complete abstraction.

In April 1934 Hepworth exhibited in the *Unit One* exhibition at the Mayor Gallery. The formation of *Unit One*, the name of a group of eleven English architects, painters and sculptors, had been announced in a letter which Paul Nash wrote to the editor of *The Times* on 2 June 1933. The members included the architects Wells Coates and Colin Lucas, the sculptors Barbara Hepworth and Henry Moore and the painters John Armstrong, John Bigge, Edward Burra, Tristram Hillier, Paul Nash, Ben Nicholson and Edward Wadsworth.

The publication *Unit One: The Modern Movement in the English Architecture, Painting and Sculpture* (1934), edited by Herbert Read, included illustrations of the work of the artists, as well as statements of their ideals and methods. Hepworth's short essay, her second and to date most important published statement, reads like a manifesto announcing the dawn of a new era. 'There is freedom', she wrote, 'to work out ideas and today seems alive with a sense of imminent new discovery'. At a time when Hepworth's sculpture had everything to do with the harmony of interrelated, separate forms, she describes the view from a train as follows: 'I see a blue aeroplane between a ploughed field and a green field, pylons in lovely juxtaposition with springy turf and trees of every stature. It is the relationship of these things that make such loveliness.'[32] Whereas, as Alan Bowness has noted, Herbert Read helped Henry Moore with his contribution to *Unit One*[33], the somewhat florid prose of Hepworth's essay suggests that she wrote it herself. She uses the words 'lovely' and 'loveliness' no less than seven times.

There were certain key terms which appeared in the writings of the sculptors and the critics at this time:

1. Read on Hepworth (1932): 'the organisation of masses in expressive relation.'[34]
Hepworth, *Unit One* (1934): 'Carving is interrelated masses conveying an emotion.'[35]
Moore, *Unit One* (1934): 'with masses of varied size ... thrusting and opposing each other in spatial relationship.'[36]

(All of the above may ultimately derive from Gaudier-Brzeska's statement which appeared in *Blast*, June 1914: 'Sculptural feeling is the appreciation of masses in relation.'[37])

2. Stokes on Hepworth (1933): 'Not shape, not form, but stone-shapes are his [the sculptor's] concern.'[38]
Hepworth, *Unit One* (1934): 'It must be stone shaped and no other shape.'[39]

3. Hepworth, *Unit One* (1934): 'It must be so essentially sculpture that it can exist in no other way, something still, yet having movement, so very quiet and yet with a real vitality.'[40]

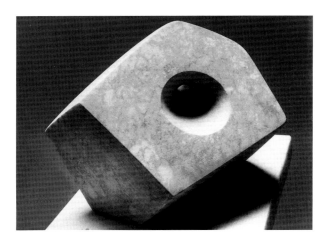

Barbara Hepworth, 'Holed Polyhedron' 1936 Alabaster

Ben Nicholson, 'October 2
1934 (white relief – triplets)'
Oil on carved board

Moore, *Unit One* (1934): 'For me a work must first have a vitality of its own. I do not mean a reflection of the vitality of life, of movement, physical action, frisking, dancing figures and so on, but that a work can have in it a pent-up energy, an intense life of its own, independent of the object it may represent.'[41]

4. Hepworth, *Unit One* (1934): 'In the contemplation of Nature we are perpetually renewed, our sense of mystery and our imagination is kept alive, and rightly understood, it gives us the power to project into a plastic medium some universal or abstract vision of beauty.'[42]

Moore, *Unit One* (1934): 'When a work has this powerful vitality we do not connect the word Beauty with it.'[43]

In these last two quotations, the differing attitudes of Hepworth and Moore could not be more clearly defined. Hepworth, in her search for what she called 'a new mythology',[44] was striving for a universal, abstract beauty, while Moore was seeking what he termed the 'power of expression'[45] by combining abstract qualities of design with the psychological, human element. Towards the end of 1934 Hepworth would eliminate the strong figurative references which informed her mother and child carvings earlier in the year, and create her first abstract sculptures.

• • •

'On October 3rd, 1934,' Hepworth wrote, 'our triplets were born, Simon, Rachel and Sarah, in a small basement flat very near our studios. It was a tremendously exciting event. We were only prepared for one child and the arrival of three babies by six o'clock in the morning meant considerable improvisation for the first few days.'[46] Shortly after the triplets were

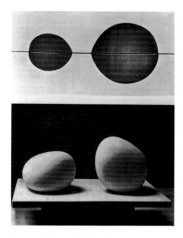

A page from *Circle* showing
Barbara Hepworth's 'Two Forms'
1936 (lower)

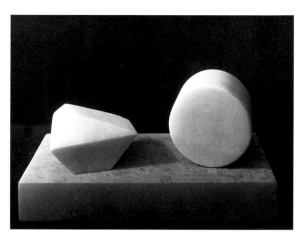

19 'Two Forms' 1934–5

born, they were put in the care of a nearby nursing training college. Barbara's first child Paul
Skeaping had lived mainly with his father since the separation.

Some four hours before the babies were born, Nicholson completed a carved relief entitled
'October 2, 1934 (white relief – triplets)', in which the two circles and one rectangle parallel
the ratio of two girls and one boy (p. 52). Of this relief carving he wrote to a friend in the late
1940s: 'I hope you recognize the forecast of Simon, Rachel and Sarah? and that after H.G.
Wells said that only writers are prophetic'.[47] Nicholson had been working on his carved
reliefs since December 1933. In 1952 Hepworth wrote that she believed that his reliefs of
1933–35 represented the most important phase of his work. Their vitality, she said, 'sprang
out of "absolute" relationships of form and colour without resorting to any compromise with
illusion or perspective and giving an impression of new and very great beauty.'[48] Hepworth
could equally well be describing the uncompromising abstract purity of the carvings which
she began about a month after the birth of the triplets.

'When I started carving again in November 1934', Hepworth wrote, 'my work seemed to
have changed direction although the only fresh influence had been the arrival of the children.
The work was more formal and all traces of naturalism had disappeared, and for some years I
was absorbed in the relationships in space, in size and texture and weight, as well as in the
tensions between the forms'.[49]

In the last four carvings of 1934 (BH 63–66) all traces of identifiable figurative 'signs', such
as an incised eye, have disappeared, indicating that these are the abstract sculptures which
Hepworth began in November. The titles, one of which uses the language of geometry for the
first time, are as abstract as the works themselves: 'Two Forms with Sphere' (BH 63), 'Two
Forms' (BH 64), 'Two Forms' (BH 65), and 'Three Forms' (BH 66). Whatever the associations
may have been for Hepworth, it is difficult not to associate 'Three Forms', with its egg-like,

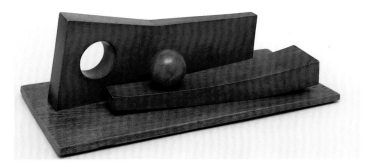

23 'Ball, Plane and Hole' 1936

Alberto Giacometti, 'Model for a Square'
1931–32 Wood

spherical and upright forms, with the arrival of the triplets. The white alabaster 'Two Forms' (p. 53), with its polyhedron and cylindrical forms, illustrates the uncompromising geometry of Hepworth's first abstract sculptures. Yet, as Ronald Alley has pointed out in discussing Hepworth's sculpture of the mid 1930s, 'these forms were seldom geometrically absolutely regular (like the circles and rectangles used by Ben Nicholson at the same period) but that they derived much of their appeal from slight deviations from regularity which gave them an organic character'.[50] This point is underlined in the way in which in 'Two Forms', and in other carvings of the period, the elements are usually fixed to the base in an asymmetrical arrangement.

Both Arp and even more so the Surrealist sculptures of Giacometti had a considerable impact on Hepworth's work of 1935–36. In the 1935 marble 'Cup and Ball' (p. 60), the relationship of the two forms is, except for the shallow hollow in which the ball rests, almost identical to that of the 'navel' and cup-like forms in Arp's 1931 painted wood 'Necktie and Navel' (p. 46). If Hepworth had not seen this sculpture when she visited Arp's studio in April 1933, 'Necktie and Navel' (whereabouts unknown) and a related work, 'Bell and Navels' 1931 (Museum of Modern Art, New York) were illustrated in *Cahiers d'art* 6, nos. 9–10, 1931. In 'Cup and Ball' the appearance for the first time in Hepworth's work of the hollowed out, circular depression may well derive from similar features found in Giacometti's platform sculptures, such as 'No More Play' 1931–32, and 'Model for a Square' 1931–32 (above). In Hepworth's 1935 marble 'Three Forms' (p. 63), the small sphere corresponds to the navel forms found in Arp's work of 1931, while with the other two forms it is as if Hepworth has taken as a point of departure Brancusi's simplified human heads, such as the 1916 'Sculpture for the Blind' (Philadelphia Museum of Art), and reduced them to the abstract. And yet, despite any affinities with the work of other artists that 'Three Forms' may suggest, the syntax of the three shapes and their relationship to each other again belongs completely to Hepworth.

For all Hepworth's allegiance to geometric abstraction, she made several carvings in the mid-1930s that could well have been included, as was Moore's work, in the 1936 *International*

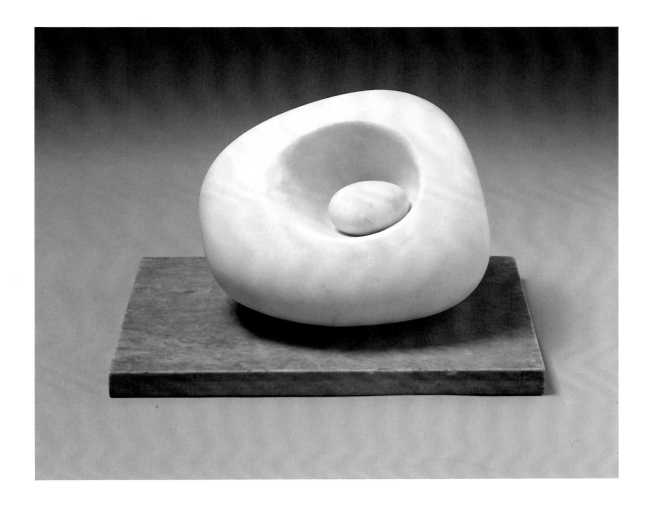

26 'Nesting Stones' 1937

Alberto Giacometti, 'Cube' 1934
(with incised self-portrait,
c.1936–46) Bronze

Alberto Giacometti, 'Head/Skull'
1934 Plaster

Surrealist Exhibition at Burlington House, London. One of these, 'Two Segments and Sphere' 1935–36 (p. 61) must surely have been inspired by Giacometti's 1930 'Suspended Ball' (p. 60), one of his best known Surrealist 'cage' sculptures. In Giacometti's construction, the sphere with a slit at the bottom is suspended by a filament so that it touches the upper edge of the crescent. With this open work, kinetic sculpture, the viewer may participate by swinging the ball back and forth, so that it glides over the crescent without touching it, thus implying, as Valerie Fletcher has remarked, 'a perpetual state of arousal with no possibility of final gratification'.[51] In Hepworth's carving, the ball is fixed to the irregularly shaped segment, yet with the potential, if released, to roll precariously down the sharp edge formed by the two planes. In the 'Two Segments and Sphere' the sexual overtones are somewhat muted, without the suggestion of painful, erotic pleasure implicit in Giacometti's 'Suspended Ball'. Another of Hepworth's sculptures with Surrealist overtones was the 1936 'Ball, Plane and Hole' (p. 54), which combines architectural, constructive forms, with the sexual imagery of the hole and ball. It relates to Giacometti's work in a more general way; the gentle curve of the plane on which the ball rests invites the participation of the viewer. As in Giacometti's platform sculptures, such as 'Man, Woman and Child (Three Mobile Figures on a Ground)' c.1931, and 'No More Play' 1931–32, Hepworth's 'Ball, Plane and Hole' also has the playful quality of children's toys.

Two carvings of 1936 appear to relate directly to two sculptures by Giacometti that were illustrated in E. Tériade's 'Aspects de l'expression plastique', (*Minotaure* no. 5, 1934), Hepworth's 'Form' (p. 57) closely resembles Giacometti's 1934 'Cube' (above), an asymmetrical polyhedron of twelve facets, which in turn was inspired by the polyhedron in Albrecht Dürer's 1514 engraving 'Melancholia'.[52] And in 'Holed Polyhedron' (p. 52), Hepworth has

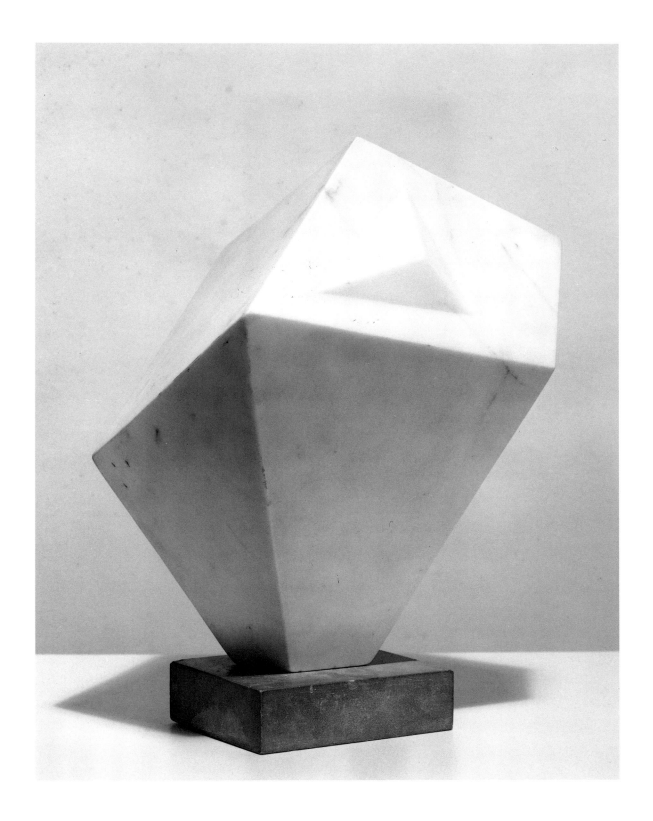

24 'Form' 1936

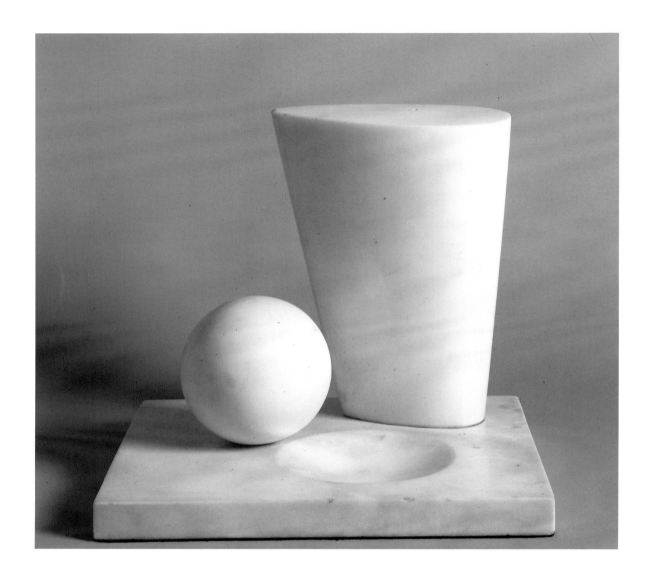

28 'Conoid, Sphere and Hollow II' 1937

Henry Moore, 'Carving' 1936
Marble

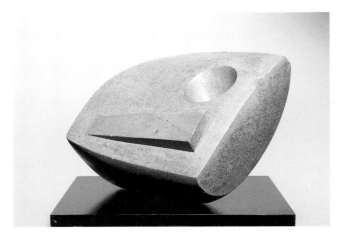

25 'Carving (sculpture)' 1936

flattened out and made abstract the deep facets found in Giacommeti's 1934 'Head/Skull' (p. 56), thereby eliminating the figurative references to the nose and mouth. (A plaster of Giacometti's 'Head/Skull' was illustrated in *Axis* no. 6, summer 1936, as 'Head'.) In Hepworth's carving, the abstract hole carved right through the alabaster corresponds to the deep, sinister eye in Giacometti's sculpture. That Hepworth appropriated several of Giacometti's Surrealist sculptures at the time of her allegiance to geometric abstraction reveals her openness to finding inspiration beyond the rigid symmetry of squares, rectangles and circles, as exemplified in the work of Nicholson and Mondrian.

In November or early December 1934, when Hepworth had completed some of her first abstract carvings which followed the birth of her triplets, she and Nicholson held a studio exhibition of her work. After Christmas she joined Ben in Paris, where he had been visiting Winifred (to whom he was still married) and their children, as he continued to do intermittently for the next three or four years. It was on this trip to Paris that Hepworth met Mondrian for the first time. In the spring or early summer of 1935 she met Naum Gabo who was in London to discuss the *Abstract and Concrete* exhibition that was being organized by Nicolete Gray.

In February 1936 Hepworth showed in the *Abstract and Concrete* exhibition in Oxford, which included works by Arp, Calder, Gabo, Giacometti, Kandinsky, Mondrian and Nicholson. The exhibition travelled to Cambridge, Liverpool, Newcastle and London. It was also in February that Nicholson made his first fully three-dimensional sculptures. As with his relief carvings of 1933–34, Nicholson was inspired by Hepworth's example. He wrote to Winifred on 13 March 1936: 'The free movement of carving goes very easily with Barbara carving in the same room.'[53] The inspiration was reciprocal. Hepworth's 1936 'Carving' (above) as well as Moore's 'Carving' of the same year (above) might both be re-named 'Homage

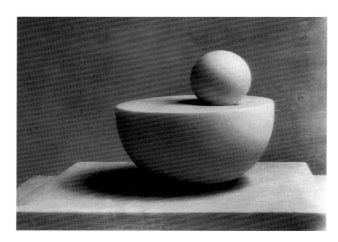

Barbara Hepworth, 'Cup and Ball' 1935 Marble

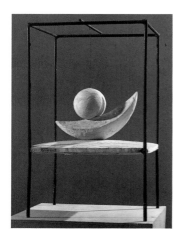

Alberto Giacometti, 'Suspended Ball' 1930 Metal and plaster

to Nicholson'. Whereas in Hepworth's sculpture the raised form in relief is asymmetrical, in Moore's carving the L-shaped projection and the geometric perfection of the incised lines which meet at 45° angles are symmetrical and therefore much closer to the squares and rectangles found in Nicholson's paintings, carved reliefs and sculptures of 1934–36 (p. 52). The closest Hepworth came to projecting into three-dimensions the circles, squares and rectangles found in Nicholson's work was the 1936 Ancaster stone 'Monumental Stela' (BH 83), her largest sculpture up to that time. This work was damaged in the war and later destroyed.

In July 1937 *Circle: International Survey of Constructive Art* was published to coincide with the opening of the *Constructive Art* exhibition at the London Gallery. Nicholson was a co-editor with the architect J.L. Martin and the Russian-born sculptor Naum Gabo. Hepworth and Sadie Speight, Martin's wife, were responsible for the layout and production. The book was divided into four sections: Painting, Sculpture, Architecture, Art and Life. The aim of the publication is stated in the editorial: 'We have, however, tried to give this publication a certain direction by emphasising, not so much the personalities of the artists as their work, and especially those works which appear to have one common idea and one common spirit: the constructive trend in the art of our day.'[54] Hepworth, Moore and Gabo contributed essays to the sculpture section, as did the distinguished physicist J.D. Bernal, F.R.S., who wrote on 'Art and the Scientist'. Moore's contribution consisted of two short paragraphs, in contrast to Hepworth's four-page essay. Compared to the more poetic, vivid language of her much shorter piece published in *Unit One* in 1934, Hepworth's essay for *Circle* was more abstract and theoretical, affirming her commitment to, and faith in abstract art:

> Contemporary constructive work does not lose by not having particular interest, drama, fear or religious emotion. It moves us profoundly because it represents the

61

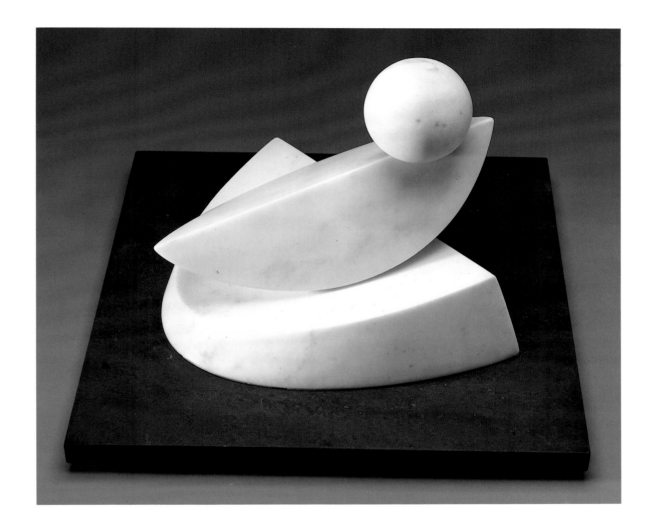

22 'Two Segments and Sphere' 1935–36

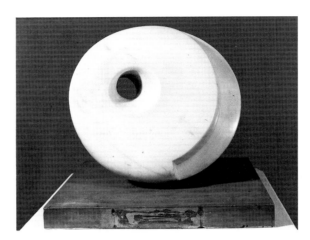

27 'Pierced Hemisphere I' 1937

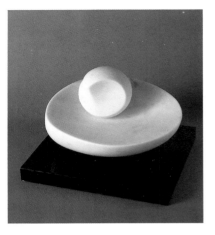

36 'Small Form Resting' 1945

whole of the artist's experience and vision ... it is an absolute belief in man, in landscape and in the universal relationship of constructive ideas. The abstract forms of his work are now unconscious and intuitive – his individual manner of expression.[55]

In October 1937 Hepworth had her first solo exhibition at Alex. Reid and Lefevre Ltd., where she and Nicholson had exhibited together in the autumn of 1933. J.D. Bernal wrote the foreword to the catalogue, thus adding his name to the already impressive list of those who had reviewed her work in the early 1930s – Read, Nash and Stokes. In his article 'Art and The Scientist', published earlier in the year in *Circle*, Bernal had written about and illustrated the remarkable affinities between Hepworth's sculpture and mathematical forms (p. 53). He devotes the first third of his foreword to the Lefevre exhibition catalogue to describing the similarities between Hepworth's sculpture and the extreme formalism of Neolithic art. Prophetically, Bernal discusses the very landscape, including one of its most famous pre-historic sites, that was to affect Hepworth so deeply after she moved to Cornwall in 1939: 'The largest group of sculptures are the upright blocks corresponding to the Neolithic Menhirs which stand through Cornwall and Brittany as memorials to long forgotten dead.' He continues: 'Another group represents stones pierced in one way or another with conical holes (above). Such stones occur in the Dolmens themselves, supposedly to furnish a means of egress for the soul. The most famous of them in Cornwall, Mên-an-tol (p. 83) may be chosen to give them a name.' No one has bettered Bernal's description of the subtle, slightly irregular geometry that underlies Hepworth's abstract carvings of the mid- to late 1930s:

> At first sight there has been a great loss of complexity when compared with her earlier work. The negative curvatures and the twists have all but disappeared and we are treated to a series of surfaces of slightly varying positive curvature which enable the

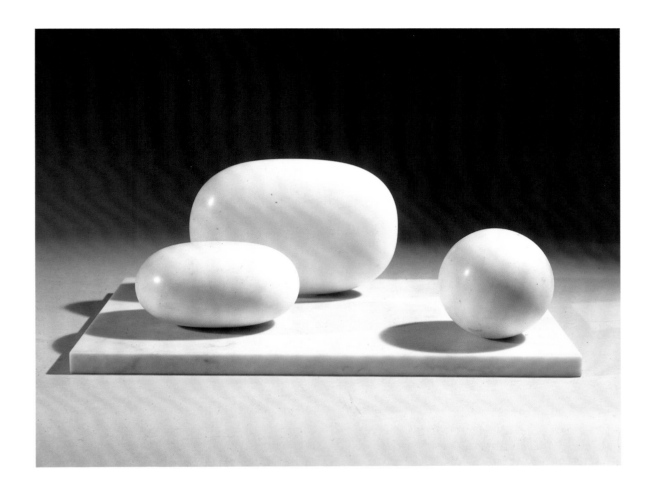

20 'Three Forms' 1935

effects of small changes to be seen in a way that is impossible when the eye is distracted by grosser irregularities. The elements used are extremely simple: the sphere and the ellipsoid, the hollow cylinder and the hollow hemisphere. All the effects are gained either by slightly modulating these forms without breaking up their continuity, or by compositions combining two or three of them in different significant ways.[56]

Geometric forms with geometric titles dominate Hepworth's carvings of 1937–38. In the 1937 'Pierced Hemisphere I' (p. 62), although the sculpture was almost certainly conceived as an abstract form, the hole may be read as an eye, with the face and mouth formed below where the two planes meet. Hepworth's interest in the subtle adjustment of geometric forms is apparent in another work of 1937, 'Conoid, Sphere and Hollow II'. (A conoid approaches a cone in shape.) As in earlier works, the shallow, hollowed out area almost certainly derives from Giacometti's platform sculptures of the early 1930s (p. 54). Her interest in twisting, spiralling, geometric forms is reflected in three carvings of 1938, all entitled 'Helicoids in Sphere', (BH 109, 109b, 110).

By the late 1930s, with carvings such as the holly wood 'Single Form' of 1937–38 (p. 70), Hepworth had established the soaring upright form as one of the major themes in her work. In 'Single Form', she created a 'minimal' image of great subtlety, with the plane at the top slightly off the horizontal, and with the entire length of the sculpture beautifully tapered, thinning out towards the base. This carving, and the two taller, single form sculptures which followed immediately (BH 103–104), show Hepworth at her most elegant and Brancusi-esque. In the Tate Gallery's 1938 tulip wood 'Forms in Echelon' (BH 107) Hepworth explored a specific relationship between two forms that had first appeared in the 1935 'Discs in Echelon' (p. 66). With the placement of two closely related forms parallel to each other but out of alignment – 'in echelon' – the repetitiveness of perfect symmetry is avoided. By the late 1930s, Hepworth had created a repertory of forms and compositional relationships which she would draw on in later years. For example, one of the two uprights in the 1938 'Forms in Echelon' looks forward to the 1961 'Single Form (Chûn Quoit) (p. 105), and ultimately to the large bronze 'Single Form' 1961–62, made as a memorial to Dag Hammarskjöld, and sited at the United Nations, New York (p. 155). The stacking of two of the five forms in the 1938–39 wood 'Project: Monument to the Spanish War' (BH 111, destroyed) anticipates the 1967 'Three Forms Vertical (Offering)' (BH 452).

In April 1938 Hepworth and Nicholson exhibited in the *Abstrakte Kunst* exhibition at the Stedelijk Museum, Amsterdam. Nicholson had frequently exhibited in Europe but this was Hepworth's first showing on the continent since exhibiting with *Abstraction-Création* in Paris from 1933–35. However, the oncoming threat of Nazi aggression was driving European artists to England and deflecting public interest in art. Hepworth has described 1938 and 1939 as the years of attrition. She found it more and more difficult to sell her work or to find an alternative source of income. On 15 September 1938, the month that Hitler invaded

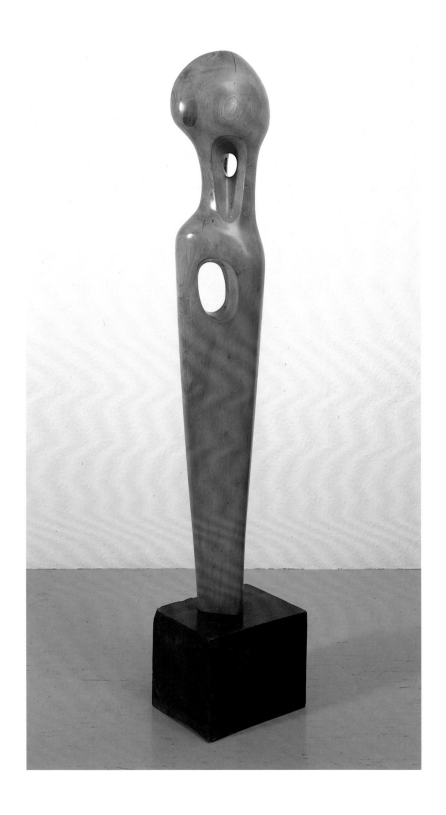

37 'Single Form (Dryad)' 1945–46

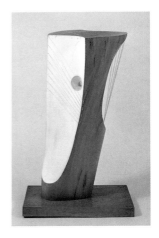

35 'Wood and Strings' 1944

21 'Discs in Echelon' 1935

Czechoslovakia, Hepworth and Nicholson, concerned for the safety of their children in case of air raids, briefly evacuated the triplets to the house of Ben's sister Nancy at Boar's Hill, Oxford. On 21 September, Winifred returned from Paris with her children and brought Mondrian with her to London. With the help of Barbara and Ben, he found a studio in Parkhill Road. Mondrian was the last of the major European artists to join the Hampstead Group. On 17 November 1938 Nicholson and Hepworth were married at the Hampstead Registry Office.

Of the five sculptures Hepworth produced in 1939, two were intended for outdoor settings. In the titles themselves – 'Project for Sculpture in a Landscape' (BH 115) and 'Project for Garden Sculpture' (BH 116), Hepworth announces for the first time what was soon to become one of the most important themes in her work: not only the relationship of the human figure to landscape, but the relationship of the human figure and of sculpture in landscape. Also significant is the fact that these plaster sketches were the first small-scale, preparatory studies for larger works. As Hepworth wrote: 'but now, for the first time I had to work imaginatively in maquette form and dream up some future monument.'[57] In 'Forms and Hollows' (BH 114) the three hollows carved into the platform continue to reflect the influence of Giacometti's platform sculptures of the early 1930s (p. 54). The plaster 'Sculpture with Colour, White, Blue and Red Strings' (BH 113) was the most innovative and prophetic of the pre-war sculptures of 1939. With the introduction of colour and strings, Hepworth has combined in a single work two elements which were to play a major role in her subsequent sculpture. Whereas the use of strings was no doubt prompted by Moore's stringed figure sculptures of 1937–39, the introduction of colour for the first time was clearly related to Nicholson's paintings and reliefs, a fact that Hepworth acknowledged some years later in discussing the exchange of ideas and the creative criticisms that flowed between them during the 1930s: 'Our influence on each other remained free and stimulating and is shown, I think,

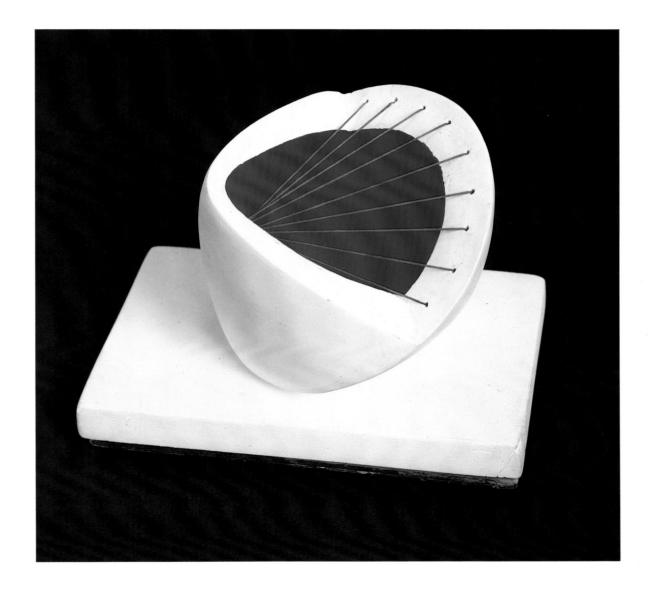

30 'Sculpture with Colour (Deep Blue and Red)' 1940

at its best in the coloured reliefs of Ben Nicholson's and in my sculptures with colour which were to come later.'[58]

Towards the end of August 1939, Hepworth, Nicholson and their three children were invited to stay with Adrian Stokes and his wife Margaret Mellis at Little Park Owles, Carbis Bay, near St. Ives in Cornwall. If war broke out, they would be welcome to stay on. 'The last person we saw was Mondrian', Hepworth wrote, 'and we begged him to come with us in our battered old car (which we bought for £17) so that we could look after him. But he would not'.[59] The departure of Hepworth and Nicholson brought to a close their London years, and marked the beginning of the end of Hampstead's 'nest of gentle artists', which they, through their friendships at home and abroad, had done so much to build. Two weeks later Naum and Miriam Gabo joined Hepworth and Nicholson in Carbis Bay. In October 1940, Henry and Irina Moore left Hampstead after their studio was damaged in an air raid, and moved to Much Hadham in rural Hertfordshire. That same month Mondrian emigrated to New York.

'At the most difficult moment of this period,' Hepworth recalled, 'I did the maquette for the first sculpture with colour, and when I took the children to Cornwall five days before war was declared I took the maquette with me, also my hammer and a minimum of stone-carving tools'.[60]

ACKNOWLEDGEMENTS

The author would like to thank the following:

The Duke of Beaufort, Sir Alan and Lady Bowness, Sophie Bowness, Julia Brown, Paddy Ann Burns, Ramsay Derry, Valerie Fletcher, Murray Frum, Christopher Green, Wendy Hebditch, Jeremy Lewison, Nancy Lockhart, Lina Miraglia, Robert O'Rorke, Geoffrey Parton, Larry Pfaff, Benedict Read, Susan Sharratt, George Wilkinson

Abbreviations used in this essay are as follows:

BH & number: catalogue number from the two volume catalogue raisonné of Hepworth's sculpture.
LH & number: catalogue number from the six volume catalogue raisonné of Henry Moore's sculpture.

1. *Art in Britain 1930–40 Centred around Axis, Circle, Unit One*, exh. cat., Marlborough Fine Art Ltd., London 1965, p.5.
2. *Barbara Hepworth: Carvings and Drawings*, introduction by Herbert Read, London 1952, section 1, n.p.
3. Ibid., sections 1, 2 and 3.
4. Henry Moore, *Henry Moore on Sculpture*, edited with an introduction by Phillip James, London 1968, p. 57.
5. *Carvings and Drawings*, section 1, n.p.
6. Barbara Hepworth, *Barbara Hepworth: A Pictorial Autobiography*, Tate Gallery, London revised edition 1978, p.17.
7. No detailed or accurate chronology has been written on Hepworth's life. In discussing Hepworth's life from 1931, when she met Ben Nicholson, until 1951, the author has relied heavily on Jeremy Lewison's detailed chronology in his exhibition catalogue *Ben Nicholson*, Tate Gallery, London 1993, pp. 238–250. At present, Sir Alan Bowness is writing a book on the life and work of Barbara Hepworth, for publication in 1995. The author is most grateful to Jeremy Lewison and Sir Alan Bowness for their helpful discussions about the life and sculpture of Barbara Hepworth.
8. *Carvings and Drawings* op. cit., section 2, n.p.
9. Ibid., section 2, n.p.
10. *Ben Nicholson* op. cit., p. 37.
11. Ibid.
12. *Carvings and Drawings* op. cit., section 2, n.p.
13. Ibid.
14. J.P. Hodin, *Barbara Hepworth*, Boston 1961, p. 12.
15. *Art in Britain*, p. 5.
16. Ibid., p. 7.
17. See *Ben Nicholson* op. cit., cat. nos. 28, 33, 34, and 36.
18. Ibid., p. 211.
19. *Carvings by Barbara Hepworth, Paintings by Ben Nicholson*, exh. cat. forewords by Herbert Read and H.S. Ede, Arthur Tooth and Sons' Galleries, London 1932, n.p.
20. The article is reproduced in a *A Pictorial Autobiography* op. cit., p. 27.
21. Paul Nash, 'A Painter and a Sculptor,' *The Week-end Review*, November 19, 1932, p. 613, as reproduced in *A Pictorial Autobiography* op.cit., p. 22.
22. Ibid., p. 23.
23. *Carvings and Drawings* op. cit., section 2, n.p.
24. Ibid.
25. Ibid.
26. Ibid.
27. Ibid. Sophie Bowness has suggested to the author that Hepworth and Nicholson did not visit the Chateau Boisgeloup, Gisors, and that Hepworth's account refers in fact to Picasso's Paris studio.
28. Adrian Stokes, *The Critical Writings of Adrian Stokes; Volume 1, 1930–1937*, London 1978, pp.309–310.
29. Ibid., p. 310.
30. *Ben Nicholson* op. cit., p.41.
31. Ibid., p. 216.
32. *Unit 1: The Modern Movement in English Architecture, Painting and Sculpture*, edited by Herbert Read, London 1934, p.19.
33. *Herbert Read: A British Vision of World Art*, exh. cat., edited by Benedict Read and David Thistlewood, Leeds City Art Galleries, Leeds 1993, p. 106.
34. *Carvings by Barbara Hepworth, Paintings by Ben Nicholson*, n.p.
35. *Unit 1*, p. 19.
36. Ibid., p. 29.
37. Ezra Pound, *Gaudier-Brzeska: A Memoir*, New York 1970, p. 20.
38. *The Critical Writings of Adrian Stokes*, p. 309.
39. *Unit 1*, p. 19.
40. Ibid., p. 19.
41. Ibid., p. 30.
42. Ibid., p. 20.
43. Ibid., p. 30.
44. Ibid., p. 19.
45. Ibid., p. 30.
46. *Carvings and Drawings* op. cit., section 3, n.p.
47. *Ben Nicholson* op. cit., p. 218.
48. *Carvings and Drawings* op. cit., section 3, n.p.
49. Ibid.
50. *Barbara Hepworth*, exh. cat., Tate Gallery, London 1968, pp.13 and 15.
51. Valerie J. Fletcher, *Alberto Giacometti: 1901–1966*, Hirshhorn Museum and Sculpture Garden, Washington, D.C. 1988, p. 26.
52. Ibid., p. 108.
53. *Ben Nicholson* op. cit., p.221.
54. *Circle: International Survey of Constructive Art*, edited by J.L. Martin, Ben Nicholson, N. Gabo, London 1937, reprinted 1971, p. vi.
55. Ibid., p. 116.
56. *Catalogue of Sculpture by Barbara Hepworth*, exh. cat., foreword by J.D. Bernal, Alex. Reid & Lefevre Ltd., London 1937, as reproduced in *A Pictorial Autobiography* op. cit., p. 36.
57. Ibid., p.41
58. *Carvings and Drawings* op. cit., section 3, n.p.
59. *A Pictorial Autobiography* op. cit., p.41.
60. *Carvings and Drawings*, section 3, n.p.

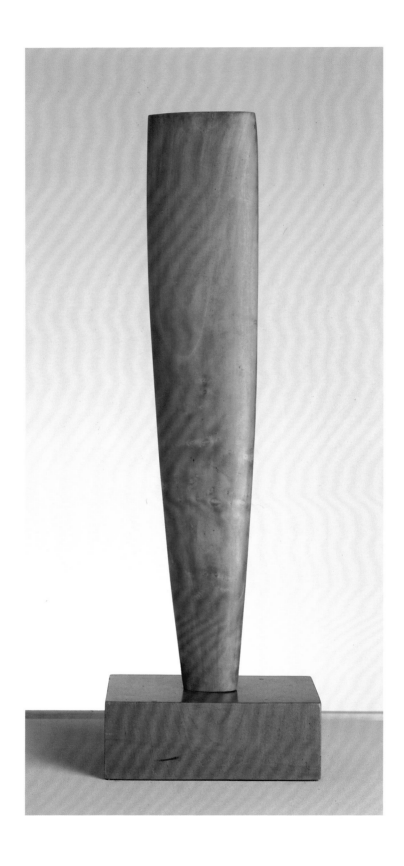

29 'Single Form' 1937

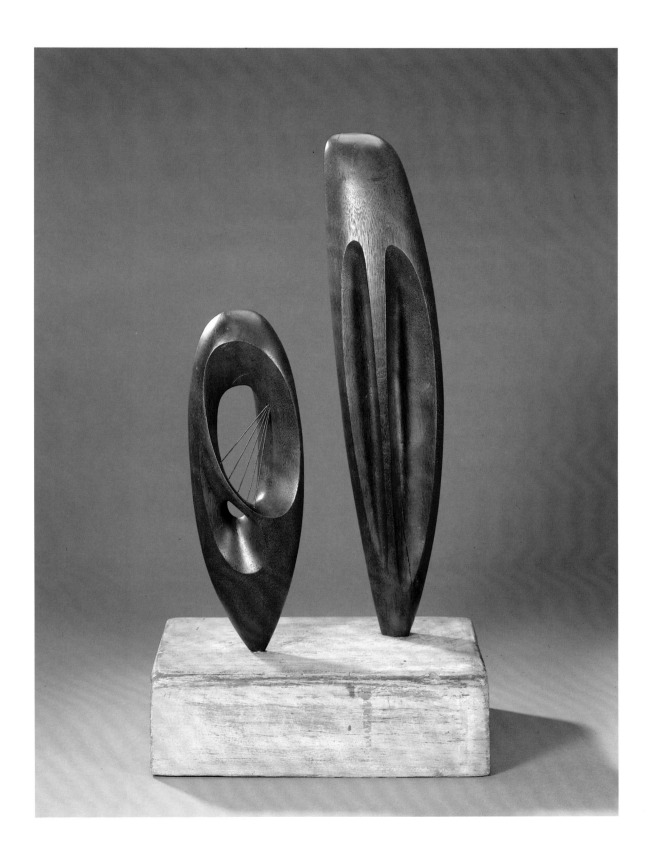

31 'Two Figures' 1943

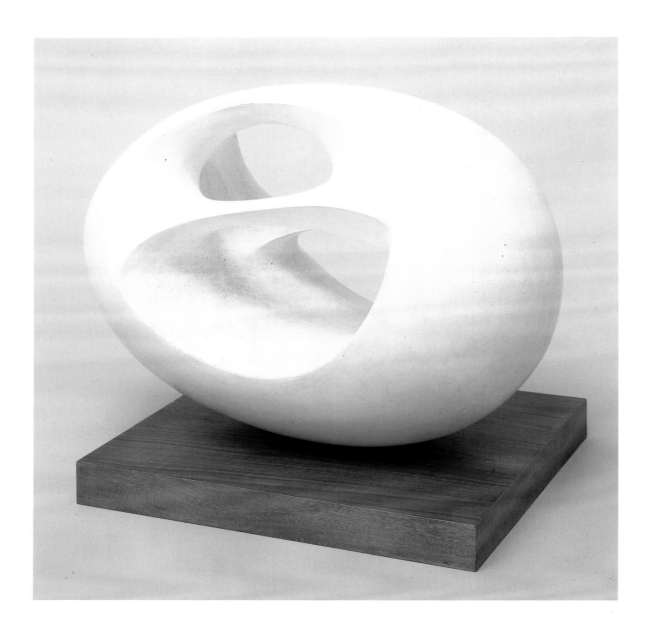

32 'Oval Sculpture (No 2)' 1943

96 'Red in Tension' 1941

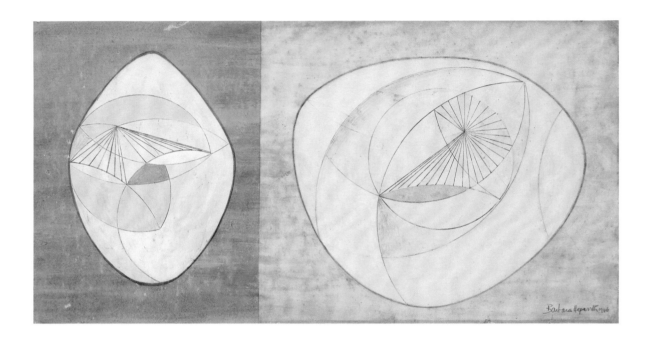

99 'Drawing for Stone Sculpture' 1946

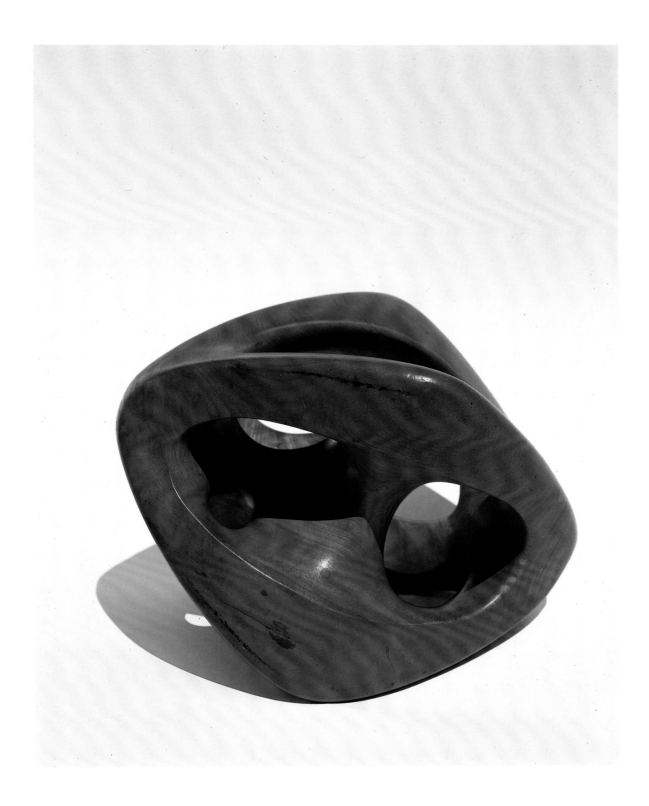

34 'Hand Sculpture' 1944

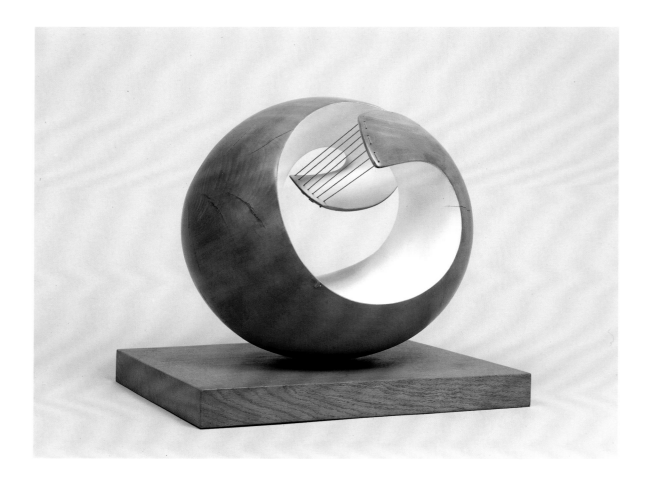

38 'Pelagos' 1946

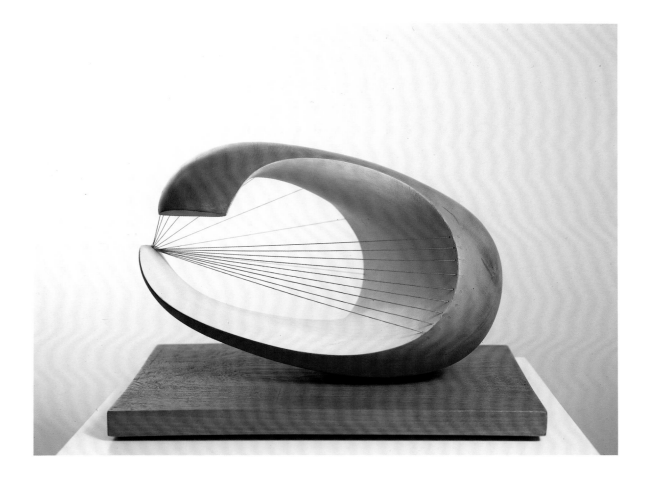

33 'Wave' 1943

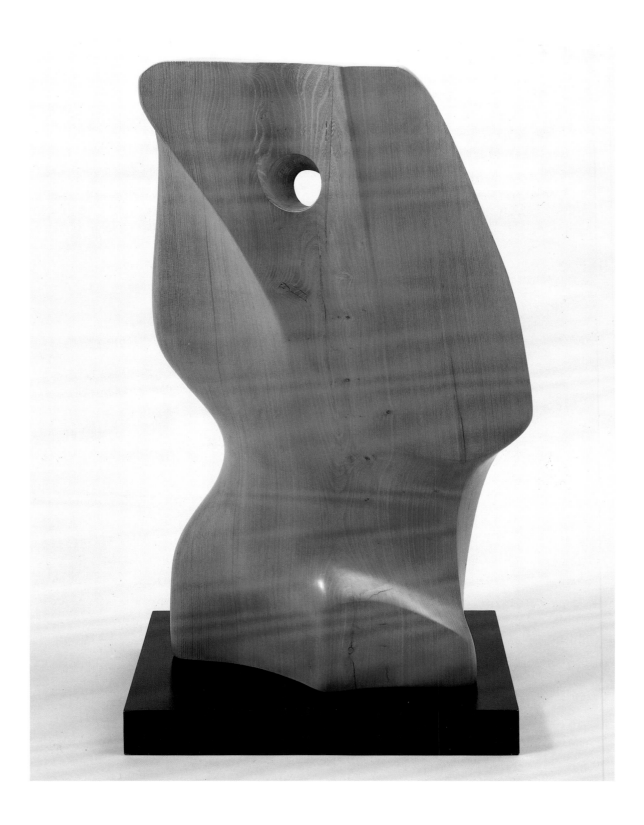

63 'Figure (Nyanga)' 1959–60

Cornwall and the Sculpture of Landscape: 1939–1975

Alan G. Wilkinson

> I cannot write anything about landscape without writing about the human figure and human spirit inhabiting the landscape. For me, the whole art of sculpture is the fusion of these two elements – the balance of sensation and evocation of man in this universe.[1]

On 25 August 1939 Barbara Hepworth, Ben Nicholson and the triplets, together with a nanny and a cook, arrived at Little Park Owles, the home of Adrian Stokes and Margaret Mellis in Carbis Bay. Ben was already familiar with this part of Cornwall, having spent two and a half months in the area in 1928. Barbara recalled her state of mind when they arrived. (Carbis Bay is a suburb of the small town of St. Ives; the names are often used interchangeably.)

> Ben knew St. Ives; but in spite of what Prof. J.D. Bernal wrote (prophetically) in 1937, I felt opposed to coming to a place I had never seen. Arriving in August at midnight with very weary children, in pouring rain, my spirits were at zero. Next morning I appreciated the beauty and the sense of community, and realized that it would be possible to find some manual work and raise the children, and take part in community life, which has nourished me ever since.[2]

When war was declared on 3 September, Stokes invited Hepworth and Nicholson to stay on with them at Carbis Bay for the safety of the children. By mid-September, Naum and Miriam Gabo arrived as guests of Stokes and Mellis and within twenty-four hours had moved into a bungalow, Faerystones, a few minutes walk from Little Park Owles. Of the three artists now living in a re-located 'constructive nest', only Gabo remained consistently faithful to constructivist ideals. Neither Hepworth nor Nicholson could ignore the landscape of Cornwall, which was to change the course of their art in the 1940s as profoundly as the theories of geometric abstraction, and the work of the Parisian avant garde, had altered the direction of their sculpture and painting in the 1930s.

Cornwall is a windy place and nowhere far from the sea. It includes England's most southerly as well as its most westerly point yet there is nothing soft in its landscape or its people. With its spectacular cliffs, headlands and caves, its rock formations rising out of the sea, its massive boulders deposited on hill tops, Cornwall is as sculptural a landscape as exists in England. The horizon is dominated by the silhouettes of abandoned tin mines, whose chimneys seem to relate, as do the prehistoric standing stones, to the vertical forms of Hepworth's sculpture, and ultimately to her obsession with the standing figure in landscape.

At the end of December 1939 Hepworth, Nicholson and the children moved to a house named Dunluce in Carbis Bay. During the early years of the war Hepworth did very little sculpture, apart from a series of small plaster maquettes with colour and strings (p. 67), which were a continuation of her first small, painted sculptures with strings (BH 113), executed in 1939 and brought with her from London. Dunluce was a small house, without adequate space for a sculpture studio. There was a severe shortage of artists' materials throughout the war, and Hepworth's life was taken up with domestic chores. 'I could only draw at night and make a few plaster maquettes', she wrote. 'The day was filled with running a nursery school, double-cropping a tiny garden for food, and trying to feed and protect the children'.[3] Drawing proved to be an important outlet for her creative energies during this period: 'In the late evenings, and during the night I did innumerable drawings in gouache and pencil – all of them abstract, and all of them my own way of exploring the particular tensions and relationships of form and colour which were to occupy me in sculpture during the later years of the war.'[4]

In Hepworth's abstract drawings of 1940–42, she was concerned, as in her carvings of the mid-1930s, with exploring geometric forms that were self-sufficient, without any references to either landscape or the human figure. They are among the most beautiful and austere of all her abstract drawings. In 'Drawing for Sculpture' 1941 (p. 81), each of the three forms has been framed separately within the boundaries of the composition. The crystalline form at lower right is defined by linear outlines, as well as by a few lines within that reveal the planes on the far side of the imaginary transparent material. Hepworth would have drawn the basic form of the largest of the three sculptural ideas in a similar way, and then added the complex network of lines that makes tangible the three-dimensional space within. It is as if she had taken as a point of departure her 1936 carving 'Form' (p. 57), transformed it into a transparent material, and then set about to give as much information as possible about the exterior planes as well as the dimensions of the interior space. Hepworth's abstract drawings of 1940–42 owe a considerable debt to the work of Gabo, who may have begun the first of many versions of 'Linear Construction in Space' as early as 1938. In the series (p. 81) which occupied much of his time during the war years which he spent in Cornwall, Gabo used actual strings for the first time, stretched across and through transparent celluloid frames. (He progressed from using red thread, to silk and elasticated thread, to nylon monofilament.) None of Hepworth's subsequent sculptures with strings has the degree of complexity of the stringed constructions found in her abstract drawings of 1940–42.

In July 1942 Hepworth and Nicholson signed a seven year lease on a larger house, Chy-an-Kerris, Carbis Bay.

> A new era seemed to begin for me when we moved into a larger house high on the cliff overlooking the grand sweep of the whole of St. Ives Bay from the Island to Godrevy lighthouse. There was a sudden release from what had seemed to be an almost unbearable diminution of space and now I had a studio workroom looking straight

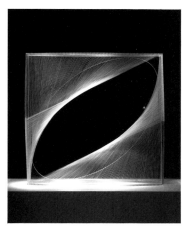

97　Drawing for Sculpture 1941

Naum Gabo, 'Linear Construction
in Space No. 1' 1945–49
Perspex with nylon filament

towards the horizon of the sea and enfolded (but with always the escape for the eye
straight out to the Atlantic) by the arms of land to the left and right of me.
I have used this idea in 'Pelagos' 1946 (p. 76).[5]

By 1943 Hepworth had found the time, the space and the materials to begin carving again. She
had also begun to explore the dramatic and varied landscape of the Penwith peninsula.
Hepworth's descriptions of the landscape of west Cornwall and its impact on her work
provide the best introduction to her sculpture of the 1940s:

> It was during this time that I gradually discovered the remarkable pagan landscape
> which lies between St. Ives, Penzance and Land's End; a landscape which still has a very
> deep effect on me, developing all my ideas about the relationship of the human figure in
> landscape – sculpture in landscape and the essential quality of light in relation to
> sculpture which induced a new way of piercing the forms to contain colour.[6]

Two carvings of 1943 reflect Hepworth's response to her new environment. The 1943 red-
wood 'Two Figures' (p. 71) combines two of the three forms which Hepworth described as
having had a special meaning for her since childhood. They are: 'the standing form (which is
the translation of my feeling towards the human being standing in landscape), and two forms
(which is the tender relationship of one living thing beside another).'[7] While the upright forms
relate to figures in a landscape, the two forms, although seemingly abstract, nonetheless convey
a human relationship. The taller form is predominantly male, with its rigid, phallic contours. In
the more rounded, sensuous stringed form, the two opened-out spaces, tapering inwards to
form a single hole on the other side, strongly suggest the female sex. The 1943 'Oval
Sculpture' (p. 72) represents the third shape which had a special significance for Hepworth. It

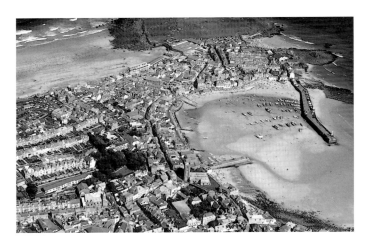

Aerial view of St. Ives, Cornwall, 1967

is, she wrote 'the closed form, such as the oval, spherical or pierced form (sometimes incorporating colour) which translates for me the association and meaning of gesture in landscape; in the repose of say a mother and child, or the feeling of the embrace of living things, either in nature or in the human spirit'.[8]

The original version of the plaster 'Oval Sculpture' was carved in plane wood in 1943, with the concavities painted white. (The plaster cast was made in 1958; an edition of four bronzes was cast in 1959.) In 1939, Hepworth had made her first sculpture with colour, but the colours had no specific references to nature. In the wood version of 'Oval Sculpture', and in the 1943–44 'Wave' (p. 77) which includes colour and strings, Hepworth has, for the first time, produced direct references to the landscape and seascape of Cornwall. The blue interior of 'Wave' corresponds to the colour of the ocean; the opened-out interior spaces of 'Oval Sculpture' echo the shapes of caves. The strings and the concavities functioned for Hepworth as abstract equivalents of bodily sensations in landscape:

> I used colour and strings in many of the carvings of this time. The colour in the concavities plunged me into the depth of water, caves, or shadows deeper than the carved concavities themselves. The strings were the tension I felt between myself and the sea, the wind or the hills.[9]

In addition to references to landscape, 'Oval Sculpture' and 'Wave' reflect an openness in the interior spaces quite unlike the 'holes' found in Hepworth's pre-war sculpture. In carvings from the 1930s such as 'Figure' (p. 29) and 'Pierced Form' (p. 37), the holes are relatively small and are defined by the solid form surrounding them. In 'Oval Sculpture' and 'Wave', the boundaries between voids and solids dissolve, so that neither space nor form dominates. This creates a sense of lightness, in contrast to the opened-out yet compact carvings of the 1930s. Hepworth has described the process as follows: 'The carving and piercing of such a

'Mên-an-tol' (stone of the hole) near Morvah, Cornwall

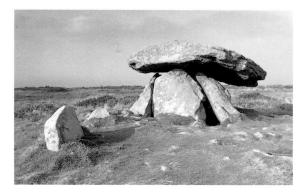

'Chûn Quoit' near Morvah, Cornwall

form seems to open up an infinite variety of continuous curves in the third dimension changing in accordance with the contours of the original ovoid and with the degree of penetration of the material.'[10]

One of Hepworth's poetic descriptions of her feelings about being in the landscape suggests that she perceived the earth itself as having a sculptural presence and identity all its own: 'Here I can slowly travel to a nearby hill and, with larks singing above and the distant sound of sea and wind and voices carrying from faraway farms, a distant figure is a monument, whilst I myself am cradled in the anatomy of landscape.'[11] The landscape of Cornwall reminded Hepworth of the grandeur and ruggedness of her native Yorkshire:

> The barbaric and magical countryside of rocky hills, fertile valleys, and dynamic coastline of West Penwith has provided me with a background and a soil which compare in strength with those of my childhood in the West Riding. Moreover it has supplied me with one of my greatest needs for carving: a strong sunlight and a radiance from the sea which almost surrounds this spit of land, as well as a milder climate which enables me to carve out of doors nearly the whole year round.[12]

During the 1940s, the titles of a number of sculptures refer to the Cornish landscape and to the sea. The 1943–44 'Wave' was followed in 1946 by 'Pelagos' (the sea). The latter is the carving which Hepworth said was inspired by the view from her house in Carbis Bay, with the Atlantic Ocean enfolded by the arms of land to the left and right. This is in fact the same prospect of St. Ives Bay which Virginia Woolf described in her 1905 journal, using language remarkably similar to Hepworth's 'grand sweep of the whole of St. Ives Bay' quoted earlier: 'From the raised platform of the high road we beheld the curve which seemed to enclose a great sweep of bay full tonight of liquid mist, set with silver stars...'[13]

Although there is no reference in the title to a specific location, 'Pelagos' was in fact the

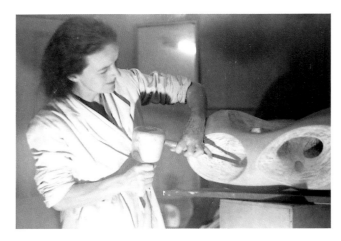

Barbara Hepworth working on the wood carving 'Pendour' at
Carbis Bay 1947

first sculpture that does relate to an identifiable geographical area of Cornwall. One can
assume that two other carvings of 1946, 'Tides I' and 'Tides II' (BH 139–140), were inspired by
the rise and fall of the tides on the beaches of Carbis Bay and St. Ives. It is important to point
out that the geographical affinities between Hepworth's sculptures and the names of Cornish
towns, hills, beaches, cliffs, coves or prehistoric *menhirs* and *quoits* that were soon to be
incorporated into the titles themselves are generalized associations rather than literal repre-
sentations. In discussing her work of the 1960s, Alan Bowness asked Hepworth about her use
of titles, with specific reference to the 1961 bronze 'Curved Form (Bryher)' (BH 299).
(Bryher is one of the Isles of Scilly.) Her explanation is essential to our understanding of the
often distant, subconscious links between the completed sculptures and the titles they were
assigned:

> They are always added later. When I've made something, I think: where did I get that
> idea from? And then I remember. 'Bryher' is being in a boat, and sailing round Bryher,
> and the water, the island, the movement of course. If I experience something bodily like
> that, I often get an idea for a sculpture. 'Bryher' is a relationship between the sea and
> the land. But I don't start with a title: I make a shape, and there may or may not be an
> association with it – but this comes afterwards.[14]

Hepworth's sculptures of the 1940s make a unique and original contribution to the
Romantic English landscape tradition of Turner, Constable and Samuel Palmer. By 1944, the
year Hepworth completed 'Wave', Nicholson had also succumbed to the lure of place in his
oil '1944 (still life and Cornish landscape)'. In his views of Cornish towns, harbours and
farms, which often include a Cubist still life in the foreground, Nicholson captures, as Steven
A. Nash has written, 'his surroundings with a topographical accuracy that rivals the great

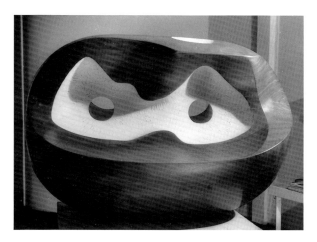

50 'Oval Form (Penwith
Landscape)' 1955–56

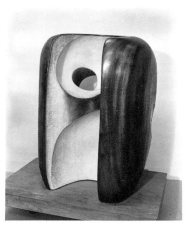

49 'Hollow Form (Penwith)'
1955–6

English landscapists of the Nineteenth century'.[15] Although none of Hepworth's Cornish landscape sculptures depicts the subjects to which they refer with any degree of accuracy let alone even recognisable features, they are, nevertheless, equivalents for elements of landscape – the ocean, the tides, the surf on a beach, hills, valleys, cliffs and caves – or for man-made forms in the landscape, such as prehistoric *menhirs* and *quoits*. In the 1930s both Hepworth and Moore had related the human figure to hills, mountains, valleys and caves, but with no reference to known, identifiable landscape settings. What is unique about Hepworth's sculpture of the 1940s is that it does evoke associations with the landscape of Cornwall. She created a semi-abstract, three-dimensional sculptural counterpart to the Neo-Romantic English landscape movement in painting, as exemplified in the work of Nicholson, Nash, Sutherland and Hitchens.

It was in 1943–44, as we have seen, that Hepworth first introduced landscape references in the sculptures from her post-London years. It was not until 1959 that Henry Moore again began to relate his sculptures to landscape as he had done in the 1930s. In Moore's 1959 bronze 'Two Piece Reclining Figure No.1' (LH 457), the dramatic thrust of the leg section was inspired by the memory of the massive outcrop of rock at Adel, near Leeds, which he had visited in his youth, as well as by the cliff in Seurat's 1885 oil 'Le Bec du Hoc, Grandcamp' (Tate Gallery). But echoes of actual landscapes are extremely rare in Moore's work. Whereas Cornish and later Greek place names occur frequently in the titles of Hepworth's sculpture from 1947 onwards, Moore very rarely included in his titles any references to place. Moore's landscape metaphors for the human figure are generalised; Hepworth's are often linked to a place and to her experience *in* landscape.

The difficulty in trying to interpret Hepworth's landscape sculptures that include place names in the titles is that often we have no way of knowing the range or the exact nature of

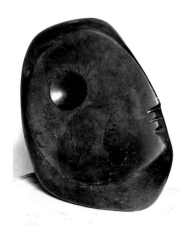

39 'The Cosdon Head' 1949

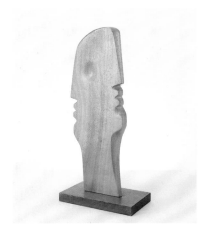

Barbara Hepworth, 'Two Heads
(Janus)' 1948 Mahogany

the associations between the geographical location and the finished work. Rarely did Hepworth discuss the sources of inspiration or subsequent connections that led to the title of a given carving. For example, without her explanation of the genesis of 'Pelagos' 1946 that links the lyrical curving spiral form to the arms of land to the left and right of St. Ives Bay, we could do little more than associate the sculpture with the waves and the surf of the sea. The 1947 plane wood carving 'Pendour' (p. 84) is the first sculpture in which a Cornish place name appears in the title. Pendour Cove is on the north coast of the Penwith peninsula, about five miles west of St. Ives. One can only speculate that the hollowed out, blue and white interior spaces relate somehow to the cave and rock formations. As Bryan Robertson commented in the 1965 exhibition catalogue *The English Eye*, whilst her work became inextricably bound up with the landscape of Cornwall, she nevertheless managed to keep her distance from it: 'She has been affected by the country but also kept it in its place, quite an achievement considering the potency of that landscape: the most atavistic in atmosphere that I know, outside Australia.'[16]

It was not only the landscape sculptures that announced Hepworth's 'return to nature' in the 1940s. The human figure also emerged as an equally important theme, in carvings such as the 1945–46 Cornish elm 'Single Form (Dryad)' (p. 65), and the 1946 sycamore 'Hamadryad' (BH 137, damaged and destroyed). No doubt the titles were suggested in part by the wood itself, the material in which the sculptures were carved. Hepworth must have been aware of the distinction between a Dryad, who was simply a nymph who lived among the trees, and a Hamadryad, who animated a tree and perished with it. The humanoid shape of 'Single Form (Dryad)' is clearly recognizable with the bulb-like head, elongated neck and tapering shoulders. The human head is the subject of several sculptures of the 1940s, such as 'Two Heads (Janus)' 1948 (above), and 'The Cosdon Head' 1949 (above) with the flat profile of the face reminiscent of her work and that of Nicholson of 1932–33.

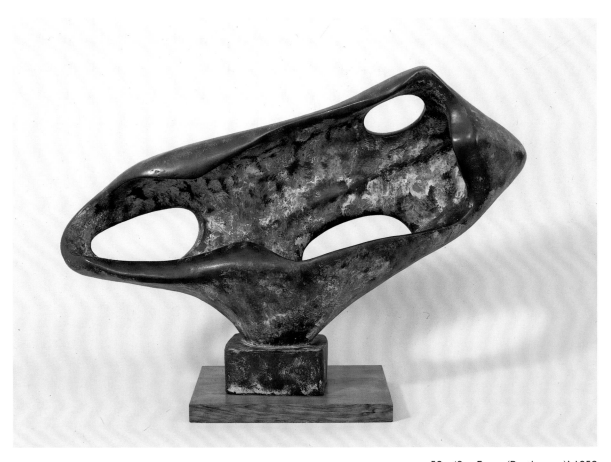

58 'Sea Form (Porthmeor)' 1958

During the 1940s Hepworth continued to create abstract sculptures that are closely related to her carvings of the 1930s, particularly to the twisting, spiralling forms found in the 1938 'Heloids in Sphere' (BH 109). In carvings such as 'Involute I' 1946 (BH 135), 'Sculpture with Colour (Eos)' 1946 (BH 141) and 'Helikon' 1948 (BH 148), the curvilinear forms are more organic and less rigidly geometrical than the cones, hemispheres and polyhedrons of the mid-to-late 1930s. This is reflected in the titles themselves: 'Convolute' 1944 (BH 126), coiled laterally upon itself, and 'Involute I' 1946, rolled or curled up spirally. It was as if the forces of nature – the wind and the rain, the erosion by the sea of boulders and cliffs – had a hand in shaping these forms.

For those with small Latin and less Greek, a dictionary is required to explain the meaning of some of the titles that Hepworth assigned to a number of works of the 1940s. Some titles are rooted in classical antiquity, while others define somewhat obscure, geometric terms. Ten years before her trip to Greece in 1954, Hepworth's love of the classical world of ancient

Greece is reflected in some of the titles she assigned to her work. While in the 1930s carvings were often called simply 'Form' 1936 (p. 57) or 'Three Forms' 1935 (p. 63), in the 1940s 'Form' becomes 'Eidos' 1947 (BH 146). The 1943–44 carving is called 'Wave'; the 1946 carving is given the Greek name 'Pelagos' (the sea). In the 1946 'Sculpture with Colour (Eos)' (BH 141), the Greek word for dawn appears in parenthesis. From the early 1950s on, Hepworth almost always put place names in parenthesis, as in 'Figure in a Landscape (Zennor)' 1952 (BH 179), and 'Sea Form (Porthmeor)' 1958 (p. 87).

Even during the war years, Hepworth continued to exhibit regularly, as she had done in the 1930s. Her first museum exhibitions were held in Yorkshire. In 1943 she showed with Paul Nash at Temple Newsam, Leeds, and in the following year had an exhibition in her home town, at the Wakefield City Art Gallery. She continued her earlier association with the dealers Alex. Reid and Lefevre, with whom she exhibited in London in 1946 and 1948. Her first show in the United States was held at Durlacher Bros., New York in 1949.

Despite the war and the relative isolation of Cornwall, Hepworth and Nicholson kept in touch with friends from their London years, many of whom came to stay – Herbert and Ludo Read, Solly Zuckerman, Desmond Bernal, Peter Gregory, Margaret Gardiner, and John Summerson and his wife, Hepworth's sister Elizabeth. Barbara and Ben also continued to enjoy close friendships with Naum and Miriam Gabo, Adrian Stokes and his wife Margaret Mellis, as well as with the painter Peter Lanyon and the potter Bernard Leach, all of whom were living in St. Ives or Carbis Bay. In November 1946 Gabo left England and moved with his wife and daughter Nina to the United States. Hepworth later recalled the impact Gabo had made on her and the community:

> Gabo made a profound effect during the six years he lived and worked here.
> His unusual powers of expression in discussion and the exceptional charm of his personality when talking of creative processes seemed to unleash a great energy in all who came near him. When he went to America everybody who knew him missed him. It is impossible to forget either the extraordinary beauty of his sculptures or the most rare warmth of his nature.[17]

On 8 February 1949 at the Castle Inn, St. Ives, The Penwith Society of Arts in Cornwall was founded. Barbara Hepworth, Ben Nicholson, Bernard Leach and Peter Lanyon were among the nineteen founding members of a group of artists and craftsmen, many of whom had resigned from the St. Ives Society of Artists. Herbert Read agreed to be the President of the Society.

• • •

Between 1947 and 1951 Hepworth executed two series of figurative drawings. A series of life drawings demonstrates her revival of interest in the male and female nude which had been the subject of numerous drawings during the 1920s (p. 157). These drawings, which were made

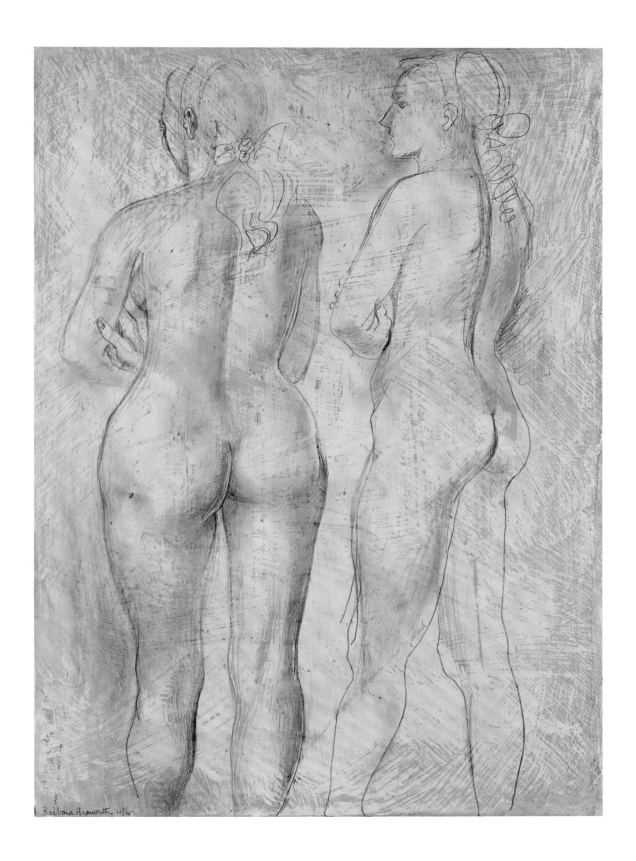

102 'Two Figures with Folded Arms' 1947

between 1947 and 1951 (pp. 89 and 91), recall the linear style of Nicholson's much earlier figure studies of Hepworth, such as '1932 (girl in a mirror, drawing)', (p. 39). Rather than hiring professional models, Hepworth used trained dancers, who were asked to move about naturally, rather than adopting traditional art school poses. Alan Bowness has described the technique of the drawings, which created rich surface textures akin to those found in Nicholson's paintings of the early 1930s:

> The rhythm of the figure is expressed in the pencil line which describes the form. Some of the drawings are done on paper ... but these tend to be the more summary ones. The more considered early ones are drawn on boards prepared with scumbled oil paints muted in colour; this is often scraped and rubbed off in places as the drawing proceeds. The pencil lines are strong and delicate, sometimes heightened with a coloured line – a red crayon, ... and supported by softly shaded areas to bring out the forms. There is, however, no question of a three-dimensional realisation of the figure, as there was in the very early figure drawings: the search is much more for the rhythm of a figure in movement. Profiles, for example, are important in giving a rhythmic pulse to the whole drawing.[18]

The 1951 'Standing Figures and Head: Caryatid' (p. 91) shows the remarkable control of line in depicting two profile views of the female nude. The lines are taut and crisp, with no *pentimenti*, no hesitation or groping for the outline. Hepworth's figure studies of 1947–51 relate to rhythms and compositions of her sculptures of the period. For example, the contours of the 1949 limestone 'Bicentric Form' (p. 102), with its strong, figurative references, echo the curved, sensuous rhythms of the nude on the left in the 1947 drawing 'Two Figures with Folded Arms' (p. 89). In addition, the way in which Hepworth often depicted two, three or four views of the same model in a single drawing relates to the groups of forms in her sculpture, such as the 1935 'Discs in Echelon' (p. 66) and the 1951 'Group I (Concourse)', (p. 97).

The second series of figure drawings developed through Hepworth's close friendship with Norman Capener, the surgeon who had earlier operated on her daughter Sarah for osteomyelitis. In 1947 Hepworth was invited to watch operations at the Princess Elizabeth Orthopaedic Hospital in Exeter, and later in London at the National Orthopaedic Hospital and the London Clinic. She was permitted to sketch, using a sterilized notebook and pen. The larger, finished drawings were done soon after when the scenes were still fresh in her mind. Although one would think that her operating theatre drawings would be unrelated to her sculptural concerns, Hepworth explained the connections:

> At first I was very scared, but then I found there was such beauty in the coordinated human endeavour in the operating theatre that the whole composition – human in appearance – became abstract in shape. I became completely absorbed by two things: first, the extraordinary beauty of purpose between human beings all dedicated to the

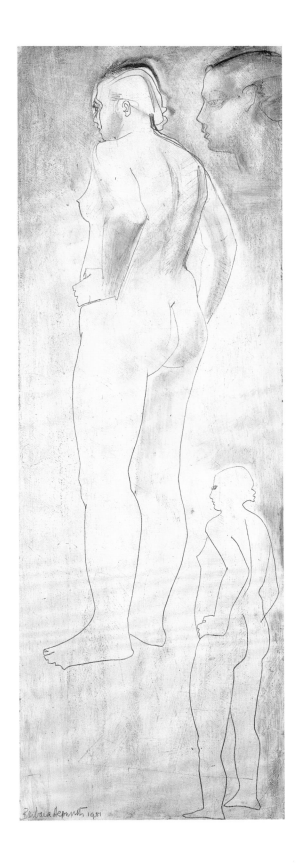

109 'Standing Figures and Head: Caryatid' 1951

98 'Reconstruction' 1947

105 'Prevision' 1948

> saving of life; and secondly by the way this special grace (grace of mind and body)
> induced a spontaneous space composition, an articulated and animated kind of abstract
> sculpture very close to what I had been seeking in my own work.[19]

The first operating theatre drawings were executed in 1947, but most were done in 1948–49.
The subjects include general views of doctors and theatre sisters at work, studies of individual
figures, sketches of drapery, and drawings focusing on the hands all directed at a central focal
point. The operating theatre series is the most self-contained of all Hepworth's series of draw-
ings, and they have about them an intensity and concentration not found elsewhere. This
must have flowed from Hepworth's deeply personal and emotional involvement in the drama
of a human event, in much the same way that the depth of feeling in Henry Moore's famous
shelter drawings of 1940–42 had much to do with his identification and sympathy with
Londoners sheltering during the Blitz. Moore's shelter drawings and Hepworth's operating
theatre drawings represent these artists' greatest achievements in the art of draughtsmanship.

By June 1949 marital relations between Hepworth and Nicholson had broken down, and
they were soon living apart. They divorced in February 1951. In early September 1949
Hepworth acquired Trewyn Studio, St. Ives, where she lived and worked until her death in
1975, and which is now the Barbara Hepworth Museum.

> It seemed a miracle indeed to find in the middle of a town a studio with workshops and
> yard and garden where nobody objected to the noise of hammering and where there
> was protection from cold winds so that I could carve out of doors nearly all the year
> round, and where there was proper space for all the multitudinous items of equipment
> needed for moving stone and carving it. The atmosphere was so ideal that I started a
> new carving the morning after I moved in – in spite of the difficulties of the move's
> involving six tons of tools and materials of all kinds.[20]

106 'Portrait of Lisa in Blue and Red' 1949

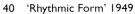

40 'Rhythmic Form' 1949

46 'Pastorale' 1953

'Artist in society', the heading Hepworth gave to the period 1949–52, in fact describes her life and work during the entire decade of the 1950s. In a mark of official recognition, Hepworth was nominated in 1950 to represent Britain at the 25th Venice Biennale. Moore had been chosen in 1948, and Nicholson was to follow in 1954. Also in 1950, two sculptures were commissioned for the Festival of Britain. Hepworth designed the sets and costumes for the 1951 production of Sophocles' *Electra* at the Old Vic Theatre, London, and also for Michael Tippett's opera *The Midsummer Marriage*, first performed at the Royal Opera House, Covent Garden on 27 January 1955. There were retrospective exhibitions of her work in Wakefield in 1951, and at the Whitechapel Art Gallery, London in 1954. She was awarded second prize in 1953 in 'The Unknown Political Prisoner' competition organized by the Institute of Contemporary Arts, London (p. 142). In 1958, Hepworth was created C.B.E. in the Queen's New Year's Honours List. Her large bronze 'Meridian' was commissioned for State House, London in 1959, and unveiled the following year. The culmination of this very public decade came in 1959 when Hepworth was awarded the Grand Prix at the 5th São Paulo Bienal, Brazil.

On several occasions in the 1950s, Hepworth commented on the position of women in the visual arts. She believed that the feminine point of view is complementary to the masculine approach, rather than in competition with it. In 1952, she addressed the issue as follows:

> I think that women will contribute a great deal to this understanding through the visual arts, and perhaps especially in sculpture, for there is a whole range of formal perception belonging to feminine experience. So many ideas spring from an inside response to form; for example, if I see a woman carrying a child in her arms it is not so much what I see that affects me, but what I feel within my own body. There is an immediate transference of sensation, a response within to the rhythm of weight, balance and

Barbara Hepworth, 'Apollo' 1951. Sculpture in steel rod for Sophocles', *Electra*, produced at the Old Vic Theatre, London

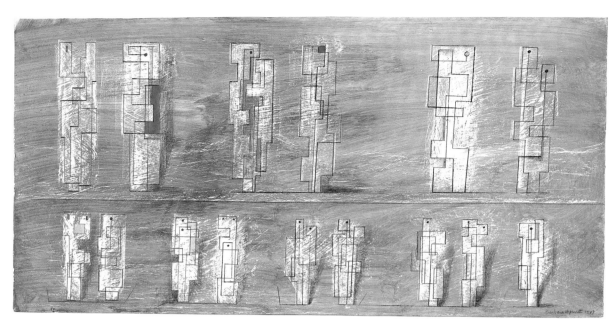

100 'Drawing for Stone Sculpture' 1947

tension of the large and small form making an interior organic whole. The transmutation of experience is, therefore, organically controlled and contains new emphasis of forms. It may be that the *sensation* of being a woman presents yet another facet of the sculptural idea. In some respects it is a form of 'being' rather than observing, which in sculpture should provide its own emotional and logical development of form.[21]

In 1954 Hepworth discussed and refuted the view that women's art, simply by being feminine, does not attain the highest levels of achievement:

It is often stated that women's work is best when it accepts the limitation of their sex and is most feminine; but that by being feminine it has never scaled the upper reaches of achievement in art and presumably never will. This belief in the inevitable inferiority of women's art presupposes a competitive element between the sexes. I do not believe that women are in competition with men. I believe that they have a sensibility, a perception and a contribution to make which is complementary to the masculine and which completes the total experience of life. If this is accepted, instead of feeling cheated because a woman is not a man, it becomes possible to enrich one's experience by the contemplation of a bivalent expression of idea.[22]

• • •

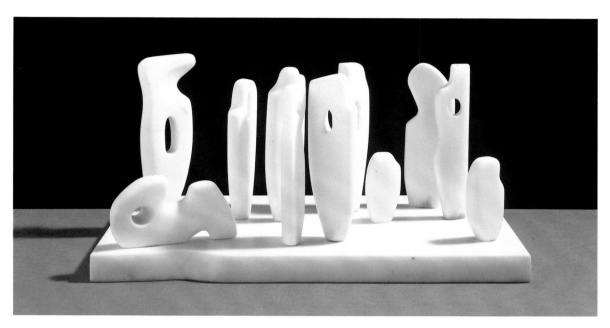

42 'Group I (Concourse) February 4 1951'

Hepworth's visit to Venice for the 1950 Biennale inspired a new set of geographic references. Every day she watched the crowds in the Piazza San Marco, moving in relation to each other and to the architecture. She described the impressions that were relevant for her sculpture:

> But the most significant observation I made for my own work was that as soon as people, or groups of people, entered the Piazza they responded to the proportions of the architectural space. They walked differently, discovering their innate dignity. They grouped themselves in unconscious recognition of their importance in relation to each other as human beings.[23]

The 1951 marble 'Group I (Concourse)' (above), which includes 12 figures, relates to Hepworth's experience in the Piazza San Marco the previous year. The groupings of figures on a base recall Giacometti's bronzes of the late 1940s, such as the 1948 'City Square II', while the biomorphic, Surrealist forms are reminiscent of the shapes that populate Tanguy's crowded landscape paintings of the 1940s and 50s. In 'Group I (Concourse)', the standing forms evoke the human figure as well as weather-worn prehistoric menhirs found throughout Cornwall. The small upright form at one corner of the composition is coincidentally remarkably close to the shape of one of the standing stones in the circle known as The Hurlers in eastern Cornwall near Liskeard.

On 13 February 1953, Paul Skeaping, Barbara Hepworth's son from her first marriage, was killed on active service with the R.A.F. over Thailand. In 1954 she carved for St. Ives Parish

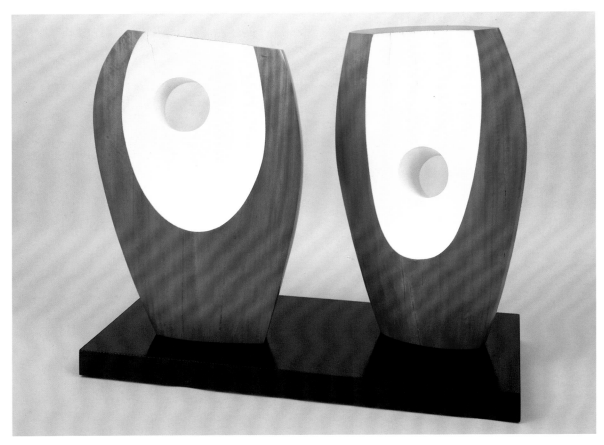

67 'Two Forms with White (Greek)' 1963

Church the tender 'Madonna and Child' (BH 193) in memory of Paul. While the composition is remarkably close to the 1927 'Mother and Child' (p. 21), the style is distinctly reminiscent of the religious carvings of Eric Gill, such as the Stations of the Cross in Westminster Cathedral, London.

Hepworth visited Greece and the Aegean and Cycladic Islands in August 1954. Not since her trips to Italy in 1924–25, and to the south of France in 1933, had she felt such excitement about a foreign landscape:

> In Greece the inspiration was fantastic. I ran up the hills like a hare, with my notebook, to get there first and have the impact of solitude. I made many drawings for new sculptures called 'Delphi,' 'Delos,' 'Mycenae,' 'Epidauros' and 'Santorin.' These forms were my experience there.[24]

The 1954–55 scented guarea wood 'Corinthos' (BH 198), the first carving inspired by her trip to Greece, was followed by two more sculptures in the same material, 'Curved Form

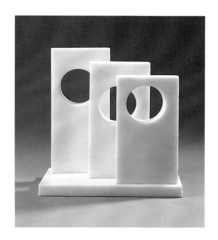

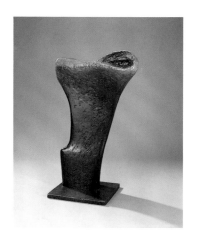

71 'Maquette for Large Sculpture: Three Uprights with Circles (Mykonos)' 1966

56 'Torso I (Ulysses)' 1958

(Delphi)' (BH 199) and 'Oval Sculpture (Delos)' (BH 201), both executed in 1955. A decade later, the Greek experience resurfaced in two carvings: the 1963 'Two Forms with White (Greek)' (BH 346), and the 1966 'Maquette for Large Sculpture: Three Uprights with Circles (Mykonos)' (above).

As Alan Bowness has pointed out, the magnificent mid-1950s wood carvings with Greek titles 'represent such a definitive statement of the carver's art that in a way it is hardly surprising to find them followed by one of the most radical departures in Barbara Hepworth's development. For in 1956 began the experiments with metal sculpture, first cut and twisted sheets of copper and brass, and then the use of bronze itself.'[25] Hepworth in fact had worked with metal in several sculptures in the early 1950s. In the 1951 'Apollo' (BH 167), made for the production of Sophocles' *Electra*, a steel rod was bent and twisted into a vertical form. The 1951–52 'Form in Tension' (BH 172) includes two wrought iron rods that encircle the marble form in a way reminiscent of the brass strip painted black in Gabo's 1933 carving 'Construction: Stone with Collar'. But 1956 was indeed the year in which Hepworth began in earnest to work with metal, and to create sculptures in plaster to be cast in bronze.

The 1956 'Forms in Movement (Galliard)' (p. 144), was made with sheets of copper which have been twisted into shape. It is immediately apparent that it would have been impossible to realise such thin, twisting, interlocking forms in stone or wood. 'Forms in Movement (Galliard)', like its pendant 'Curved Form (Pavan)' (BH 210) 1956, made in metalised plaster, reflects Hepworth's interest in dance. A galliard is a quick and lively dance in triple time; a pavan is a grave and stately dance in which the dancers are elaborately dressed. The 1956 'Curved Form (Trevalgan)' (p. 103) was the first sculpture of the period that was created specifically to be cast in bronze. For the next twenty years, Hepworth's sculpture is fairly evenly divided between stone and wood carvings and bronzes.

115 'Stone Form' 1961

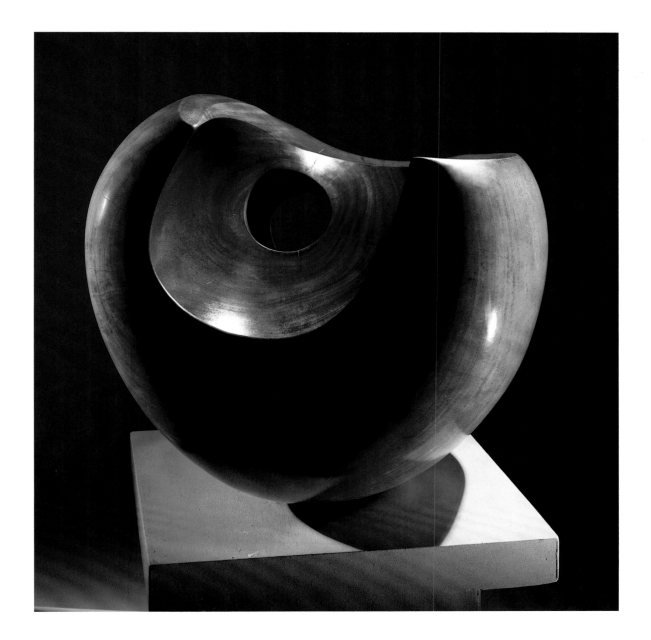

48 'Configuration (Phira)' 1955

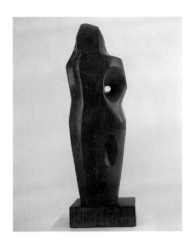

41 'Bicentric Form' 1949

A sculptor, in working towards bronze, makes the original in wax, clay or plaster from which the bronze edition will be cast. Rodin, Degas, Giacometti, Epstein and Lipchitz all modelled in clay or wax. Hepworth, who hated modelling, worked with plaster, as did Moore. She compared creating an armature to building a boat, 'and then putting the plaster on is like covering the bones with skin and muscles. But I build it up so that I can cut it. I like to carve the hard plaster surface'.[26] Hepworth's original plasters are, in essence, carvings. One of the great advantages in working in plaster is that mistakes can be easily rectified by adding additional wet plaster, letting it dry and beginning again. In carving wood or stone, mistakes are irreversible.

Working towards bronze radically altered the scope of Hepworth's sculpture in a number of ways. Stylistically she was able to create much more open, linear, transparent forms that would have been impossible to realise in stone or wood. Two bronzes, the 1956 'Involute II' (BH 218), and the 1958 'Maquette (Variation on a Theme)' (p. 139), reflect her response to this new freedom of expression. Now that she had the space, the time and the money, she was able to work on a much larger scale. Having her sculpture cast in bronze in limited editions meant that her work reached a much larger audience, as many more sculptures were available for museums and private collectors.

During the 1950s and 60s Hepworth continued to explore the landscape of the Penwith peninsula and to draw inspiration from it. She has discussed the associations of a number of her sculptures that include Cornish place names in the titles. One of her most detailed accounts focused on the 1956 bronze 'Curved Form (Trevalgan)' (p. 103):

> This 'Curved Form' was conceived standing on the hill called Trevalgan between St.
> Ives and Zennor where the land of Cornwall ends and the cliffs divide as they touch the
> sea facing west. At this point, facing the setting sun across the Atlantic, where sky and

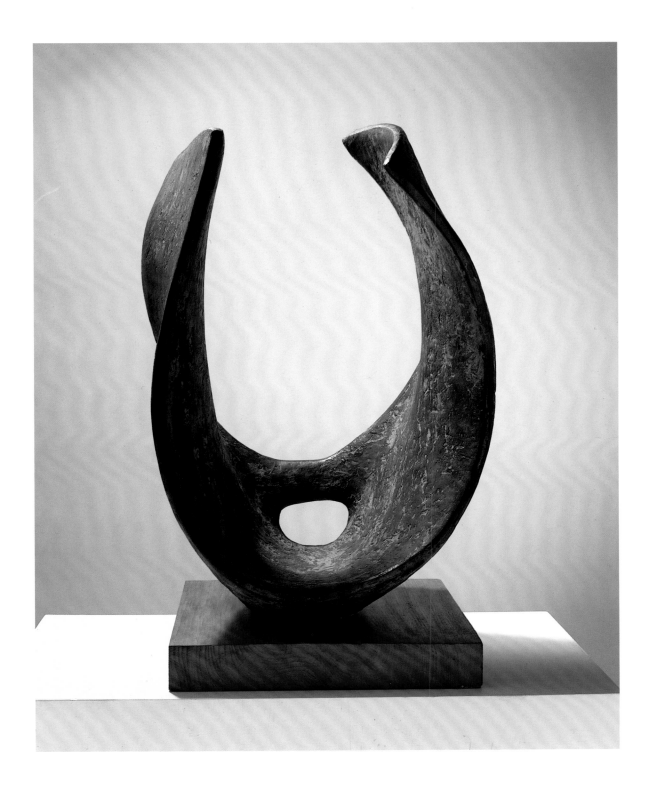

53 'Curved Form (Trevalgan)' 1956

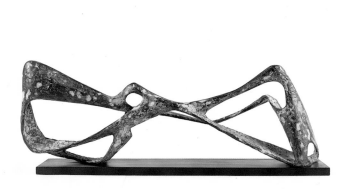

Barbara Hepworth, 'Reclining Figure (Landscape, Rosewall)' 1957

'Mên Scryfa' (stone of writing)
near Morvah, Cornwall

sea blend with hills and rocks, the forms seem to enfold the watcher and lift him towards the sky.[27]

As there is no explanation for the 1957 bronze 'Reclining Figure (Landscape Rosewall)', (above), one can only speculate on the connection. The sculpture may relate to the view of the landscape seen from the top of Rosewall Hill (about a mile south-west of St. Ives), or it may be connected with the horizontal rock formation at the top of the hill. The 1958 bronze 'Sea Form (Porthmeor)' (p. 87), refers to Porthmeor Beach, now popular the year round with surfers. The protected harbour of St. Ives faces east, while Porthmeor Beach faces north-west, and is exposed to the full might of the Atlantic Ocean (p. 82). Hepworth described her bronze as follows: 'I had by this time become bewitched by the Atlantic beach. The form I call Porthmeor is the ebb and flow of the Atlantic.'[28] The new Tate Gallery St. Ives overlooks Porthmeor Beach.

The Chûn Castle hill fort and the nearby Chûn Quoit tomb are two of the most impressive prehistoric sites in west Cornwall. They are situated on Chûn Downs, about four miles north-west of Penzance. The flat, curved shape of Hepworth's 1961 bronze 'Single Form (Chûn Quoit)' (p. 105), must relate to the five leaning and balancing stones of the neolithic period (4300–2100 B.C.) Chûn Quoit tomb that resembles a gigantic mushroom (p. 83). The 1960 bronze 'Figure (Chûn)' (p. 108), is more problematic. Was this Brancusi-esque torso inspired by or reminiscent of one of the standing stones that are found in the circular, Iron Age (800 B.C. – A.D. 410) Chûn Castle hill fort or was it somehow connected to Chûn Quoit? The weathered standing stones at the inner gate of the fort look like unfinished blocks removed from Hepworth's carving studio. Although, as Alan Bowness has pointed out, titles were often assigned to works for practical reasons of identification,[29] one must assume that

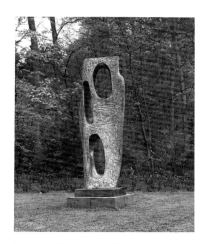

Barbara Hepworth, 'Rock Form
(Porthcurno)' 1964 Bronze

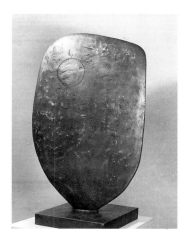

65 'Single Form (Chûn Quoit)'
1961

Hepworth included a specific place name in a title, as in 'Figure (Chûn)' (p. 108), because the completed sculpture did have some association with it.

Following the completion in 1959 of the bronze 'Meridian' (p. 145), Hepworth continued to work on a large scale. The title of the 1960 bronze 'Figure for Landscape' (BH 287) indicates that it was created for an outdoor, rural setting. This sculpture is one of Hepworth's few post-1939 works that relate to Moore. The rhythms of the outer shell, and the contours of the holes themselves closely echo Moore's internal/external sculptures of 1951 to 1954, particularly the 1953–54 'Reclining Figure: External Form' (LH 299), and are a pleasing reminder of these artists' shared idiom. Hepworth's 1960 bronze looks forward to the sequence of sculptures that focus on the ocean and the caves, rocks and cliffs in and around Porthcurno, on the south coast of the Penwith peninsula, about four miles south-east of Land's End. The series of bronzes includes 'Oval Form (Trezion)' 1961–63 (BH 304), 'Sea Form (Atlantic)' 1964 (BH 362) and 'Rock Form (Porthcurno)' 1964 (BH 363). Hepworth described these sculptures as follows:

> Yes, these are all sea forms and rock forms, related to Porthcurno on the Land's End coast with its queer caves pierced by the sea. They were experiences of people – the movement of people in and out is always a part of them. They are bronze sculptures, and the material allows more openness of course. I was a comparative newcomer to bronze, so I used it extravagantly to see how far I could go. It has a presence, but it doesn't look at you in the way that a carving does. There is a stronger sense of participating in the form – you want to go in and out as you look at a sculpture like 'Trezion' or 'Porthcurno'. Maybe it's not big enough to do this, but you don't need to be physically entangled if you've got a pair of hands. If you feel something, you know what the experience is.[30]

Barbara Hepworth, 'Four-Square (Walk Through)' 1966 under construction

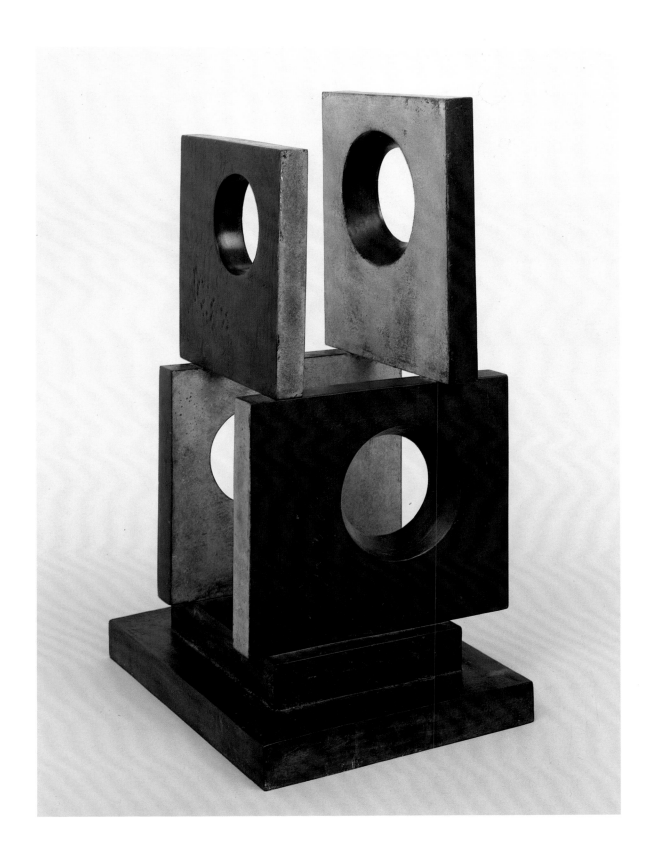

74 'Four-Square (Four Circles)' 1966

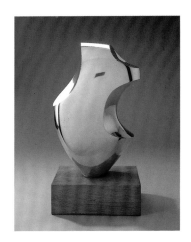

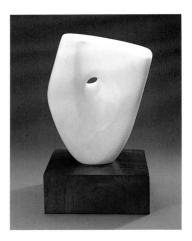

64 'Figure (Chûn)' 1960

60 'Holed Stone' 1959

This series led to the fourteen-foot high bronze 'Four-Square (Walk Through)' 1966 (BH 433), that was based on 'Four-Square (Four Circles)' (p. 107). Of this, her first sculpture which allows people to move into and through the forms, Hepworth has written, 'I wanted to involve people, make them reach to the surfaces and the size [sic], finding out which spiral goes which way, realizing the differences between the parts'.[31]

Major exhibitions at home and abroad, public commissions and academic honours filled the decade of the 1960s. In 1960 Hepworth exhibited at Galerie Charles Lienhard, Zürich; at the Whitechapel Art Gallery, London in 1962; at the Kröller-Müller Museum, Otterlo in 1965; and at the Tate Gallery, London in 1968, the last major retrospective exhibition of her work until the present one. She was awarded Hon. D. Litt. from the University of Birmingham in 1960; the University of Leeds in 1961; University of Exeter in 1966; and Oxford University in 1968. In 1965 she was created Dame Commander of the British Empire. In September 1968 she received two honours that were particularly important to her: the Honorary Freedom of the Borough of St. Ives was conferred upon her, and she was invested into the Gorsedd of Cornwall as a Bard, the ancient Celtic order of minstrel poets. She chose the Cornish name 'Gravyor' (sculptor) and said, 'I think the name 'Gravyor' suits me and could well go on my head-stone as showing my love for this land and its people'.[32]

Barbara Hepworth lived in Cornwall for more than half her life. The work she did there, her prolific output of carvings and bronzes, supported by her evocative writing, alters and enhances one's perception of the landscape and seascape of the Penwith peninsula, with its ancient standing stones, tombs, hill forts and stone circles. The similes operate in two directions – from sculpture to landscape and from landscape to sculpture. Chronology becomes irrelevant, as Professor J.D. Bernal made clear in his 1937 article, in which he compared Hepworth's vertical sculptures to the neolithic *menhirs* in Cornwall and Brittany, even though at the time she had no knowledge of Cornwall or of its prehistoric monuments. Can

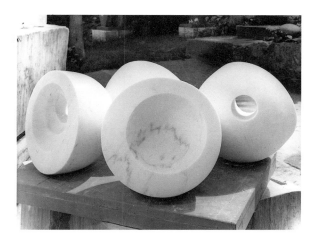

Barbara Hepworth, 'Four Hemispheres' 1969 Marble

anyone who has seen these ancient stones look at Hepworth's 1934 marble 'Standing Figure' (BH 62) without being reminded of them? The six foot inscribed Mên Scryfa (Cornish for stone of writing), dating from the Dark Ages and early Christian period, (p. 104), with its eroded tapered contours, looks uncannily like an enlarged version of her 18″ high 1934 carving. The nearby bronze age Mên-an-tol (stone of the hole) (p. 83), with the circular holed stone, inevitably recalls Hepworth's 1937 'Pierced Hemisphere I' (p. 62). Like Hepworth's 1966 bronze 'Four-Square: (Walk Through)', Mên-an-tol invites us to participate in the sculpture. (It is also known as the Crick Stone, and there is a ritual of crawling through the hole nine times in the hope of curing rickets and scrofula.) The view of St. Ives Bay towards Godrevy Lighthouse, with the ocean enfolded by the arms of the land to the left and right, reminds us that this setting not only influenced Virginia Woolf's novel *To the Lighthouse*, but also the lyrical rhythms of Hepworth's 1946 carving 'Pelagos'. The surf at Porthmeor Beach inspired the 1958 'Sea Form (Porthmeor)', and likewise the caves at Porthcurno the 1964 'Rock Form (Porthcurno)'. Even the ruined tin mines seem strangely to echo the geometry and vertical thrust of Hepworth's standing figures. In the same way that Suffolk belongs to John Constable, the region around Aix-en-Provence to Paul Cézanne, Tahiti to Paul Gauguin, and the Pacific coast of Canada to Emily Carr, so, on an imaginative level, the landscape of Cornwall belongs to Barbara Hepworth.

• • •

From 1965 to 1975, the last decade of her career, Barbara Hepworth continued to explore the three basic forms which had had a special relevance for her since her youth: the standing form, two forms and the closed form. But in a number of carvings and bronzes from these years she had moved on, found new and unexpected sources of inspiration, and created a group of works that constitute a genuine late style. As Alan Bowness has remarked, in

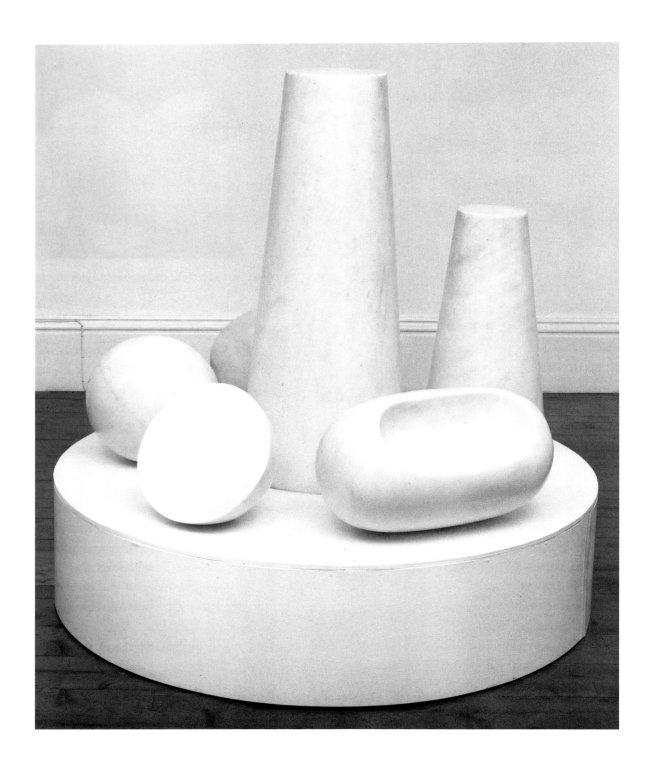

86 'Fallen Images' 1974–5

78 'Two Faces' 1969

Barbara Hepworth, 'Conversation with Magic Stones'
1973 Bronze

discussing the greatness of the late style of a number of artists, including Henry Moore, 'The late work is invariably more private, more centred on the artist's own obsessions, often reverting to much earlier moments of his artistic career or of his life. It is inevitably more difficult to appreciate for the public at large, who may be impressed, without quite understanding why.'[33] Hepworth's late style is best represented by the series of multi-part compositions that present vertical and horizontal groupings of abstract and figurative forms that are more complex and more mysterious than anything that came before. But it is not only the more populated groupings of forms that define the late style. It is also the introduction of themes hinting at myth, magic and fantasy.

Three carvings from her last decade illustrate the diversity of Hepworth's new imagery. The archaic rigidity of 'Two Ancestral Figures' 1965 (p. 142) suggesting a couple belonging to some hierarchical order, recalls two bronzes by Max Ernst, 'The King Playing with the Queen' 1944 and the male and female figures in 'Capricorn' 1948, as well as Henry Moore's 1952–53 bronze 'King and Queen (LH 350)'. The 1965 slate 'Two Forms (Maori)' (BH 405) would appear to relate to tribal sculpture. The notches on the outer edge of each of the two forms may well derive from the notches found on the sides of two types of Maori hand clubs, known as *wahaika* (fish mouth) and *kotiate paraoa*, or from the indentations where the arms meet the legs on *hei tiki* pendants. The 1969 marble 'Four Hemispheres' (BH 483) reflects Hepworth's interest in science and technology. But in discussing this carving, she makes the important point that a sculpture can have very different meanings or associations. 'You might say,' she commented, 'that the 'Four Hemispheres' (p. 109) equals the dishes at Goonhilly and the trackers of the sky',[34] referring to the satellite dishes at Goonhilly Downs on the Lizard peninsula between Falmouth and Penzance. 'Though at the same time', she added, 'the 'Four Hemispheres' has nothing to do with Goonhilly: they're part-blind faces, looking in four directions'.[35]

76 'Six Forms (2x3)' 1968

Two large multi-figure sculptures made between 1970 and 1975 epitomize the late style of Hepworth's last years. Although in the past she had made a number of very large bronzes, such as the 1962–63 'Single Form' commissioned by the United Nations, Hepworth had never before created multi-form sculptures on the scale of 'The Family of Man' 1970 (p. 115), and 'Conversation with Magic Stones' 1973 (p. 112). As Hepworth remarked: 'It's so natural to work large – it fits one's body ... I've always wanted to go to my arm's length and walk round things, or climb up them. I kept on thinking of large works in a landscape: this has always been a dream in my mind.'[36] 'The Family of Man' consists of nine standing figures, each with two, three or four forms stacked on top of each other. Their combined titles suggest a seven ages – 'Youth', 'Young Girl', 'Bridegroom', 'Bride', 'Parent I & II', 'Ancestor I & II' and finally, 'Ultimate Form' which perhaps represents the sculptor's own contribution to the cycle of life. 'The Family of Man' established once and for all Hepworth as the sculptor of the upright, standing figure, as Moore was the sculptor of the horizontal, reclining figure. 'Conversation with Magic Stones', shown here in the garden of the Hepworth Museum, St. Ives, deals with a more private world. Each of the three large vertical forms is entitled 'Figure'; each of the three smaller forms is called 'Magic Stone'. The three smaller forms are as abstract as Hepworth's carvings of the mid 1930s. Indeed, in the small central form and in the one beyond it and to the right, Hepworth has re-introduced the geometry of the 1930s, recreating on a much larger scale the sharp, angular form in the 1934–35 'Two Forms' (p. 53), and the 1936 'Holed Polyhedron' (p. 52) respectively. An imaginary dialogue seems to operate on two levels – between the three figures and the magic stones, and between the spectator and the entire sculptural group. In 'The Family of Man' and 'Conversation with Magic Stones', Hepworth has created a twentieth century visual equivalent of the *menhirs*, *dolmens*, *quoits* and stone circles from prehistoric times.

Barbara Hepworth, 'Assembly of Sea Forms' 1972 Marble

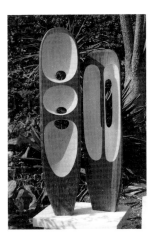

47 'Two Figures' 1954–55

Three carvings made between 1967 and 1973 represent another theme of Hepworth's late style – the vertical stacking of related or of incongruous, disparate forms. The 1967 'Three Forms Vertical (Offering)' (BH 452), falls somewhere in between, with two polished forms balancing on the more massive, roughly hewn base. In the 1971 white marble 'Three Part Vertical' (p. 116), the elements are stacked in much the same way as the forms in each of the figures in 'The Family of Man'. But here, instead of the sections relating to each other stylistically, Hepworth has created three forms whose only bond is that they are attached to each other. The egg-like form with the flat plane could, in its purity and simplicity, be a homage to Brancusi's 1915 marble 'The Newborn' (Philadelphia Museum of Art). The central form, with the flat rectangular face and circular hole, looks back to the geometry of the mid-1930s, and to the carved reliefs of Ben Nicholson. The unfinished block speaks of the process of carving the roughly hewn marble, with the unrealised form concealed within. Again Hepworth evokes the sculpture of Brancusi, works such as his 1933 'Blond Negress II' (Museum of Modern Art, New York). Not only did Brancusi produce a vertical assembly of stylistically unrelated forms, but he also used four different materials: polished bronze, marble, limestone and wood. In 'Three Part Vertical' Hepworth completely abandoned all notions of stylistic and formal consistency that had prevailed in her multi-part compositions since the 1930s, and created a composite image that is both tough and rugged, elegant and pure. The 1973 marble 'Cone and Sphere' (p. 120) does have a stylistic unity between the two geometric forms that one finds in Hepworth's abstract carvings of the 1930s, such as 'Conoid, Sphere and Hollow II' 1937 (p. 58). In the 1973 sculpture, there are two conical depressions on either side of the interlocking circles incised on the cone. Again, as in the 1930s, Hepworth has avoided cool, mathematical perfection by slightly distorting the geometric shapes.

The 1972 'Assembly of Sea Forms' (above), and the 1974–75 marble 'Fallen Images'

Barbara Hepworth, 'The Family of Man' 1970 Bronze

(p. 110), convey another characteristic of the late sculpture that first appeared in the mid 1960s, in works such as 'Six Forms in Echelon' 1965–66 (BH 402) – the proliferation of forms. 'Assembly of Sea Forms' and 'Fallen Images' are imbued with a new feeling of freedom, as the elements seem to have spilled onto the circular bases in a profusion unlike anything in Hepworth's earlier work. In 'Assembly of Sea Forms', the stainless steel plinth recalls the highly polished metal or mirror bases found in a number of Brancusi's sculptures, such as 'The Fish' 1922 (Philadelphia Museum of Art). While Hepworth assigned different titles to each of the eight forms – a delightful fantasy world of 'Sea King', 'Sea Form', 'Embryo', 'Sea Mother', 'Sea Bird' – there are no names for the individual forms in 'Fallen Images'. And yet, by association with her earlier work, the two truncated cones suggest on an almost subliminal level two standing figures – a man and a woman. In this composition, one of the last works she completed before she died in a fire at Trewyn Studio, St. Ives, on 20 May 1975, Hepworth seems to be looking back through T.S. Eliot's 'remembered gate' to the serene, abstract

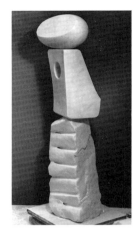

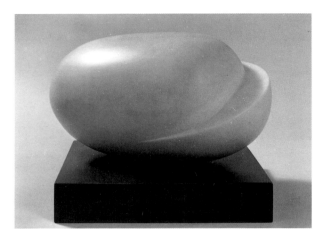

Barbara Hepworth,
'Three Part Vertical'
1971 Marble

81 'Sleeping Form' 1971

carvings of the mid 1930s, still, as throughout her life, finding fresh interpretations and con-
texts for familiar forms:

> We shall not cease from exploration
> And the end of all our exploring
> Will be to arrive where we started
> And know the place for the first time.[37]

Abbreviations used in this essay are as follows:
BH and number: catalogue number from the two volume catalogue raisonné of Hepworth's sculpture
LH and number: catalogue number from the six volume catalogue raisonné of Henry Moore's sculpture

1. *Barbara Hepworth: Drawings from a Sculptor's Landscape*, introduction by Alan Bowness, London 1966, p. 9.
2. Barbara Hepworth, *Barbara Hepworth: A Pictorial Autobiography*, Tate Gallery, London, revised edition 1978, p. 41.
3. Ibid., p. 42.
4. *Barbara Hepworth: Carvings and Drawings*, introduction by Herbert Read, London 1952, section 4, n.p.
5. Ibid.
6. Ibid.
7. *A Pictorial Autobiography* op. cit., p. 53.
8. Ibid.
9. *Carvings and Drawings* op. cit., section 4, n.p.
10. Barbara Hepworth, 'Approach to Sculpture,' *Studio*, vol. 82, 1946, p. 98 as quoted in *Barbara Hepworth*, exh. cat., Tate Gallery, London 1968, p. 21.
11. *Drawings from a Sculptor's Landscape* op. cit., p. 11.
12. *Carvings and Drawings* op. cit., section 4, n.p.
13. Virginia Woolf, *A Passionate Apprentice: The Early Journals 1879–1909*, Toronto 1990, p. 282.
14. Alan Bowness (ed.), *The Complete Sculpture of Barbara Hepworth 1960–69*, London 1971, p. 12.
15. Steven A. Nash, *Ben Nicholson: Fifty Years of his Art*, exh. cat., Albright-Knox Art Gallery, Buffalo, NY 1978, p. 28.
16. *The English Eye*, introduction by Robert Melville and Bryan Robertson, exh. cat., Marlborough-Gerson Gallery, New York 1965, p. 16.
17. *Carvings and Drawings* op. cit., section 4, n.p.
18. *Drawings from a Sculptor's Landscape* op. cit., p. 20.
19. *A Pictorial Autobiography* op. cit., p. 50.
20. *Carvings and Drawings* op. cit., section 5, n.p.
21. Ibid., section 6, n.p.
22. *Barbara Hepworth: Retrospective Exhibition 1927–1954*, exh. cat., Whitechapel Art Gallery, London 1954, p. 29.
23. *Carvings and Drawings* op. cit., section 6, n.p.
24. *A Pictorial Autobiography* op. cit., p. 71.
25. *Drawings from a Sculptor's Landscape* op. cit., p. 23.
26. *The Complete Sculpture of Barbara Hepworth 1960–69* op. cit., p. 7.
27. *A Pictorial Autobiography* op. cit., p. 75.
28. Ibid., p. 76.
29. In conversation with the author.
30. *The Complete Sculpture of Barbara Hepworth 1960–69* op. cit., p. 12.
31. Ibid.
32. *A Pictorial Autobiography* op. cit., p. 117.
33. Alan Bowness (ed.), *Henry Moore: Volume 4, Sculpture 1964–73*, London 1977, pp. 17–18.
34. *The Complete Sculpture of Barbara Hepworth 1960–69*, op. cit., p. 16.
35. Ibid.
36. Ibid., p. 7.
37. T.S. Eliot, *Four Quartets*, London 1968, p. 55.

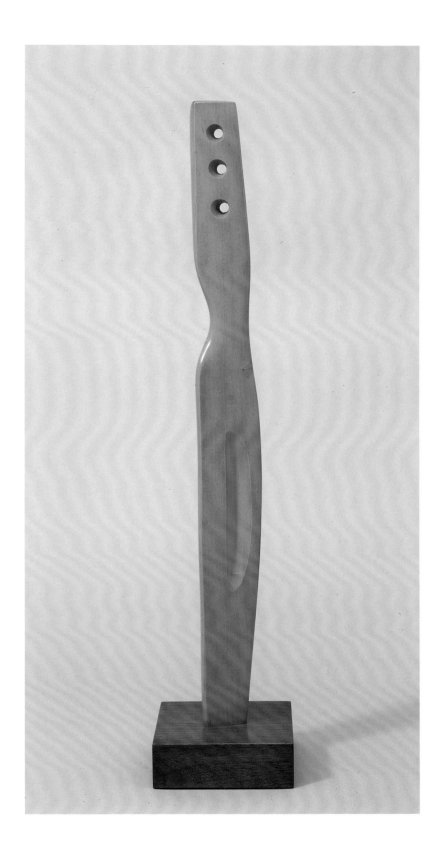

51 'Idol' 1955–56

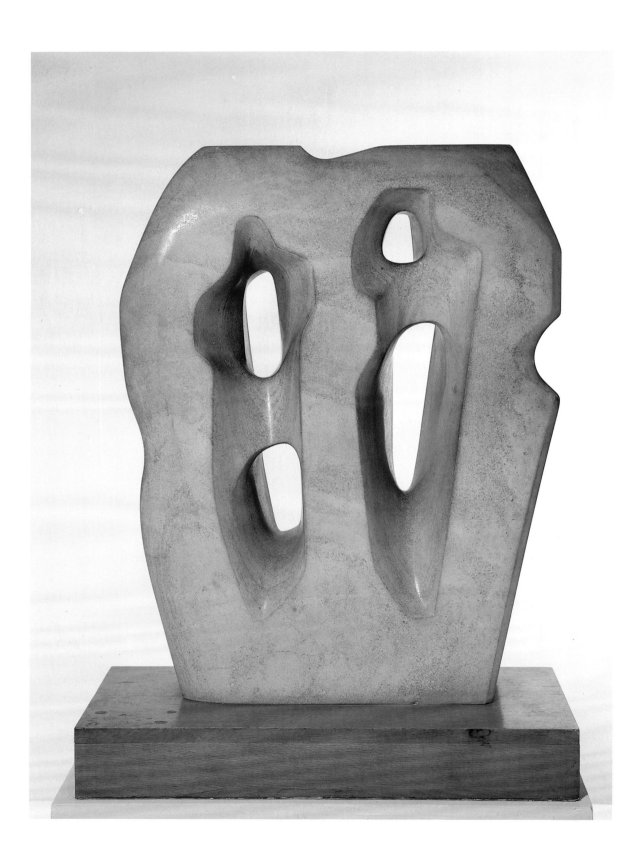

45 'Hieroglyph' 1953

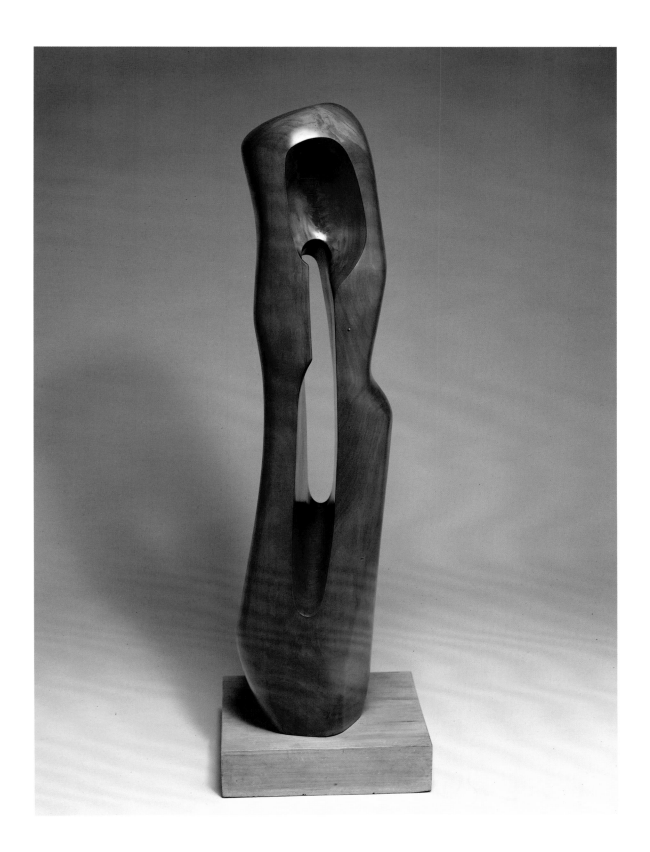

43 'Figure (Churinga)' 1952

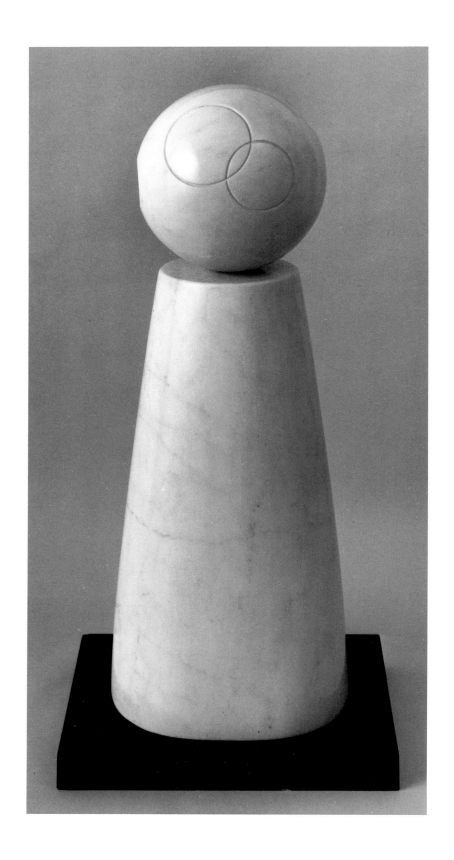

85 'Cone and Sphere' 1973

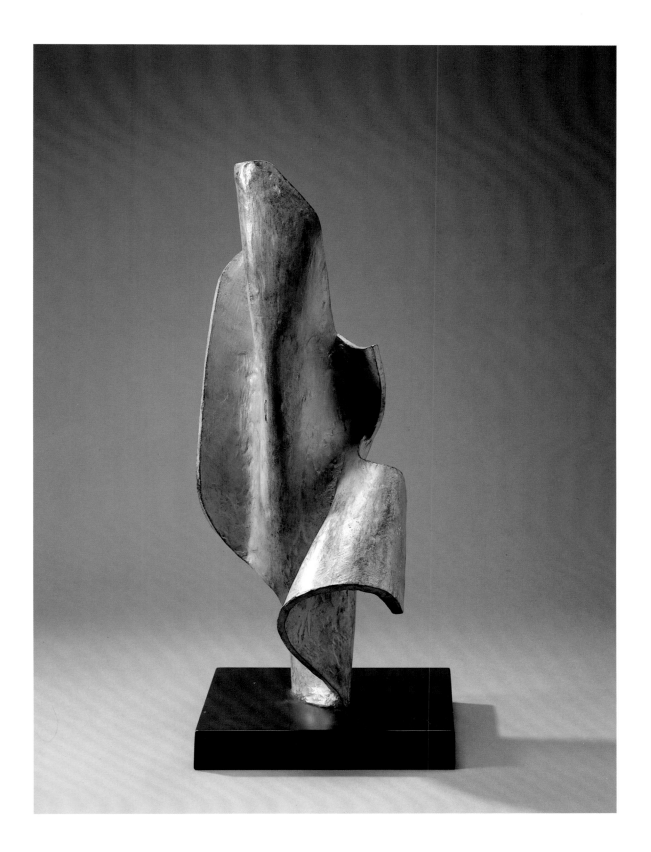

68 'Vertical Form' 1962

114 'Concave Form' 1960

77 'Two Opposing Forms (Grey and Green)' 1969

124

75 'Sphere with Inside and Outside Colour' 1967

The Artist in Post-War Britain

Penelope Curtis

> It is hopeless to presume that I, or anybody, thinks the same as in 1936, either about Art, Philosophy or Religion.
>
> You won't have a friend who thinks the same after this war as they did before it.
>
> (Barbara Hepworth to Ben Nicholson c.1940)

The war encouraged Hepworth to think about her place as an artist with renewed vigour. She was one of those favoured by the new government bodies set up after the war for the encouragement of the arts, and her work became increasingly public. At the same time, she became fiercely defensive of her interest in large-scale work. Juggling her newly-won status with the demands that the production of large-scale sculpture brings with it was difficult for Hepworth, and problems were exacerbated in her mind by two factors. One was the sense of competition with Henry Moore, and the other was the predicament of whether to place herself with new or with past developments. To be part of Hampstead modernism, Hepworth had to be seen alongside Moore, but she also wished to assert her independence of him. She lived sufficiently long to see the historicization of her own early career and the increasing adulation of that 'gentle nest of artists'. She also lived long enough to see the relatively recent trend towards outdoor commissions – to which she had herself contributed – thrown into question and a concurrent reinvestment in the values of small-scale sculpture for the gallery.

In 1939, at the outbreak of war, Hepworth and Nicholson established their young family in St. Ives. Initially Hepworth was loathe to give up London,[1] and at the end of the war she still talked of returning to life in the capital. However, she did come to depend on life in a small town, and as early as 1942 was able to recognise how it had changed her outlook. She told Herbert Read (whom she had not seen for two years) that it had been good for them both to be decentralised, and thus 'much more a part of a responsible community'. She felt encouraged that 'the emotional link is far greater now between society and the artist than at any time since the last war ... we are clear, quite clear about reconstruction but there is so much to be done – now ... as you say – good art is always socially relevant and the art of the last 30 years has been GOOD and being a part of the revolution it must contain the seed of social change'.[2]

In local debates Hepworth put forward her 'practical plan for giving the artist a place in society – the reorientation of teaching based on the principle that "every man is a special kind of artist"'. She was cheered by St. Ives's small but successful campaign to raise funds for an x-ray unit for the USSR. In her later letters to Dag Hammarskjöld at the UN she revealed her

72 'Two Rotating Forms I' 1966

sense of the community of artists in the town: 'St Ives is a small place; but the artists and writers here do, I know, think of you and your work each day.'[3]

In some ways the war seems to have inspired Hepworth, giving her a new energy and a new sense of direction. In its early years she told Nicholson, 'I feel life is just beginning for me ... The war has released energy – let us use it'.[4] From the end of the war another interesting letter survives in which she describes to him her feelings on seeing a film about Belsen: 'In Belsen I can find the heart of things which was missing for our Civilisation before the war. I don't want to share in a crusade of only abstract qualities – but a crusade which is fully religious.'[5] At the end of the war she told a friend 'one does certainly get an intensity of vision under such conditions. But the odd thing is that I have discovered in myself ... an "easy flow" for the first time in my life ... Perhaps joy and grief are now rightly mixed'.[6]

Despite Hepworth's distance from the capital her life in St. Ives appears to have encouraged her to think in less isolated terms. From a local base, she was now ready to think more internationally. Her new interest in bridging the gap between the artist and society was clearly expressed in her belief in the function of sculpture. In 1944 she complimented Read on a recent text about Moore, which she felt made the important point that 'sculpture is public – it must have a place, and the people'. She was concerned that, 'there is the sculpture for the first time and no where to put it'.[7]

In 1949 Hepworth was given an opportunity to realise her new ideals when she was asked by the Arts Council to work on a special commission for the Festival of Britain (p. 151 and 153). She told Philip James that to work *for* a site was, for a sculptor, 'almost the very reason for "his being" ... I should be especially delighted [to work for this site] as too many years have passed working in a vacuum, endlessly working for hyperthetical [sic] sites'.[8] 'We have all worked for 25 years breaking new ground and fighting battles for both architecture and the arts – and to associate ourselves together on a Festival job is the first natural flowering of our generation. The natural reward for 25 years fight!'.[9]

The sculpture Hepworth made was 'Contrapuntal Forms'. After the Festival Philip James attempted to convince her that Harlow New Town was a worthy home for the piece: 'I do think that it is a magnificent thing for the new towns to start off with a sculpture of that importance. If these towns are in years to come to reflect all that is best in contemporary British art, the presence of good sculpture cannot I think be overestimated.'[10] Although Hepworth would have preferred a site in London, she accepted James' argument, and in the end viewed the decision as a justification of the 'enlightened policy of the Arts Council towards sculpture in this country during these last 2 years' (p. 154).[11]

Hepworth's relationship with Dag Hammarskjöld, the Secretary General of the United Nations, must be seen in the light of her interest in a responsible society. She felt the UN represented a crucial development of the post-war years. In 1959 she told Hammarskjöld that 'meeting you has impelled within me a tremendous reassessment of values and this re-evaluation contains within itself the innate strength to correct and confirm my ideas ... What

61 'Reclining Form (Trewyn)' 1959

you are doing and saying and creating is the one "reality" in a conflicting nightmare of un-reality and disbelief. In England the artists are deeply implicated because we are such a small and concentrated unit, and the impulse to create depends on the ability to resolve and establish what UN stands for as being an essential part of the true discipline of the creative imagination'.[12]

Hepworth met Hammarskjöld through a contact of J.R. Brumwell. She struck up a deep mutual understanding with Hammarskjöld and was particularly devastated when she learnt of his death in a plane over the Congo in August 1961. At Hepworth's New York show in 1956 Hammarskjöld chose 'Single Form' as 'representing the integrity both of the artist and of this operation', and kept this piece in his office. He saw in her new work 'an increasing sense of the drama of the present fight between sub-human chaos and human creative order'.[13] A poem entitled 'Single Form' was found in Hammarskjöld's papers (later published as *Markings*) after his death. It is closely related to the sculpture of Hepworth's he liked so much. Hepworth expressed her reciprocal admiration for Hammarskjöld in the memorial she made to him outside the UN Secretariat Building in New York: 'Single Form' (p. 155). At its unveiling at the UN in July 1964, the Director of the Museum of Modern Art thanked the artist for giving New York its first large scale modern public monument, and quoted an earlier speech Hammarskjöld himself had made, in which he referred to modern art as the 'art which reflects the inner problems of our generation and is created in the hope of meeting some of its basic needs'. On the first anniversary of this inauguration, Hepworth affirmed 'that the UN [is] never out of our thoughts ... [we] depend on the pure courage of the UN – we

79 'Maquette, Theme and Variations' 1970

are doing all we can to help and to keep our own courage ... if the arts in all new forms can be recognized as valid – then all other forms of new thinking (through UN) will be understood and become acceptable and part of our new life in the future'.[14] Hepworth described all her work of 1949–52 as coming out of her feeling for the 'artist in society'. This feeling, which began during the war in the small community of St. Ives, provided the impetus for the public sculpture which gave her an international reputation: 'As a woman I've nothing to say – only as a sculptor and what one has to say as a sculptor at *this* point could be most easily understood by working in direct contact with society and architecture – by being given actual sculptural problems to solve.'[15]

Hepworth was still a young sculptor after the war – only 42 when it ended, with a career of little over a decade before the war intervened – but it was not long before she began to be treated as one of the establishment. In 1949 she was asked to be one of the British representatives at the 1950 Venice Biennale, and she was soon one of the natural choices for a committee to make. New commissions for large, outdoor work may be seen as part of this success (before the war she had planned only two monumental outdoor sculptures: 'Two Forms' 1935, in Roland Penrose's garden and 'Monument to the Spanish War' 1938–39). In the two decades after the war Hepworth was invited to submit designs for the many outdoor sculptures detailed in the chronology of Public Commissions below.

The extent of her outside work proves Hepworth's commitment to 'sculpture in society' and shows how wrong it would be to see Hepworth after the war as a retiring sculptor who lived privately at St. Ives. In 1948 she rented a room in London from her sister and brother-

110 'Family Group – Earth Red and Yellow' 1953

84 'Group of Three Magic Forms' 1973

in-law for 'when I dash up to town for commissions (I hope)'.[16] She was very protective of these commissions: she appears to have been an efficient and assiduous business woman, who paid close attention to detail. Her copious correspondence with those individuals or societies who could further her standing and reputation shows that she was not only concerned, but extremely active in her own promotion.

Confirmation of Hepworth's post-war standing should have been her representation at the 1950 Venice Biennale – 'At long last you are getting the recognition you deserve – Venice ought to make a difference' – wrote Herbert Read. It is ironic, however, that this moment of success allowed for the invidious comparison of Hepworth's work with that of Henry Moore and marked the development of this comparison in the very years in which Hepworth had seemingly sprung to fame. Henry Moore had been chosen for the Biennale immediately preceding Hepworth's, and in the succeeding years came to represent the acceptable face of modernism within the establishment.

Henry Moore's success at the 1948 Venice Biennale was seen by the British Council at the time as their first direct hit on the European art world, and after his show in Paris in 1951 they felt that they had at last made their mark on its capital. 'Moore's name is a by-word of artistic fame in the International School of Paris'.[17] Even in later years the British Council continued to identify the shift in the fortunes of contemporary British art quite precisely as in 1948, 'when Henry Moore received the International Sculpture Prize in the Venice Biennale'.[18]

Barbara Hepworth was only selected by the British Council to show at the following Biennale after it was clear that Graham Sutherland was not available to represent contemporary art alongside Constable. She shared the honours with Matthew Smith. In addition to Lilian Somerville, Secretary to the Selection Committee and long-standing friend to Hepworth, the committee included her friends Herbert Read and Philip Hendy.[19]

Barbara Hepworth exhibition at the Whitechapel Gallery, London 1954

Barbara Hepworth in her new studio, the Palais de Danse, St. Ives 1961

Hepworth was unhappy about the selection made by the committee for the Pavilion.[20] She had a strong conception of the show as a whole which she felt the committee had disregarded. She sent lists to both Somerville and Read, and was asked to accept reductions on several occasions. She chose forty-eight sculptures, wanting 'a kick out of the variety of form and colour'; the committee cut it down to twenty. Hepworth was terribly upset, afraid of a 'pernickty exhibition ... preciously presented'. She told Lilian in January 1950, 'I like variety of scale and imagination and material and I like strong juxtapositions. Something dynamic and not "discreet" and ladylike'. In March she wrote again that 'It just lacks the fire, the imaginative juxtapositions which in my view make life worth living!' She wanted 'more texture, sharper, colourful drawings, more violence and formality, the element of disturbance'.[21] 'The committee have taken the spice out of the exhibition and the result will be damned ladylike'. She felt, according to Ben Nicholson's letter to Read[22] that the committee had lost the 'contrast and emphasis' which she liked.

For three months after her visit to Venice, Hepworth repeatedly asked the Council for press cuttings and reports of the show, but received no answer.[23] In August she was told that they had asked their Representative (Georgette Lubbock) in Rome for a report. In February 1951 the Council sent her translations from the Italian Press. The 1950 Biennale had received only half the visitors of the 1948 one, partly because the latter was the first after the war, and also because of the political situation in 1950. The British Pavilion itself got only half the press notices, of which 80% were devoted to Constable.

The chronology of the Venice Biennale confirmed international opinion; Hepworth would always now be seen as the pupil of Moore. Most of the press defined her as a descendant, disciple or pupil, a *sottoprodotto* or her shapes as 'Moore-like'. The report of the functional officer confirms this view; 'In contrast (to Moore), Barbara Hepworth's work was found to be cold and imitative. She was certainly at a great disadvantage ... inevitable she should be labelled as a "pupil"'.[24] The officer felt that 'Hepworth would have had fairer treatment had

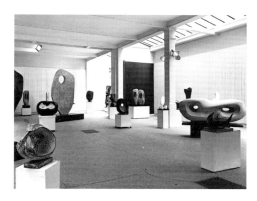

Barbara Hepworth exhibition at the
Whitechapel Gallery, London May 1962

Guggenheim International Exhibition, New York 1967, showing
Barbara Hepworth, 'Three Forms'

she not followed so closely upon his heels', and argued that the Council 'ought now to show a group of sculptors, as no single artist can rival Moore'.[25]

If the timing of her representation after Moore's undermined Hepworth's international reputation, it probably did her more harm by the fact that the organisers, the British Council, were now bound to compare her to him in weighing them up for future projects. Both the official report and Lilian Somerville made overt comparisons between their two personalities: 'Henry Moore was a great success by reason of his personality'; 'Miss Hepworth was practically a total loss ... her reserved temperament prevented her from making useful contacts'.[26] Where Hepworth was criticised for 'her inability to speak either French or Italian', Moore 'was a great success by reason of his personality without being able to speak either language'. 'Moore was extremely energetic in Venice, and his presence was deemed by the Council to be one of the most important factors in the resounding success of the British Pavilion – the most important artistic event undertaken by the British Council'.[27]

The next major presentation of Hepworth by the British Council was at the 1959 São Paulo Bienal, where she was the first British artist to take the Grand Prix. Echoing his earlier words, Read wrote, 'you need have no more worries – we are so happy that this success has come at long last'.[28] On receiving the Council's congratulations, Hepworth maintained that 'the artists of this country owe a great debt to the British Council for the "creative" understanding shown at all times by the Administration'.[29] These words do not however reflect the true nature of Hepworth's feelings about the Council. As becomes clear from a wartime letter of Nicholson's, the feeling of injustice done to Hepworth by the British Council was longstanding. In 1943 he complained on Hepworth's behalf 'it is no exception to omit Barbara's work – it has never yet been included in a British Council exhibition! The big show that went to New York World Fair included the *4 great English sculptors only* – Dobson, Moore, Epstein and Gill! ... there are no snob reasons for including her and they evade it. Moore could always have helped but he has never done so. I suppose he prefers showing with Dobson'.[30]

Barbara Hepworth, 'Square Forms
(Two Sequences)' 1963 Sonsbeek
International Sculpture Exhibition,
Arnhem

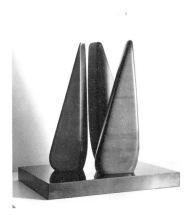

69 'Three Personages' 1965

As early as 1949 the Council reported that their most frequent requests from abroad were
for works by Moore, Sutherland, Nicholson and Smith.[31] The Chairman of the Fine Arts
Advisory Committee reported after the 1950 Biennale that there had been practically no
interest in Hepworth.[32] In the minutes of a 1955 Executive Committee Meeting the parallel
successes of Moore, Sutherland and Nicholson at successive Biennales are highlighted.
Hepworth is not mentioned. Moore is described as a 'super ambassador'.[33] Though Hepworth
took the prize at São Paulo, she was shown late there in relation to her peers: six years after
Moore, and after both Sutherland and Nicholson.

Analysis of the British Council's minutes in this period shows that from 1956 Hepworth
was neither promoted as a solo artist, nor as one of the group of younger British sculptors.
Yet international survey shows[34] were becoming increasingly important in this period – very
largely due to the activities of the Council – and as they became more significant for an artist's
reputation, it was correspondingly important to be in favour with the Council, who frequently
were directly responsible for the British selection. The Council chose, for instance, the British
contribution for the *Salon de mai* and the *Salon des réalités nouvelles* in Paris, and the
Sonsbeek International Open-Air Exhibition of Sculpture in Arnhem (above). Moreover, the
selection committees were not only remarkably consistent (standard members at this period
were Hendy, Penrose, Read, Richards and Rothenstein), but also frequently responsible for
choosing a whole batch of shows at once.

In the early 1960s Hepworth received invitations to exhibit in Germany and Holland and
felt the Council was prevaricating over realising these opportunities. Between 1964 and 1966
they toured a retrospective of her work to Copenhagen, Stockholm, Helsinki, Oslo, Otterlo,

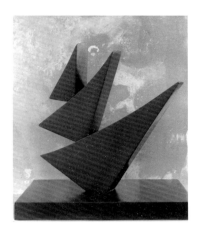

80 'Bird Flight' 1971

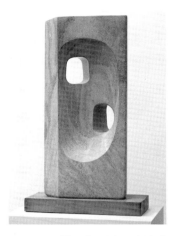

83 'Rock Face' 1973

Basel, Turin, Karlsruhe and Essen, but this was to be their last major effort in her lifetime. In 1969 she was invited to show at the Hakone Open Air Museum, but wrote, rather despairingly to Somerville: 'it is many years now since the BC did anything to help me with these overseas demands'. This was partly due to, she felt, to the Council's concentration on Moore: 'I felt somewhat left out in the cold when I found out that you were totally occupied with Henry and Ben etc'.[35] *Die Zeit* recognised her point: 'The British Council, which understands better than any private dealer or any comparable national organisation how best to launch the work of British sculptors on the international scene has, in the case of Barbara Hepworth, so far held back.'[36]

In the face of the British Council's indifference, and the threat of competition represented by Henry Moore, Hepworth felt she had to promote herself. In 1957 she told her dealers Gimpel Fils that she wanted to 'blossom out and expand *extend all my activities*'.[37] After the war she had felt the need to sign her first gallery contract – Ben Nicholson's re-marriage had materially altered the position of herself and her children – and negotiated her post-war career with Gimpel Fils. Her volatile but intimate correspondence with members of the Gimpel family sets on record her personal ambition. In 1960 she talked of wanting to '"open-up" in every way and make a dozen more works a year as a better investment all round'.[38] 'I have been thinking about the future' she wrote in 1962; '... as for the next decade, I want the freedom and exhileration [sic] for my future work which allows of a real flow of the imagination'.[39] Like all sculptors, Hepworth had to learn how to juggle the expense and production of large-scale works with the need to keep them visible in the public arena. In 1964 she told Kay Gimpel that she had to plan ahead, and to keep her reputation and recent success alive

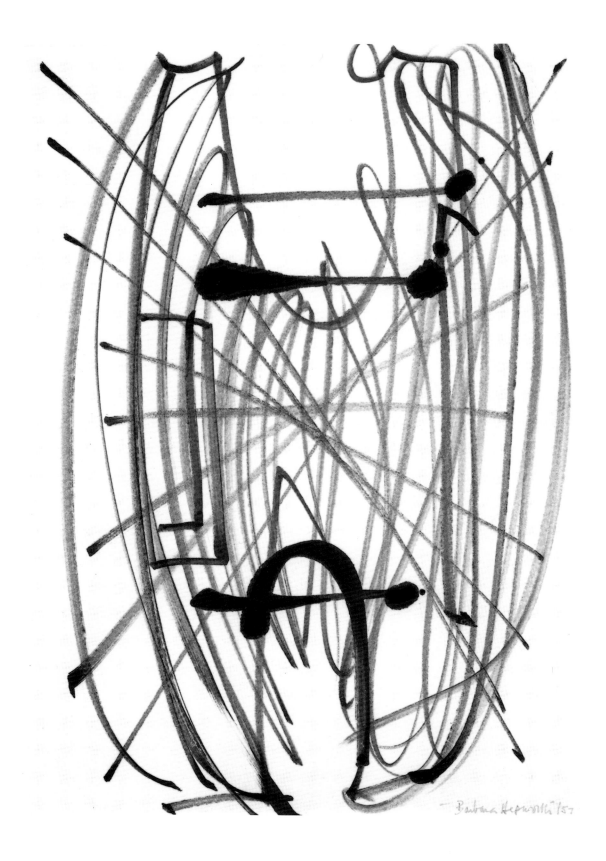

112 'Project for Sculpture (Winged Figure)' 1957

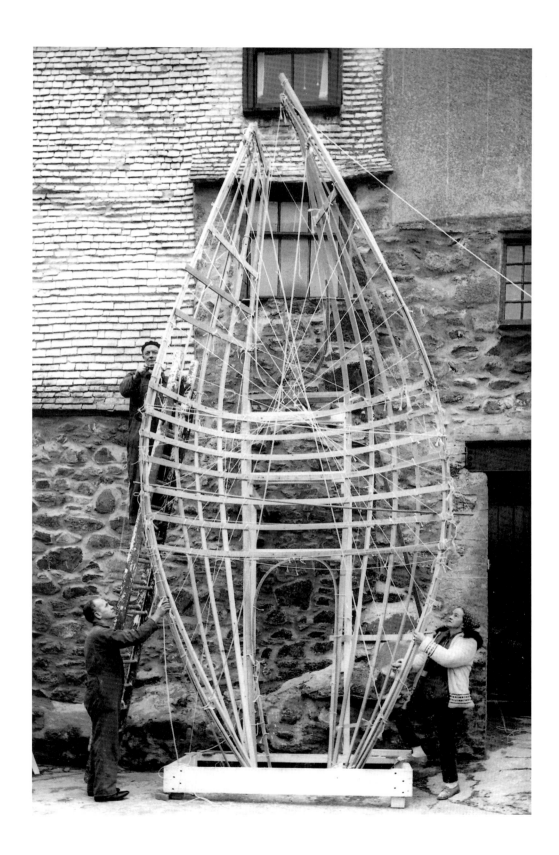

Barbara Hepworth working on the armature for 'Winged Figure' 1962

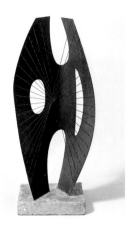

55 'Maquette for Winged Figure' 1957

111 'Group (Dance) May 1957'

she must reserve enough work for important continental shows the following year.[40] At this point she regarded the showing of large works in the States as her main option until she had a Tate exhibition.[41]

The re-negotiation of Hepworth's contract with Gimpels, driven through by her solicitor, was difficult. In 1957 she had already asked for more latitude in selling large works from her studio. She regarded them as having made her reputation. Gimpels were willing to affirm this as a new phase in her work, and in their letters of 1960 described her as having now achieved 'definitive international standing'. They asked her to allow them to send clients to Cornwall, hoping that they could 'feel confident about this interflow working to the mutual benefit', and remarking that it was Moore's 'personal charm' that had made his clients' visits to Perry Green memorable and rewarding.[42] Hepworth later set up a store in London which she hoped would add to her St. Ives garden as a selling space to visitors. But Gimpels were unable to accept Hepworth's demand that she could sell directly to collectors, and reprimanded her for her 'inclination [not only] to sculpt but to deal with the whole machinery of selling etc.'[43] In her defence, Hepworth maintained that she was 'no different to either Henry or Ben'. Hepworth described her work from 1960 onwards as 'free from the restrictions in size, emergence of subconscious imagery, general fusion of ideas and themes'. She had increasingly come to work on a large scale, and saw large sculpture as the key to future success. She gave this a retrospective logic in a letter to Ben Nicholson:

> You never liked arrogant sculptures nor fierce forms – but I do. I have deliberately studied the photos of my early dreams of large works done in 1938–39 in maquette form ... It has taken 25 yrs to find the space time and money; and meanwhile those dreams have matured and so have my abilities. This is not retrograde – it is for me, a

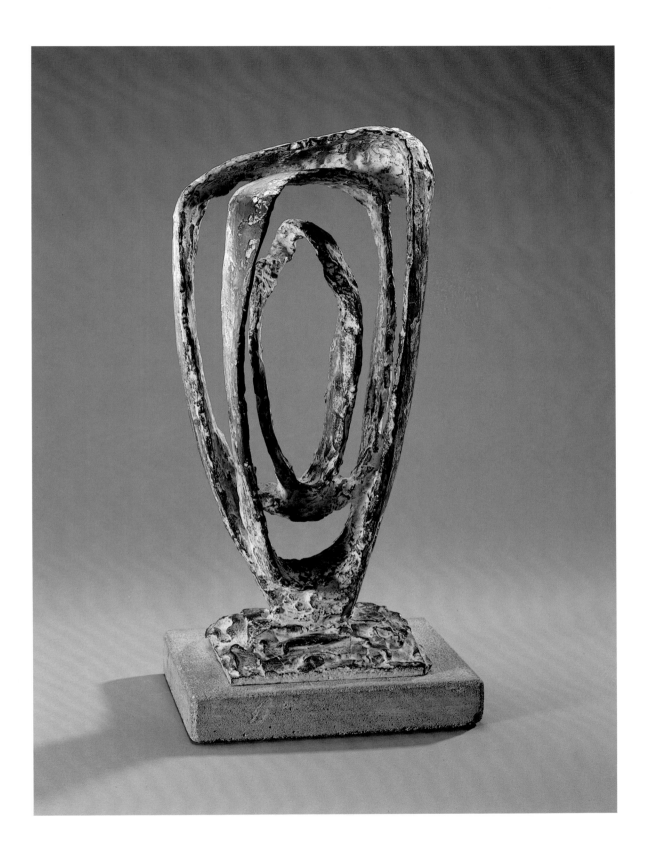

57 'Maquette (Variation on a Theme)' 1958

54 'Stringed Figure (Curlew) (Version II)' 1956

fulfilment of my life long ideas, and in my new book you will see, eventually, the early projects and the fulfilment so many years later.[44]

As well as being ready to be involved in the promotion of her post-war work, Hepworth was also concerned about its context, particularly with the emergence of the younger generation, or 'Geometry of Fear', group of sculptors. She was very upset not to be included in the selection for the British Pavilion at the 1952 Venice Biennale, which showed the younger sculptors inside and Henry Moore outside on the terrace. Hepworth asked Lilian Somerville whether she had been able to 'insert the postscript in the Biennale catalogue about why I was not included ... ? I am terribly interested in the matter as I feel most strongly about the two main-streams in contemporary sculpture carving on the one hand and a more fluid approach (in metal) which is perhaps nearer to the realism of painting than carving (on the other) ie Masson's metal 'Preying Mantis' 1942? Both streams are facets of the sculptural idea – both essential and expanding and complementary. The interplay between painting and sculpture during the time since Cubism has been most interesting'.[45]

Hepworth recognised that the 'Geometry of Fear' sculpture tapped a sensibility associated with working with metal. With time it became clear that metal sculpture was coming to domi-nate British sculpture, and Hepworth became less and less happy with it. In response to her criticisms, Read reassured her (with reference to Venice), 'I don't feel it has lasting qualities', but 'appeals to modern sensibility'.[46] Hepworth must have complained to Read about the same group's dominance at the Unknown Political Prisoner competition, for Read replied 'I agree (this is going back to Venice &c) one should not pay too much attention to the present fashion for metalwork: most of it is just bad tinkering. But Reg Butler has some quality, and Armitage is good (but he is a modeller)'.[47]

Read had already tried to put forward the Committee's reasons for putting Moore and not herself outside the Pavilion: 'if you had had a large metal sculpture to balance Henry's that would be the ideal solution'.[48] Thus an almost overt suggestion had been made to Hepworth that if she had used bronze she could have been alongside both Moore and the next genera-tion in Venice.

It was not until 1956 that Hepworth began to use bronze, and copper sheet, and then only until the mid-60s. Bronze dominated for only a few years of her career, and does not occupy a large proportion of her œuvre. It is however, very closely associated with her large-scale public commissions. Comments indicate that she was never entirely happy with it. In 1959 she told Peter Gimpel that the bronze question had created a crisis for her: 'With direct carving, the forms I make are as I make them. I have only just realised what a poor cast can do to one's work!'[49] In 1960 she told Kay Gimpel that she could not bear the 'deviations in casting', questioned whether she should be doing bronzes at all, and deplored the 'lowered standards which demand has made on supply'.[50]

Ironically, Hepworth's descriptions of why she began to use bronze seem to set her against

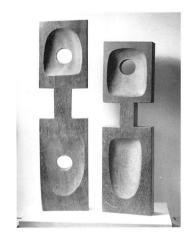

44 'The Unknown Political Prisoner' 1952

70 'Two Ancestral Figures' 1965

new developments rather than to position her work alongside that of younger sculptors. She allowed herself to use bronze by citing her seniority:

> The reason Henry Moore and I do good bronzes is because we are good carvers. But I can say that all our original carvings, have, in 45 years been biffed, banged, bruised, broken and boiled so that they are cracked ... No wonder the young take to polystyrene. I only learned to love bronze when I found that it was gentle and I could file it and carve it and chisel it. Each one is a "person" to me – as much as a marble.[51]

It seems plausible to suggest that Hepworth in fact began to use bronze so as to compete with Moore on more equal terms. She wanted her share of the new market that came with the post-war world: large works on outdoor sites. Certainly she recognised that her earlier patrons – those who bought English modernism on a domestic scale – could only now be expected to buy paintings, and that sculptors must look elsewhere.[52] The Outdoor Sculpture shows of 1948–1966 were a manifestation of this new market, which was now institutional rather than domestic, and they excited Hepworth a good deal (p. 152).[53]

If bronze helped to accord Hepworth the same working conditions as Moore, it also allowed her work to assert its difference from his, and to take its place alongside first the 'Geometry of Fear' group and then with the following 'New Generation'. In 1966 Gene Baro could write that the 'New Generation' sculptors had 'much more in common with her attitudes and approach – intellectual, understated, given to a wholly formal expression of feeling – than to those of some of her famous contemporaries'.[54] Hepworth could certainly still be interested in the work of the younger generation, writing in 1969 to Nicholson 'I like sharp provocation just as I like the new sculpture, King, Caro, Wall, Turnbull. The young

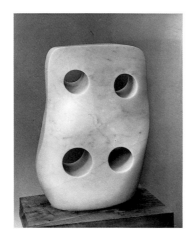

73 'Marble Rectangle with Four Circles' 1966

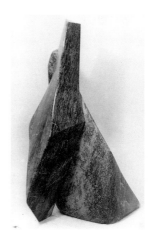

82 'Two Rocks' 1971

generation'.[55] She wanted a context for her own most recent work, and to keep up to date with the international exhibition schedule.

Hepworth was keen to be part of all contemporary survey exhibitions and studied opportunities for exhibiting. She prepared three and five year plans for Gimpels, noting that 'there are some 15–20 shows of historical importance in the next two or three years', and that she wanted to participate in them.[56] 'I want to follow through the USA success. My representation in historical shows is a must and I must direct this'.[57]

Hepworth strongly lamented any opportunities that were lost. One of her biggest quarrels with Gimpels was that they allowed her to show small-scale work in the 1959 *Documenta II: Art since 1945*. Hepworth was deeply distressed that '3 very small works of mine were allowed to go' on show, as 'I consider these international exhibitions of quite vital importance. Next year is again full of important sculpture shows. I am planning for it most carefully … At the age of 56 I just cannot afford to be represented by works ten inches high at International Shows'.[58] She told Peter Gimpel that on seeing the catalogue she had been 'shattered by the size and importance of this volume and the shocking sight of my poor contribution'. She wished Gimpels had warned her about the significance of the book; 'through sheer lack of scale my contribution is entirely inadequate and absolutely damming'.[59] However, Hepworth was excluded altogether from the next Kassel *Documenta* in 1964, of which she took a 'very serious view … I cannot possibly afford set backs of this kind … Most of the critics and dealers were there and I believe Henry Moore and Ben Nicholson who had a fine showing … Of my age group and reputation, I was pretty well the only one left out'. The gallery told Hepworth that no-one could have predicted how much more important this *Documenta* would turn out to be in comparison with the first one in 1955, at which Hepworth had been 'extremely well shown'.[60] (Read told her she was 'well out' of it, as the

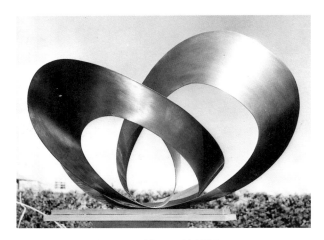

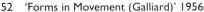

52 'Forms in Movement (Galliard)' 1956

Barbara Hepworth, 'Meridian' 1958–9. Detail
in situ at State House, Holborn, London

sculpture resembled a 'scrap-yard'.[61]) Looking to the future, she declared 'The next Kassel is three years hence and I wish to plan and organize now'.[62] Hepworth felt particular regret at not showing in Kassel because she had had good feedback from the German press, and more reviews about her UN project from there than anywhere else. This sense of pique may have pushed her towards changing her dealer. Herbert Read suggested that Harry Fischer of Marlborough would represent her in Germany as well as the States, but, not wanting to offend Gimpels, would rather she made the first approach, as 'obviously you can't continue the present unsatisfactory position'.[63] From 1965 Marlborough Fine Art listed Hepworth as their artist. In January 1965[64] Harry Fischer told Hepworth that though the agreement with her solicitor was taking time, he had already started 'working for you as arranged, breaking the ice on the Continent and in America also ...'.[65] Within the month the contract was signed: Fischer could write 'I am very proud of this day which for me in my art dealing career is a historic one'.[66] In 1972[67] Hepworth told Peter Gimpel that she had made exclusive agency arrangements with Marlborough and would have to ask Gimpels to release all her unsold work.

Hepworth explained her desire to exploit all possible opportunities by the fact that 'I belong to the generation that had rather a tough time making a way in sculpture when I was 30 to 40 years old, and now all the chances for good showing seem to come along at once...'. This explanation encapsulates the contradictions in her attitude to her work: by turns she wanted to be contemporary, to show new work, to be part of the *Documenta* exhibitions, but also to be historic. As the generation of the 1930s increasingly came to be labelled as 'classic' Hepworth felt she was missing out. For all her efforts to be shown alongside newer generations of sculptors, she did not want to be merely contemporary. In a letter to Charles Gimpel she affirmed, 'You will appreciate that I have been carving for nearly 35 years and that

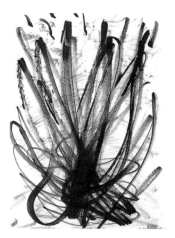

113 'Summer (Project for
Sculpture) April 1957'

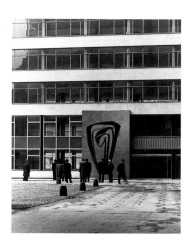

Barbara Hepworth, 'Meridian'
1958–9 Bronze

Herbert Read and Ben and Henry Moore were contemporaries and my friends. We all fought for certain values in what was at that time in England, a very alien world.'[68]

Hepworth explained her dissatisfaction with Gimpel Fils in terms of this contradiction:

> Your pressure on me separated me from my age group – the 1930s and 1940s when I worked side by side with Ben Nicholson, Henry Moore, Mondrian and Gabo ... Please do not split my personality.[69]

> I am a practical person. I approach 62. I need a five year plan of great forethought to fulfil my mature work. And anything which we decide to do must recognise the fact that (although younger) I belong absolutely to the era of Ben and Henry and Arp. I do not belong to the younger generation at all.[70]

Yet although Hepworth wanted to be seen alongside Moore, she did not want to 'belong' to him either. As early as 1943 she criticized Philip Hendy for suggesting in his writing that she was influenced by Moore at different times. As she explained to E.H. Ramsden:

> This was rather a loose statement I thought. Actually there will always be a bond between Moore and myself because we are carvers. But you are the only one who knows how essentially different Moore and I are – when he finally matured on the surrealist side and I on the constructive side in 1934. Hendy didn't even mention 'constructive'.[71]

In a 1966 letter Hepworth objects to the 'twinning act' between her and Moore:

> I must confess I get very angry to find after 45 years this utterly boring comparison between Henry and me. For at least 35 years our paths have been totally different[72]

146

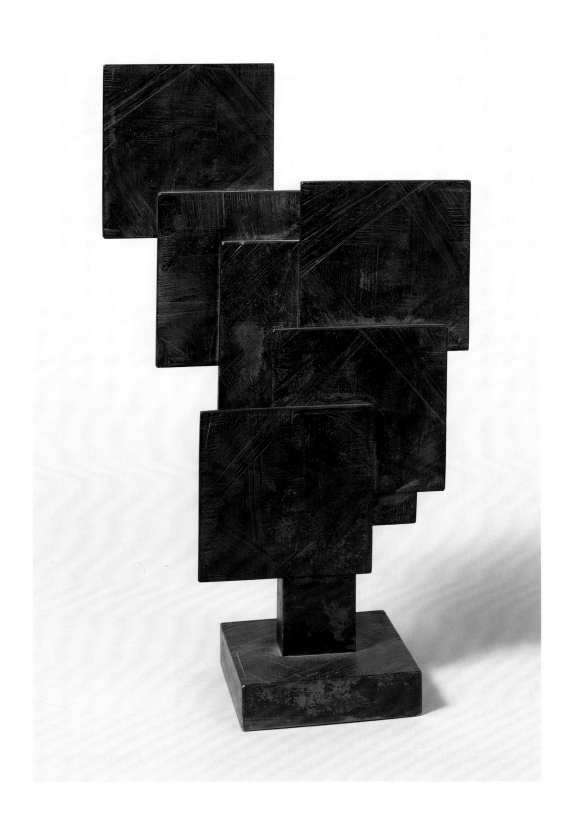

66 'Square Forms' 1962

A large part of Hepworth's grievance with Gimpels arose from her sense of the injustice done to her in comparison to Moore. 'It seemed to me that there is one set of rules for Henry and another set for me?'[73] In 1964 she told them that she had been watching Moore's prices go up with Marlborough and, 'having a somewhat native Yorkshire shrewdness I recognise success and efficiency. I wish to expand as Henry Moore has been free to expand'.[74] Gimpels tried to deflect some of her thinking; telling her that Moore's price rise had come through auction sales.[75]

Caring for one's reputation meant not only finding the right dealer, the right clients, being in the right shows, and making bequests to major museums, but also setting the record straight. Hepworth wrote to Nicholson about the scrapbook which she published as her *Pictorial Autobiography*:

> Its main use was to put beyond dispute certain dates. My dates have been much altered by writers on Henry Moore. And of course, apart from being a woman, it has not been easy always having great bears breathing down one's neck![76]

Barbara Hepworth is in one way representative of the post-war situation in British sculpture. She was excited by the mood of reconstruction, by government help and interest in the arts, and by the sense of sculpture's increasing relevance to society. She had been part of that pre-war world where sculpture occupied a much more precarious terrain. Yet the certainties which gave her and other sculptors opportunities in the 1950s were soon themselves to be eroded, and by the mid-1960s she was disillusioned: 'I think most of the British sculptors must be pretty well browned off with the attitude towards sculpture which has made so little progress during the last 2 or 3 decades'.[77]

The story of the London County Council's Outdoor Sculpture exhibitions reveals this change rather neatly (p. 152). When they were first suggested, in 1946, the Assistant Director of the Tate Gallery could not imagine that there was enough sculpture, never mind good sculpture, to make tri-annual shows feasible. The first show was, however, a tremendous success, and attracted nearly 150,000 paying visitors. Outdoor sculpture soon became an accepted part of the art world. However, through the next decade, the jury system which had worked so efficiently at first for selecting the shows, steadily broke down. By 1963 it was impossible to reach a consensus about what sculpture was. Whereas the nominated representatives of the official bodies (Royal Society of British Sculptors, Royal Academy, Institute of Contemporary Arts and the Arts Council) had at first been able to work together, by 1960 it was judged impossible to achieve agreement or even compromise.

Outdoor sculpture, on a monumental scale, had been uncomplicated. Hepworth's post-war career was based on this premise, and she had taken advantage of it. Her work had to take account of the rising star of Henry Moore, and of his disciples, but could not deal with the fact that, from the 1960s, sculpture itself was open to question. The premises for the kind of

62　'Corymb' 1959

sculpture that Hepworth made were no longer assured. Whereas Moore's work has managed to do without those premises, and has continued to be shown in isolation, Hepworth's work now asks us to think again.

SOURCES AND ACKNOWLEDGEMENTS

The nature of this essay reflects the fact that Hepworth's own archives are not yet open to the public. I have therefore sought out sources in the public domain. I am most grateful to the following institutions and their staff:

Herbert Read Archive, University of Victoria: Chris Petter, Head of Special Collections and David Thistlewood, University of Liverpool.
Tate Gallery Archive: Jennifer Booth, Adrian Glew.
Tate Gallery Records: Jane Ruddle.
Arts Council of Great Britain, Royal Festival Hall: Pam Griffin.
Hammarskjöld Papers, Royal Library, Stockholm, courtesy of Peder Hammarskjöld, thanks also to Brian Urquhart at the Ford Foundation.
United Nations Archive: Marilla B. Guptil.
British Council, Portland Place: Veronica Burt.
British Council, Spring Gardens: Victorine F. Martineau, Head of Archives.
Public Record Office, Kew.
Gimpel Fils: Kay Gimpel, Charles Gimpel, Réné Gimpel, Simon Lee.
Marlborough Fine Art: Geoffrey Parton, Joanna Northey.
Greater London Record Office.

The author would also like to thank Norman Pollard and Brian Smith of St. Ives for all their help.

Information for the Chronology was brought together from a variety of sources, and with the help of the following:

For LCC records: Greater London Record Office; B. Howlett, Mrs Gillian Phillips, Amy Thomas, Miss J. Coburn, Isobel Humphreys.
For Festival of Britain records: Library & Archive, Royal Festival Hall; Pam Griffin; PRO, Kew, WORK series 25.
Harlow: Harlow Art Trust; Lady Gibberd and Gordon Dawson; Harlow Study & Visitors Centre; Jackie Storey and David Devine.
St Albans: Hertfordshire County Council; Principal Surveyor, R.D. Pettitt; Marlborough School; Headteacher, A. Bartlett.
Hatfield: University of Hertfordshire; P.G. Jeffreys, Secretary & Registrar; Hertfordshire Education Services: Peter Dawson, Adviser for Art & Design; Hertfordshire Arts; Margo Ladell, Arts Development Officer.
Philips Components: Jennie Hubbard, Marketing Communications.
United Nations: Chief Archives Unit: Marilla B. Guptil; The Ford Foundation; Brian Urquhart; Hammarskjöld Archive, Swedish Royal Library; Stockholm, by kind permission of Peder Hammarskjöld.
John Lewis Partnership: Lorna Poole, Partnership Archivist.
Chetwynd House: Post Office Counters Ltd; Alan Heardman, Building Services Manager.
Cheltenham & Gloucester Building Society; Gill Colver, Head of Public Relations.

Abbreviations used are as follows:

TGA — Tate Gallery Archive. Nicholson Archive (8717) and
 Eates Ramsden Archive (9310)
Victoria – Special Collections, University of Victoria, Canada
Hammarskjöld – Hammarskjöld Archive, Swedish Royal Library,
Stockholm
UN — United Nations Archive
BC — British Council Archive (Spring Gardens)
PRO — Public Record Office, Kew
GF — Gimpel Fils Gallery Archive
MFA — Marlborough Fine Art Gallery Archive
ACGB — Arts Council of Great Britain (Royal Festival Hall
 Archive)

1 In 1932 she had told Ben, 'I should *hate* to *live* in the
 country. I do so love cities', TGA 27/12/32.
2 Victoria 8/4/42.
3 Hammerskjöld 5/12/59.
4 TGA n.d. c. winter 1939/40.
5 TGA 11/5/45.
6 To Margot Eates, TGA 21 November ?1945.
7 Victoria 14/5/44.
8 ACGB 1951: Sculpture Commissions: Hepworth 13/6/49.
9 Ibid. 15/12/49.
10 ACGB Festival Disposals 4/10/51.
11 Ibid. 5/10/51.
12 Hammarskjöld 16/10/59, permission of Peder
 Hammarskjöld.
13 Ibid. 15/10/60.
14 UN - DAG – 1/2/3, Box 321, File 2475 28/6/65. Both
 Hepworth and Hammarskjöld's vocabulary has strong
 links with Christian Science terminology.
15 TGA 4/4/43.
16 To Ben Nicholson, TGA 12/4/48.
17 BC; Minutes of FAAC 1950-51 Feb 1951.
18 Ibid. FAAC 1964-7 15/12/64.
19 The committee also included Sir Eric MacClagan and John
 Rothenstein. Somerville was in office at the Council from
 1948 to 1970. As Somerville explained, Constable had to be
 fixed before the two or three contemporary artists could be
 chosen. The General Secretary of the Biennale had wanted
 Sutherland, who was considered alongside Matthew Smith
 and Paul Nash, but by December Sutherland was no
 longer an option, and Hepworth was chosen with Smith.
 PRO BW40/31.
20 PRO BW2/420 12/1/50 to 17/3/50.
21 Ibid. 17/3/50.
22 TGA 20/3/50.
23 PRO 25/7/50 et seq.
24 PRO BW40/31 20/9/50.
25 Report by Mrs G. Lubbock, PRO BW40/46 10/9/50.
26 PRO BW 40/31, Correspondence between Official Rep.
 and Somerville, 20/9/50 and 2/10/50.
27 BC FAAC 1948, 37th Meeting.
28 TGA 7/11/59.
29 BC 23/9/59 GB/652/25.
30 TGA 2/2/43 to E.H. Ramsden.
31 BC 45th Meeting of FAAC 29/6/49.
32 BC 48th Meeting 11/7/50.
33 BC Exec. Cttee. GB/640/2 22/11/55.
34 International, in the Council's own definition (16/2/49)
 meant 'Western Union'.
35 BC GTB/641/223 5/5/69.
36 10/6/66.
37 GF 2/8/57.
38 Ibid. 20/3/60.
39 Ibid. 19/6/62.
40 Ibid. 4/8/64.

41 Ibid. 11/8/64. From 1965 Hepworth was a Trustee of the
 Tate, and during this period made a bequest of five
 sculptures to the gallery (1967) and had her major
 retrospective exhibition ratified in 1966. Hepworth is at
 once concerned with her posterity, and with her currency.
 As early as 1962 she had begun to think of a Trusteeship
 'to handle my works for some years after my death'.
42 Ibid. 16/2/60.
43 Ibid. 11/4/60.
44 TGA 21/1/69.
45 BC GB/652/25 6/4/52.
46 TGA 9/7/52.
47 Ibid. 28/4/52.
48 Ibid. 6/12/51.
49 GF 27/4/59.
50 Ibid. 10/4/60.
51 TGA 2/10/66.
52 TGA 19/5/51 to Ben Nicholson.
53 She had served on the Advisory Panel for the 1951 show,
 and had been so enthused about outdoor sculpture that she
 was later to attempt to found her own sculpture park. She
 took part in the outdoor shows at Sonsbeek, Middelheim,
 Otterlo and Varese.
54 In *Studio International*, June 1966, pp. 252-257.
55 TGA 21/1/69.
56 GF 28/10/64.
57 Ibid. 11/8/64.
58 Ibid. 16/7/59.
59 Ibid. 27/7/59.
60 Ibid. 9/7/64.
61 TGA 1/11/64.
62 GF 11/8/64.
63 TGA n.d, 1964.
64 MFA 29/1/65.
65 Hepworth had not been slow to acknowledge the
 importance of America, and her first show in the States
 was at Durlacher Bros. in 1949. From 1948 she was in
 correspondence with Curt Valentin (MOMA/TGA) trying
 to arrange a showing of her sculpture through him in New
 York in 1949. George Dix was to show her drawings, but
 would not take sculpture. In 1954 (TGA 16/4/54) Read felt
 that once Hepworth had a success in the States 'all your
 worries will be ended'. Many of her letters of the time to
 Gimpel Fils are concerned with how she should be shown
 in New York, after finishing with Martha Jackson. In 1958
 (GF 4/12/58) Hepworth saw it as 'really essential that I
 should have a New York exhibition arranged for October
 1959'. It was only in the 1960s that the British Council
 began to be seriously concerned about their standing in
 America. A draft paper from December 1964 (FAAC 1964-
 7) indicates this realisation: 'It is now generally accepted
 that while Paris still has some significance, Great Britain
 cannot afford to ignore the preeminent international
 standing of American art.'
66 MFA 4/2/65.
67 GF 3/2/72.
68 Ibid. 11/6/59.
69 Ibid. 19/10/64.
70 Ibid. 11/8/64.
71 TGA. 1943.
72 BC GB 641/167c 25/1/66, to Margaret McLeod.
73 GF 9/7/64.
74 Ibid. 11/8/64.
75 Ibid. 14/8/64.
76 Ibid. 31/5/70.
77 GB/641/167c 25/1/66.

Barbara Hepworth at work on 'Contrapuntal Forms' in St. Ives c. 1950

A CHRONOLOGY OF PUBLIC COMMISSIONS

Outdoor sculpture exhibitions

The five shows of sculpture in London parks organized by the London County Council between 1948 and 1960 give a good picture of the state of British sculpture in the post-war period. Mrs Patricia Strauss of the Council's Parks Committee first suggested the idea in 1946, and it was extremely cautiously received. However the idea was put into practice, and the first show was held in 1948. The selection of the artists was divided into three tiers: those whose offers were accepted – Moore, Dobson, Wheeler and Ehrlich; those who were invited to send a work – Epstein, Charoux, Reid Dick, Ledward, Hardiman, MacMillan, Lambert, Underwood, Hepworth and Nimptsch; those who were to allow the committee to choose a work – Skeaping, Gordine, Henghes, Hermes, Jonzen, MacWilliam, Bedford, Pollen, Soukop, Machin. The system devised to represent the diversity of interests admitted a more-or-less simplistic divide between two styles of work, a divide which widened in the period of these exhibitions. Four bodies were each asked to nominate two representatives to be on the selection panel. The Royal Academy and the Royal Society of British Sculptors found themselves to be natural allies against the ICA and the Arts Council of Great Britain. From the mid-1950s the RSBS, in the person of its president Ledward, often had occasion to complain about the bias of the Arts Council as well as the British Council.

L.C.C. Outdoor Sculpture Exhibition Battersea Park 1948

Between 1948 and 1960 Hepworth was in all five exhibitions, as were Moore, Epstein and Charoux. In all but one were Butler, Ledward, McWilliam, Nimptsch, Skeaping and Wheeler. Complaints received over the 1963 exhibition were shelved because this was the last before the Greater London Council took over the LCC's open spaces in 1965. The GLC reviewed the achievements of these LCC exhibitions but noted that 'recently it has become more difficult, if not impossible, to secure sufficient agreement or compromise among the expert members ... the "contemporaries" were forthright and dogmatic, the "traditionalists" were ineffectual' (CL/PK/1/52). Even when they attempted to resolve their differences by resorting to committee vote, as they did for the 1960 show, only six sculptors achieved the desired 5 or more votes (Moore, Butler, Epstein, Chadwick, Skeaping and Wheeler).

From 1949 Hepworth was a member of the Advisory Panel – with fellow sculptors Epstein and Ledward – which chose the 1951 show. She approved very heartily of an initiative which she saw as 'quite unique and of such very great importance to the appreciation of sculpture generally' (23/12/48, CL/PK/1/55). She wrote to Ben that 'It was all beautifully done perfectly placed – couldn't have been better but for the choice'. However, 'In the catalogue I am ranked with the Hermes, Gordine, Heughies crowd G-G-G'(1948 TGA). The first exhibition inspired Arnhem to emulate the London initiative in their Sonsbeek Park. The LCC shows were tremendously popular, although the numbers did decline: there were over 148,901 paying admissions in 1948; 110,227 in 1951; 66,000 in 1954, and 72,000 in 1957.

L.C.C. Outdoor Sculpture Exhibition Holland Park 1954

In the mid-1960s Hepworth, encouraged by the examples of Louisiana and Otterlo, was trying to raise support for a sculpture park in England. She hoped to set it up on twenty five acres run by the Dartington Trustees at Totnes Castle, and in 1966 sought financial support for a whole complex of supporting buildings. Eventually a site at Kennall Vale was acquired, and a board of Trustees formed, but Hepworth lost heart, despite the subsequent interest of Cornwall County Council.

These outdoor shows informed both the sculptor and their public in terms of interpreting their work. Hepworth liked to find homes outdoors for her sculpture, whether or not they were designed for the sites. During the 1960s and 1970s many public institutions – University Colleges in particular – asked Hepworth for pieces for their quadrangles, squares and lawns. She liked to help, and often put pieces out on loan, and her work is perhaps best known from such sitings. These cannot however be termed as commissions, which are outlined above. Commissions reflect more particular desiderata, nuanced within the immediate post-war desire to link art and society.

L.C.C. Outdoor Sculpture Exhibition Battersea Park 1966

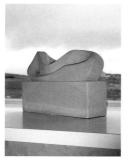

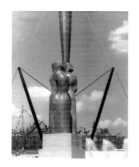

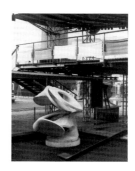

Barbara Hepworth, Maquette for Waterloo Bridge commission 1947

1947 Town Planning Committee, London County Council: Waterloo Bridge

In 1947, when the Town Planning Committee of London County Council decided not to proceed with the designs for the 'Four Winds' submitted by Charles Wheeler for the new *Waterloo Bridge* designed by Giles Gilbert Scott, they resolved instead to invite 'sculptors of high repute': Dobson, Epstein, Hepworth, Kennington, Moore and Wheeler (LCC/MIN,11,214). Though the choice of subjects and treatment was left open, none of the four schemes submitted (Epstein and Moore did not submit) was considered suitable by the assessors (Scott, Reid Dick and Hendy).

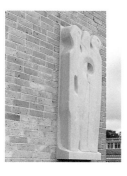

1949 Hertfordshire County Education Committee: 'Vertical Forms'

In January 1949 the Hertfordshire County Education Committee decided that from 0.25 to 0.33% of the total cost of construction of schools would be spent on a work of art. John Newsom, County Education Officer 1940–57, laid great stress on the provision of art in schools, and was a personal friend of Henry Moore. He introduced financial independence for head teachers, who were provided with a cheque book and left to decide on their own expenditure. The architects Stanley Hall, Easton & Robertson who designed the Hatfield Campus of the Technical College (what is now the University of Hertfordshire) commissioned Reg Butler and Ben Nicholson in addition to Hepworth (Howard Robertson knew both Moore and Hepworth) and Hepworth's 'Vertical Forms' is still sited on one of the building's walls. It appears from the accounts that the sculpture cost £562. It was illustrated on the cover of *The Architectural Review* of October 1952.

1949–51 Festival of Britain: 'Contrapuntal Forms', 'Turning Forms'

In June 1949 Hepworth was invited by the Secretary General of the Arts Council to consider their invitation for a commission for sculpture in connection with the *Festival of Britain 1951*. (Arts Council: Royal Festival Hall 1951 Sculpture Commissions). An accompanying letter from Philip James, the Director of Art, stressed that the siting of the sculpture on the South Bank would depend on the pieces by Henry Moore and Epstein. Hepworth replied that she was 'most interested in doing a sculpture to be inspired by the site', 'as the site "conditions" the form' (13/6/49). She cautioned against showing any kind of scale models. Within a week, however, James had sufficiently warned Hepworth against planning for a particular site that she was beginning to think instead of a 'free sculpture that would find its own home' (21/6/49). In a talk he gave in March 1950 (PRO, WORK, 25/43) Hugh Casson described the task before the Festival Committee in the same ideal terms which Hepworth attached to her sculpture: 'that close harmony of sculpture and building, of landscape and mural painting, of colour play and typography – that harmony which we all strive for in our more permanent work.' In August Hepworth was keen to make the commission public as 'It would enhance my prestige and status in the town'. By September it was clear that Moore and Epstein were going to abandon the Dome of Discovery site, and thus Hepworth was invited to look at this. By the end of the year Hepworth had settled on two figures about 8'6" in height, though she was still waiting for exact plans from Mischa Black before giving Hugh Casson accurate estimates. In the files kept in Kew this piece is described as a 'monumental group of abstract sculpture symbolising the spirit of discovery' (PRO/Work 25–29/A2/E3). The stone arrived from County Galway in March 1950, and by Spring work was well underway. The Press were interested, and though many of their stories led with Epstein, this was Hepworth's first extensive coverage.

Hepworth was represented by two pieces at the South Bank; Sir Hugh Casson recalled 'The Festival Design Group in charge of the Exhibition had its own budget for works of art ... We chose the sites and the artists in collaboration with Huw Weldon representing the Arts Council in the Festival Office'. In addition, each of the twenty seven architects commissioned for works on the South Bank was asked if possible to find room and cash for a work by an artist of their choice' (29/3/93). At first Hepworth was told that she could not be considered for further South Bank commissions in connection with the Festival because of the Arts Council piece. Hepworth protested with an interesting letter, all the stronger for the fact that she wanted to work with the architect Jane Drew: 'From a personal point of view the Jane Drew job would be a delight ... it would give me especial pleasure to work with another woman on a scheme which is peculiarly sympathetic to me' (15/12/49). In the end Hepworth secured a direct contract from the Festival Committee to work with Fry, Drew and Partners and made 'Turning Forms' for their Thamesside Restaurant, in addition to her 'Contrapuntal Forms' for the Arts Council.

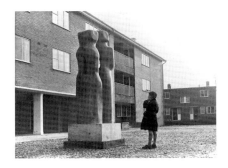

Festival Disposals (1): Harlow New Town, Essex: 'Contrapuntal Forms'

The Arts Council offered 'Contrapuntal Forms' to one of the New Town Development Corporations and Dame Evelyn Sharp, Deputy Secretary to the Ministry of Housing and Local Government, drew lots between those who were interested. Harlow was successful. *The Daily Telegraph* and *Morning Post* reported that 'Residents of the new town here are still recovering from the shock of having more than 7 tons of modern art in their midst'(28/11/51). The Corporation sited the sculpture in Glebelands while the Town Centre was being built. It was handed over to the Harlow Art Trust in 1953, and from then, and on occasion through the following twenty years, the Trust debated where to site it permanently. Some felt strongly it should be in the Town Centre; others in a park. By 1973 it was felt that Glebelands residents would be upset if it were moved, but a majority of the Trust found in favour of moving it to the town centre. However the residents apparently campaigned for it to be kept at Glebelands, where it is still sited. (Minutes of the Harlow Art Trust.)

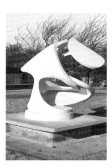

Festival Disposals (2): St Julian's (now Marlborough) School, St. Albans: 'Turning Forms'

'Turning Forms' (also called 'Dynamic Forms' and 'Pierced Revolving Abstract Form') was offered by the Festival Authorities to Hertfordshire County Council. On 18 June 1952 the County Architect told the architects of St Julian's School that they would be receiving the 'Barbara Hepworth' and that the 'charge would be deducted from the 1/3 per cent allowed for sculpture'. This opportunity arose shortly after Philip James had alerted John Newsom (9/6/52) to the possibility of its being auctioned and asked him what was being done about it. The sculpture was delivered to St. Albans (via the Tate) in late June 1952, but even at the end of 1953 its gearing and motor was still on its original South Bank site.

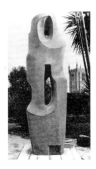

1954 London County Council, South Bank: 'Monolith (Empyrean)'

Commissioned by the LCC, originally sited on the South Bank. Now sited at Kenwood (English Heritage), in London.

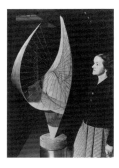

1956 Mullard Electronics: 'Orpheus: Theme on Electronics'

Philips Components commissioned this piece from Hepworth for their Electronics Centre at Mullard House, Torrington Place, London, where it still stands. It is positioned on a small column with a revolving motor, and Hepworth regularly checked up on its smooth performance.

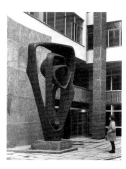

1958 State House, London: 'Meridian'

In 1958 Lilian Somerville of the British Council put Hepworth in touch with the firm of architects Treherne & Norman Preston who were working on an enormous office block on High Holborn for the Wohl Group. This was to be

State House (recently demolished), and the sculpture which Hepworth realised was to be 'Meridian'. (Now owned by the Pepsi Cola Corporation, USA.) Somerville explained that 'for once these architects do not want symbolism or a subject or a theme but an *abstract* sculpture' (BC/GB/652/25 10/10/58). In a British Council transcript of a taped interview Hepworth spoke of needing 'an immediate formal impact when first seeing the site. With this commission I felt no hesitation whatsoever. By next morning I saw the sculpture in my mind quite clearly. I made my first maquette, and from this, began the armature for the working model. The architect must create a valid space for sculpture so that it becomes organically part of our spiritual perception as well as our three dimensional life. To do less is to destroy sculpture and admit to an impoverished architecture'.

At Christmas 1958 she told Ben that 'the big job for Holborn is a fantastic experience which I would not have missed, tho' the bigger the sculpture the less money one makes, but it is going so much slower than I anticipated' (TGA). In 1960 Hepworth wrote, 'Mr Mortimer is an angel and is most generously going to build the wall higher to make 'Meridian' look perfect' (GF20/1/60). 'Meridian' was unveiled by Philip Hendy in March 1960.

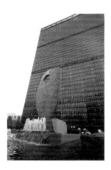

1961–64 United Nations, New York: 'Single Form'

Barbara Hepworth was introduced in 1956 to the Secretary General of the United Nations, Dag Hammarskjöld. Over the next few years before his death in 1961 they corresponded occasionally, but enthusiastically, seeing in each other a parallel for their own kind of vision. Before his death Hepworth had already given Hammarskjöld a number of pieces, and he had endeavoured to keep up to date with her work.

Hammarskjöld had already talked of bringing work by Hepworth and Moore to the Secretariat, and a few months before he died, his colleague Dr Ralph Bunche told him that he had found a patron who would cover the cost of a piece of sculpture by Hepworth for the pool in front of the building. (18/6/62 to G.I. Smith; UN: Dag-1/1.2.9/Box 16) Hepworth's correspondence with the United Nations Officials responsible for the execution of her Memorial is extensive and purposeful; she brooked little delay or discussion, always one step ahead of them, and yet replying in careful and punctual detail to all their reservations and questions. The correspondence lasts from November 1961 to November 1965 and is filed at the United Nations Archive. (DAG –1/2.3 Box 321 Files 2472–2475)

In November 1961 Hepworth wrote to Ralph Bunche that there was 'no work in the world' she would prefer than the project for a sculpture for a fountain in front of the Secretariat. She was working from the memory of her visit in 1959, and she was thinking of carving a piece around eight feet tall. The Engineering Department proposed that she work in bronze instead, and on a scale of at least fifteen to twenty feet, and she accepted their

recommendations. Although Hepworth was invited to come and study the location she preferred to begin the carving immediately as she 'could not bear any kind of contamination or blurring of the conception'. The benefactor, Jacob Blaustein, was worried that Hepworth had begun before his Foundation had approved the grant, and Bunche had to caution her that she had not actually yet been commissioned. In June 1961 a mock-up was erected in the fountain area. Hepworth worked on 'Single Form' during the winter and spring of 1962, and was keen to make it the centre of her Retrospective at the Whitechapel (although she would cover up the dedication to Dag). She had already reserved provisional casting dates at the foundry, and on the condition that the UN liked the half scale model would call in engineers to make the armature for the big one. On seeing the photos the engineer was worried about the mass, but Hepworth assured Bunche that from the sides the sculpture was so thin as to be merely linear. Once again she was asked to visit New York, but she did not want to lose her slot at the foundry; instead she accepted their judgement on scale.

> Knowing how Dag was thinking about world ideas and about ideas in sculpture, when I last saw him in June last year, I feel that it is my duty to keep my ideas dedicated and untramelled for the final work ... I can only do it by being single-minded.

Hepworth was concerned in May 1962 that the half-size sculpture would be cast and the inscription read before the commission was confirmed. She tried to persuade the architects to move ahead, waiting for their decision on the size and position which she had marked on the map: 'The minute that is settled I can make the broad and essential gestures here in my studio, to scale, and then be in position, in Sept to settle every detail.' She began to feel in June that she would have to go to New York to get the job tied up, but did not want to lose her inspiration. In July the Engineer again asked her to come over, but despite seeing his memorandum, she was unmoved: 'I know the site and the pool intimately. I consider the problem is resolved and I want to proceed immediately.' She asked Bunche whether she was wanted in New York to 'unify people's ideas or to change my own?' In September the Secretary General approved the acceptance of Hepworth's sculpture which had been finished and exhibited at the Whitechapel that Spring. The costs, excluding Hepworth's honorarium, were estimated at £75,000. During the summer and autumn of 1962 Hepworth was waiting for the authorization from Bunche, and by December felt she needed the 'all clear' as the news was already leaking out. In the end she decided to act unilaterally: 'I feel it is both historically and professionally necessary to announce this fact. I have declared its dedication and it will be shown at the great International Open Air exhibition in London next May' (20/2/63). It was only now that Hepworth learnt the identity of the benefactor, and in March that his Foundation had voted the funds. She wanted Blaustein to ratify the contract with the foundry so that she did not have to cancel 'all the very complicated arrangements for cranes, scaffolding, transport and so forth'. In June 1963 it was publicly announced that the costs were to be covered by Jacob Blaustein of Baltimore, a former US delegate to the UN. The UN wanted Hepworth to have it cast by September, but she insisted they give the foundry until February, especially given their previous lack of commitment and public support. In May 1963 she wrote, 'The sculpture has gone! After 8 months of work I feel bereft'. Hepworth even looked after details such as the typography for the inscription; engaging both a typographer and an engraver. The work was brought in on budget by Hepworth, but the UN overspent on the siting and surround. After ten months' work at Morris Singer Foundry the casting was finished in April 1964 and the work was shipped to New York on the *American Champion*. Hepworth travelled for the first time to see the site for its unveiling, and described this as 'the happiest period I have ever known'.

1962 John Lewis Partnership, Oxford Street, London: 'Winged Figure'

The re-building of the John Lewis building in Oxford Street began in 1956, and the Partnership first talked to Epstein about the provision of a sculpture on the new building's South-West corner. Six artists were then invited to contribute designs for a project, but no one was chosen. Finally in May 1961 Hepworth was asked to enlarge her 1957 'Winged Figure'. At its inauguration in April 1963 Hepworth spoke of this piece as 'a project I have long wished to fulfil and this site with its wonderful oblique wall [the south-east wall on Holles Street] was quite perfect'. In addition to R.H. Uren, the architect of the building, four other advisers were particularly involved: Hugh Casson, Robin Darwin, J.M. Richards, and Gordon Russell (*The Gazette*, 27 April 1963). Hepworth's piece was cast by Morris Singer, with her usual close collaboration with its manager, Eric Gibberd.

1962 The Ministry of Works: Chetwynd House, Chesterfield: 'Curved Reclining Form, Rosewall'

In 1962 the Chief Architect of the Ministry of Works, E. Bedford, wrote to Hepworth asking if she would be interested to help them and the local authority in finishing off the Civic Square development in front of the new Post Office in Chesterfield. 'It has been suggested that a piece of sculpture by Barbara Hepworth would be most suitable for the purpose' (3/7/62 Post Office). Hepworth replied: 'Most of my larger works have been done with the hope and imagination that they might be placed in such situations in close contact with people out of doors' (5/7/62), but that it would however be difficult for her to see him before the John Lewis work was finished. Bedford replied that he wanted to meet, rather than looking at photographs, so as to discuss the size of the sculpture and her fee. (24/7/62) In 1963 Hepworth told Kay Gimpel that ''Rosewall' has found a home through the Ministry of Works' (GF 15/5/63;). 'Rosewall' was placed on the piazza, beside a pool, and Hepworth supplied a description of the piece, referring to the hill named Rosewall outside St. Ives from which she conceived the sculpture.

1969–72 Cheltenham & Gloucester Building Society, Cheltenham: 'Theme and Variations'

In 1969 the architects Healing & Overbury of Cheltenham asked Hepworth among 'a few selected sculptors of repute' to consider an abstract sculpture about 25' long and 12' high (20/11/69). This was the beginning of a project for the Cheltenham & Gloucester Building Society building in Cheltenham. Hepworth replied, 'I like the proportions and I have several ideas in mind for wall sculptures, and I am delighted to hear that you would want an abstract work' (1/12/69). Within a month Hepworth was invited to prepare a design, and by January 1970 was asking for precise details of girder fixings, proposed drainage etc. The Board approved her project in June 1970, Eric Gibberd of Singers met the architect and the building was opened in September 1972. In October Hepworth received the photos and was happy with the views. She had not visited the building either before or at its opening.

BIOGRAPHY

The first section of this biography was compiled by Barbara Hepworth for her gallery and signed and dated by the artist on 1/1/66. We have extended it to 1976.

1903 January 10
Barbara Hepworth was born in Wakefield, Yorkshire, England, the eldest of four children of Herbert R. Hepworth, CBE (late County Surveyor to the West Riding) and Gertrude Allison (née Johnson). The families of both parents came from the West Riding of Yorkshire.
Educated at Wakefield Girls' High School, with holidays often spent at Robin Hood's Bay, on the North Yorkshire coast, where she liked to draw and paint. Deeply impressed as a child by the Yorkshire landscape, which she got to know from these holidays and from accompanying her father in motorcar journeys connected with his work.

1920 September
Won a scholarship to the Leeds School of Art, where she first met Henry Moore who was also a student there.

1921 September
Awarded a county major scholarship and entered the Royal College of Art in London to study sculpture. During vacations she began to carve 'direct', which was not, at that time, part of the teaching programme at the RCA. She had already been to Paris, and was to continue to make regular visits until the outbreak of war in 1939.

Barbara Hepworth and John Skeaping at the British School in Rome 1925

1924 July
Awarded the diploma of the Royal College of Art, and a West Riding Scholarship for one year's travel abroad.
September
Left England for Italy. Making Florence her headquarters she spent the first months drawing and studying Romanesque and Early Renaissance sculpture and architecture in Tuscany.
November
Short visit to Rome

1925 January (late)
To Siena, for two months.
May 13
Married John Skeaping in Florence, and went to live and work at the British School in Rome where Skeaping was then a Rome Scholar in sculpture. They both learned the traditional Italian technique of marble carving from the master-carver Ardini.
July
Returned to England for brief summer vacation, and then went back to Rome.

1926 November
Returned permanently to England, and, with Skeaping, worked for a year in a studio in St Ann's Terrace, St John's Wood, London.

1927 December
Arranged an exhibition of carvings with John Skeaping in their St John's

Wood studio. On the recommendation of the sculptor Bedford, George Eumorfopoulos visited the exhibition and bought 'Seated Figure' and 'Doves'.

1928 (early)
Moved to 7 The Mall Studios, Parkhill Road, Hampstead, and remained here in this studio which had a garden suitable for working out of doors, until 1939.

1928 June
First one-man public exhibition at the Beaux Art Gallery, London.

87 Figure Study of Crouching Woman 1929

1929 August 3
Birth of son, Paul Skeaping. Died February 13th 1953. Paul Skeaping was a pilot officer in the RAF stationed in Malaya and his plane crashed over Thailand.

1930 July
Spent summer vacation on the Norfolk coast, and gathered iron-stones on the beach for carving. Henry Moore and the painter Ivon Hitchens were also on holiday there.

1931 (summer)
Returned to the Norfolk coast, and took a farmhouse near Happisburgh for the summer.

Barbara Hepworth and Ben Nicholson in Paris 1933

1931
Met her second husband, Ben Nicholson, and joined the Seven and Five Society, with which she exhibited until its disintegration in 1936. In this year too the first 'Pierced Form' (also called 'Abstraction') was carved.

1932 November
Joint exhibition with Ben Nicholson at Arthur Tooth & Sons' Gallery, London.

1933 Easter
With Ben Nicholson, visited Paris and St. Rémy de Provence; met Picasso, Braque and Brancusi and Sophie Taeuber-Arp at Arp's studio in Meudon.
Summer
In Paris, met Brancusi again, met Mondrian and Jean Hélion, invited by Herbin and Hélion to become a member of the *Abstraction-Création* group.

Barbara Hepworth's studio at 7, The Mall, Hampstead 1933

1934
Became a member of Unit One, London.
October 3
Birth of triplets, Simon, Rachel and Sarah Hepworth Nicholson.

1935
In Paris, met Mondrian again, also Naum Gabo, work on *Circle* began (with Nicholson, Gabo and J.L. and Sadie Martin).

1936 Summer
Vacation with Ben Nicholson at Dieppe, where Miró and his wife were staying at Alexander Calder's house in Varengeville. Met Braque again at his studio there, met Arp in London on the occasion of the Surrealist Exhibition.

1937 July
Circle published.

1938
With Ben Nicholson, helped Mondrian to find a studio near them in Parkhill Road, Hampstead, where he remained until 1940.

1939 August (late)
A week before the outbreak of war, moved to St. Ives, Cornwall with her husband and children. Stayed at first with Adrian Stokes at Little Park Owles, then moved to Dunluce, Carbis Bay, St Ives. Naum Gabo and his wife moved to St. Ives at the same time.
During the first three years of the war, ran a nursery school and a small market garden. At night, drew and made small plaster sculptures.

1942
Drawings for Kathleen Raine's *Stone and Flower Poems 1935–43*, Nicholson & Watson, London 1943 commissioned.
September
Moved to a larger house, Chy-an-Kerris, Carbis Bay, St. Ives, where she had a studio and could work in the garden.

1943 April
First retrospective exhibition, held at Temple Newsam, Leeds.

1946
Small monograph published by Faber & Faber, London, Ariel Series, foreword by William Gibson.

1946
Invited by the London County Council in a limited competition to produce maquettes for four sculptures at the ends of Waterloo Bridge. (No commissions were awarded.)
October
First post-war one-man show at Alex. Reid & Lefevre, London.

1947
Drawings of operating theatres.

101 'Hospital Theatre' 1947

103 'Operating Theatre Sketch' c. 1947

104 'Nude Holding Mirror' 1948

107 'Life Study, Male and Female' 1949

1949 August
Bought Trewyn Studio, in St. Ives, where she lived permanently from 1951 when her marriage to Ben Nicholson was dissolved.
Founder member of Penwith Society of Arts in Cornwall.

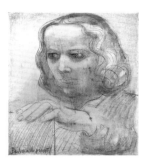

108 Self Portrait 1950

1950 June
Visited Venice, where her work was shown at the 25th Biennale, two works commissioned for the Festival of Britain: 'Contrapuntal Forms' (by the Arts Council of Great Britain), and 'Turning Forms' (by the Festival authorities). Both sited March 1951.

1951
Served on committee of second LCC open air exhibition of sculpture, held at Battersea Park.
May
Retrospective exhibition held at native town of Wakefield, Yorkshire. Opened by Sir Herbert Read.
Executed sets and costumes for the production of Sophocles' *Electra* at the Old Vic Theatre, London.
'Vertical Forms' commissioned for Hatfield Technical College, Hertfordshire.
Awarded Hoffman Wood Trust Leeds Gold Medal for sculpture, for her stone sculpture 'Biolith'.

1952
Monograph on her work produced by Lund Humphries, London, with an introduction by Sir Herbert Read.

1953 March
Awarded a second prize in Unknown Political Prisoner competition, organised by the Institute of Contemporary Arts, London.
Carved 'Monolith (Empyrean)' owned by London County Council and sited on the South Bank, outside the Royal Festival Hall.
Colour film on her work, *Figure in Landscape*, produced and directed by Dudley Shaw Ashton.

1954 April
Major retrospective exhibition at Whitechapel Art Gallery, London.
August
Visited Greece and the Aegean and Cycladic Islands.
Executed sets and costumes for Michael Tippett's opera, *The Midsummer Marriage* (first performed at Royal Opera House, Covent Garden, 27 January 1955).

1955–56
Carved large wood sculptures, 'Corinthos', 'Delos', and 'Delphi'.

1956
'Theme on Electronics' commissioned for Mullard House, London.

1958 January
Created CBE in New Year's Honours List.
'Meridian' bronze, fifteen feet high, commissioned for State House, London. Unveiled March, 1960.

Europaische Bildhauer: small monograph on her work, foreword by Professor A W Hammacher. Dutch Edition by Allert de Lange; German Edition by Kiepenheuer & Witsch, Köln-Berlin; English Edition by A. Zwemmer, London.

1959 September
Exhibited at 5th São Paulo Biennal, Brazil. Won the major award, The Grand Prix, known as the 'Prime of the São Paulo Prefecture'.
Visited Paris to complete the work on 'Meridian'.

1960
Awarded an Honorary Degree – Hon. D. Litt. – University of Birmingham.
Visited Zurich for opening of one-man exhibition at Galerie Charles Lienhard.

1961
Awarded an Honorary Degree – Hon. D. Litt. – University of Leeds.
Monograph – *Barbara Hepworth, Life and Work*: Foreword by Dr J.P. Hodin; French and German editions published by Editions du Griffon Neuchâtel, Switzerland. English edition by Lund Humphries, London.
BBC Television film produced by John Read: *Barbara Hepworth*, commentary by Barbara Hepworth and Bernard Miles. Music is written by Frederick Phillips. Produced at the artist's studio on Cornwall. Awarded Lion of Saint Mark Plaque at 5th International Festival of Films on Art at Venice, June 1962.

1962
'Winged Figure', aluminium, nineteen feet three inches high, commissioned for John Lewis Partnership Limited, London.
May
Major retrospective exhibition at Whitechapel Art Gallery, London.

1963
'Single Form', bronze, twenty one feet high, commissioned for United Nations, New York.
Exhibited at 7th Biennale, Tokyo, Japan. Awarded the 'Foreign Minister's Award'.
Monograph – *Barbara Hepworth* in Art in Progress Series. Foreword by Michael Shepherd, statement by the artist. Published by Methuen, London.

Inauguration of 'Single Form' at the United Nations Secretariat Building in New York, 11 June 1964

1964 June
Visited New York for the unveiling of the memorial to Dag Hammarskjöld at the United Nations Secretariat, gifted by the Jacob and Hilda Blaustein Foundation. Ceremony performed by the Secretary General, 11 June 1964.
September
Visited Copenhagen for the opening of one-man exhibition organised by The British Council, touring Scandinavia.
Also visited Backakra in Sweden to see the Dag Hammarskjöld museum there.

Inaugural exhibition of Barbara Hepworth's work at the Rietveld Pavilion, Rijksmuseum Kröller-Müller 1965

1965 May
Visited Holland for the opening of retrospective exhibition of sculpture and drawings at Rijksmuseum Kröller-Müller, Otterlo; on the occasion of the opening of the new Rietveld Pavilion there.
June
Created DBE in Queen's Birthday Honours List.
September
Became a Trustee of the Tate Gallery, London.

1966 May
Awarded an Honorary Degree – Hon. D. Litt – at University of Exeter.
Showed at Fifth International Sculpture Exhibition at Sonsbeek.
Diagnosed to have cancer of the throat; cared for by specialist Stanley Lee at Westminster Hospital, London.

1967
TV film by Westward Television with score by Benjamin Britten.
June
Breaks femur in Scilly Isles; unable to walk for six months.
December
Gift of nine sculptures to Tate Gallery [had given four sculptures and two drawings in 1964].
In correspondence with Dean Hussey at Chichester Cathedral over commission for 'Crucifixion'.

1968
Film by Central Office of Information for international distribution.
April – May
Major retrospective exhibition at Tate Gallery, London.
April
Elected Honorary Fellow of St. Anne's College, Oxford.
June
Awarded Honorary Degree – Hon – D. Litt. at University of Oxford.
July
Filmline film for distribution in Germany.
September
Invested as a Bard of Cornwall.
September
Conferment of Freedom of the Borough of St. Ives.

1969
Tate planning an Archive of 20th century art, Director asked Hepworth, Moore and Nicholson to commit their papers.

1970
Published *Barbara Hepworth: A Pictorial Autobiography*, London 1970.
Awarded Grand Prix at *Salon international de le femme*, Nice, by Prefect of Alpes-Maritimes.
July
Made Senior Fellow of Royal College of Art, London.

Naum Gabo, Barbara Hepworth, Henry Moore and Lady Reid at a reception at the Tate Gallery, London 10 March 1970

1971
Arts Council travelling exhibition in Britain.
Curwen Gallery shows new suite of nine lithographs ('Aegean Suite').
May
Awarded Honorary Degree – Hon. D. Litt – by University of Manchester.

1972
Exclusive Agency with Marlborough Fine Art.
Marlborough Fine Art shows 'The Family of Man'.
End of term as Tate Gallery Trustee.

1973
Exeter University campus Open-Air Exhibition.

1975
Died 20 May, aged 72.

1976
Opening of Barbara Hepworth Museum, St. Ives.

Barbara Hepworth at work on 'Three Forms Vertical (offering)' 1969

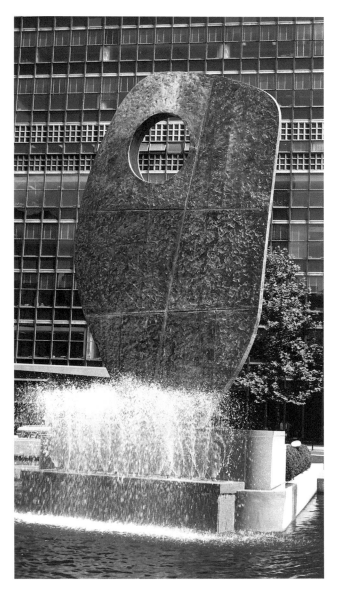

Barbara Hepworth 'Single Form' 1963, United Nations

SOME FURTHER READING

Barbara Hepworth: sculptress; with an introduction by William Gibson; collected and edited by Lillian Browse. London: Faber and Faber, 1946 (1947 reprint). (Ariel books on the arts). 65p., ill.

Barbara Hepworth: carvings and drawings; with an introduction by Herbert Read. London: Lund Humphries, 1952. xvip., 160 plates.

A. M. Hammacher. *Barbara Hepworth*. London: A. Zwemmer, 1958. (Modern sculptors series). [19]p., 32 plates. Text in English; captions in English, French, German, Dutch. Original Dutch ed. published Amsterdam: Albert de Lange, 1958. German ed. published Cologne; Berlin: Kiepenheuer & Witsch, 1958. Also published New York: Universe Books, 1959.

J. P. Hodin. *Barbara Hepworth*; [catalogue of works by Alan Bowness]. London: Lund Humphries; Neuchâtel: Editions du Griffon, 1961. 171p., ill.

Michael Shepherd. *Barbara Hepworth*. London: Methuen, 1963. (Art in progress). [48]p., ill.

The unveiling of 'Single Form' by Barbara Hepworth, gift of Jacob Blaustein after a wish of Dag Hammarskjöld. New York: United Nations, 1964. Published on occasion of the unveiling ceremony, 11 June 1964. 22p., ill.

Barbara Hepworth: drawings from a sculptor's landscape; with an introduction to the drawings by Alan Bowness. London: Cory, Adams & Mackay, 1966. 32p., 76 plates.

A. M. Hammacher. *Barbara Hepworth*. London: Thames and Hudson, 1968. (World of art library: artists). 216p., ill. Rev. ed. published London: Thames and Hudson, 1987.

Barbara Hepworth: a pictorial autobiography. Bath: Adams and Dart, 1970. Also published New York: Praeger, 1970. (Books that matter). 128p., ill. New and extended ed., prepared under the direction of Alan Bowness, published Bradford-on-Avon: Moonraker Press, 1978; reprinted London: Tate Gallery, 1985.

The complete sculpture of Barbara Hepworth 1960 – 69; edited by Alan Bowness. London: Lund Humphries, 1971. 222p., ill.

Alan Bowness. *A guide to the Barbara Hepworth Museum*. St. Ives: Trewyn Studio and Garden, 1976 (reprinted 1984). Leaflet, [8]p.

Barbara Hepworth: a guide to the Tate Gallery Collection at London and St. Ives, Cornwall; introduction by David Fraser Jenkins. London: Tate Gallery, 1982. 48p., ill.

Margaret Gardiner. *Barbara Hepworth: a memoir*. Edinburgh: Salamander Press, 1982. 63p., ill.

Barbara Hepworth: the Art Gallery of Ontario collection, by Alan G. Wilkinson. Toronto: Art Gallery of Ontario, 1991. 47p., ill. 25 works. Organised and circulated by the Art Gallery of Ontario. Exhib. Art Gallery of Algoma, Sault Ste. Marie., Aug. – Sept. 1991. Travelling throughout Canada to May 1992.

An extensive bibliography, compiled by Meg Duff of the Tate Gallery Library, will be published in *Re-presenting Barbara Hepworth*, Critical Forum Series Volume III, Liverpool 1995, on the occasion of Tate Gallery Liverpool's Barbara Hepworth conference. The bibliography will be divided into six sections: monographs; writings by the artist, statements and interviews; selected books containing articles or references; solo exhibition catalogues; group exhibition catalogues; articles from periodicals.

LIST OF WORKS

BH numbers refer to the catalogue numbers from
the two volume catalogue raisonné of
Hepworth's sculpture.

1.
Doves 1927 (BH 3)
Parian marble
280 × 250 × 325mm, 11 × 9¾ × 12¾"
Manchester City Art Galleries
Illustrated p.13

2.
Mother and Child 1927 (BH 6)
Hopton wood stone
450 × 276 × 210mm, 17¾ × 11 × 8¼"
Art Gallery of Ontario, Toronto. Purchased with
assistance from the Volunteer Committee Fund
1983
Illustrated p.21

3.
Mask 1928 (BH 14)
Pentelicon marble
338 × 297 × 205mm, 13¼ × 11¾ × 8"
Wakefield Museums, Galleries and Castles
Illustrated p.14

4.
Torso 1928 (BH 14c)
Marble
300 × 100 × 80mm, 11¾ × 4 × 3"
Hiscox Holdings Ltd
Illustrated p.23

5.
Musician 1929 (BH 19)
Alabaster
490 × 205 × 285mm, 19¼ × 8 × 11¼"
Private Collection
Illustrated p.20

6.
Infant 1929 (BH 24)
Burmese wood
438 × 273 × 254mm, 17¼ × 10¾ × 10"
Tate Gallery, presented by the executors of the
artist's estate 1980
Illustrated p.14
UK only

7.
Standing Figure 1930 (BH 26)
Teak
570 × 140 × 130mm, 22½ × 5½ × 5"
Lady Zuckerman
Illustrated p.24
UK only

8.
Figure of a Woman 1929–30 (BH 27)
Corsehill stone
533 × 305 × 279mm, 21 × 12 × 11"
Tate Gallery, presented by the artist, 1967
Illustrated p.30

9.
Head 1930 (BH 32)
Cumberland stone
280 × 170 × 400mm, 11 × 6¾ × 15¾"
Leicestershire Museums, Arts and
Records Service
Illustrated p.22

10.
Two Heads 1932 (BH 38)
Cumberland alabaster
300 × 380 × 230mm, 11¾ × 15 × 9"
The Pier Gallery, Stromness, Orkney
Illustrated p.36

11.
Torso 1932 (BH 41)
African blackwood
1080 × 180 × 165mm, 42½ × 7 × 6½"
City of Aberdeen Art Gallery & Museums
Collections
Illustrated p.22
UK only

12.
Reclining Figure 1933 (BH 44)
Alabaster
178 × 305 × 158mm, 7 × 12⅛ × 6⅜"
Hirshhorn Museum and Sculpture Garden,
Smithsonian Institution, Gift of Joseph H.
Hirshhorn 1966
Illustrated p.27
Canada only

13.
Seated Figure 1932–33 (BH 46)
Lignum vitae
356 × 267 × 203mm, 14 × 10½ × 8"
Tate Gallery, presented by the executors of the
artist's estate 1980
Illustrated p.27
UK only

14.
Figure 1933 (BH 47)
Grey alabaster, slate base
190 × 146 × 63mm, 7½ × 5¾ × 2½"
Private Collection
Illustrated p.29

15.
Two Forms 1933 (BH 51)
Pink alabaster on limestone base
267 × 343 × 190mm, 10½ × 13½ × 7½"
Private Collection
Illustrated p.42

16.
Mother and Child 1934 (BH 57)
White alabaster
90 × 160 × 82mm, 3½ × 6¼ × 3¼"
50 × 50 × 30mm, 2 × 2 × 1⅛"
Private Collection
Illustrated p.47

17.
Mother and Child 1934 (BH 58)
Grey Cumberland alabaster
230 × 455 × 189mm, 9 × 18 × 7½"
Tate Gallery, purchased 1993
Illustrated p.48

18.
Single Form 1934 (BH 61b)
Iron-stone
150 × 65 × 75mm, 6 × 2½ × 3"
Private collection
Illustrated p.33

19.
Two Forms 1934–35 (BH 65)
White alabaster
145 × 292 × 152mm, 5¾ × 11½ × 6"
Private Collection
Illustrated p.53

20.
Three Forms 1935 (BH 72)
Serravezza marble
200 × 533 × 343mm, 8 × 21 × 13½"
Tate Gallery, presented by Mr and Mrs J.R.
Marcus Brumwell
Illustrated p.63

21.
Discs in Echelon 1935 (BH 73)
Padouk wood
311 × 491 × 225mm, 12¼ × 19⅛ × 8⅞"
Museum of Modern Art, New York,
Gift of W.B. Bennett, 1936
Illustrated p.66

22.
Two Segments and Sphere 1935–36 (BH 79)
Marble
267 × 267 × 216mm, 10½ × 10½ × 8½"
Private Collection
Illustrated p.61

23.
Ball, Plane and Hole 1936 (BH 81)
Teak
205 × 610 × 305mm, 8 × 24 × 12"
Tate Gallery, purchased 1982
Illustrated p.54

24.
Form 1936 1936 (BH 82)
White marble
290 × 215 × 190mm, 11½ × 8½ × 7½"
Gimpel Fils, London
Illustrated p.57

25.
Carving (sculpture) 1936 (BH 87)
Blue ancaster stone
height 342mm, 13¹/₂″
Private Collection
Illustrated p.59
UK only

26.
Nesting Stones 1937 (BH 90)
Serravezza marble
length 305mm, 12″
Ivor Braka Ltd, London
Illustrated p.55

27.
Pierced Hemisphere I 1937 (BH 93)
White marble
350 × 380 × 380mm, 13³/₄ × 15 × 15″
Wakefield Museums, Galleries and Castles
Illustrated p.62

28.
Conoid, Sphere and Hollow II 1937 (BH 100)
White marble
320 × 355 × 305mm, 12¹/₂ × 14 × 12″
Government Art Collection of the
United Kingdom
Illustrated p.58

29.
Single Form 1937 (BH 102)
Holly wood
height 787mm, 31″
Leeds City Art Galleries
Illustrated p.70

30.
Sculpture with Colour (Deep Blue and Red)
1940
(BH 117)
Plaster and strings
105 × 149 × 105mm, 4 × 6 × 4″
Tate Gallery, presented by the executors of the
artist's estate, 1980
Illustrated p.67

31.
Two Figures 1943 (BH 120)
Redwood with strings
612 × 314 × 210mm, 24 × 12¹/₄ × 8¹/₄″
Art Gallery of Ontario, Toronto: Gift of Sam
and Ayala Zacks, 1970
Illustrated p.71

32.
Oval Sculpture (No 2) 1943 (BH 121)
Plaster cast
286 × 413 × 254mm, 11¹/₄ × 16¹/₄ × 10″
Tate Gallery, presented by the artist, 1967
Illustrated p.72

33.
Wave 1943 (BH 122)
Plane wood with colour and strings, interior
blue
305 × 445 × 210mm, 12 × 17¹/₂ × 8¹/₄″
Private Collection, on loan to Scottish National
Gallery of Modern Art, Edinburgh
Illustrated p.77
UK only

34.
Hand Sculpture 1944 (BH 123)
Satinwood
229 × 179 × 179mm, 9 × 7 × 7″
Private Collection
Illustrated p.75

35.
Wood and Strings 1944 (BH 125)
Plane wood with colour, pale blue and grey and
strings
908 × 407 × 246mm, 33¹/₂ × 16 × 9³/₄″
Private Collection
Illustrated p.66

36.
Small Form Resting 1945 (BH 129)
Marble
229 × 311 × 267mm, 9 × 12¹/₄ × 10¹/₂″
Sheldon Memorial Art Gallery, University of
Nebraska, Lincoln, Nebraska Art Association,
Thomas C Woods Memorial Collection 1959,
N-112
Illustrated p.62

37.
Single Form (Dryad) 1945–46 (BH 132)
Cornish elm
1950 × 340 × 280mm, 76³/₄ × 13¹/₄ × 11″
Trustees of the Barbara Hepworth Estate
Illustrated p.65

38.
Pelagos 1946 (BH 133)
Wood with colour and strings
368 × 387 × 330mm, 14¹/₂ × 15¹/₄ × 13″
Tate Gallery, presented by the artist 1964
Illustrated p.76

39.
The Cosdon Head 1949 (BH 157)
Blue marble
635 × 365 × 540mm, 25 × 14¹/₂ × 21³/₄″
Birmingham Museums and Art Gallery
Illustrated p.86

40.
Rhythmic Form 1949 (BH 158)
Rosewood
1003 × 305 × 122mm, 39¹/₂ × 12 × 4³/₄″
The British Council
Illustrated p.94
UK only

41.
Bicentric Form 1949 (BH 160)
Blue limestone
1587 × 483 × 311mm, 62¹/₂ × 19 × 12¹/₄″
Tate Gallery, purchased 1950
Illustrated p.102
UK only

42.
Group I (Concourse) February 4 1951 1951
(BH 171)
Serravezza marble
248 × 505 × 295mm, 9³/₄ × 20 × 11¹/₂″
Tate Gallery, bequeathed by Miss E.M.
Hodgkins, 1977
Illustrated p.97

43.
Figure (Churinga) 1952 (BH 177)
Spanish mahogany
1230 × 311 × 313mm, 48¹/₂ × 12¹/₄ × 12¹/₄″
Collection Walker Art Center, Gift of the T.B.
Walker Foundation, 1955
Illustrated p.119

44.
The Unknown Political Prisoner 1952 (BH 186)
Three forms in wood
height 495mm, 19¹/₂″
Private Collections
Illustrated p.142

45.
Hieroglyph 1953 (BH 188)
Ancaster stone
height 1016mm, 40″
Leeds City Art Galleries (given by the artist
1968)
Illustrated p.118
UK only

46.
Pastorale 1953 (BH 192)
Serravezza marble
length 1143mm, 45″
Kröller-Müller Museum, Otterlo
Illustrated p.94

47.
Two Figures 1954–55 (BH 197)
Polished wood and white painted teak
height 1385mm, 54¹/₂″
The Art Institute, Chicago, Bequest of Solomon
B. Smith
Illustrated p.114

48.
Configuration (Phira) 1955 (BH 200)
Scented guarea wood
677 × 677 × 635mm, 26¹/₂ × 26¹/₂ × 25″
Leeds City Art Galleries (Leeds Art Collections
Fund)
Illustrated p.101
UK only

49.
Hollow Form (Penwith) 1955–6 (BH 202)
Lagoswood, partly painted
898 × 657 × 648mm, 35³/₈ × 25⁷/₈ × 25⁵/₈″
The Museum of Modern Art, New York, Gift of
Dr and Mrs Arthur Lejwa, 1960
Illustrated p.85

50.
Oval Form (Penwith Landscape) 1955–56
(BH 203)
Scented guarea wood, concavities painted white
and blue
length 410mm, 16¹/₈″
Marlborough Fine Art (London) Ltd
Illustrated p.85

51.
Idol 1955–56 (BH 206)
Boxwood
788 × 155 × 155mm, 31 × 6 × 6″
Trustees of the Barbara Hepworth Estate
Illustrated p.117
UK only

52.
Forms in Movement (Galliard) 1956 (BH 212)
Copper
430 × 760mm, 17 × 30″
Gimpel Fils, London
Illustrated p.144

53.
Curved Form (Trevalgan) 1956 (BH 213)
Bronze
902 × 597 × 673mm, 35¹/₂ × 23¹/₂ × 26¹/₂″
Tate Gallery, purchased 1960
Illustrated p.103

54.
Stringed Figure (Curlew) (Version II) 1956
(BH 225)
Brass
514 × 768 × 432mm, 20¹/₄ × 30¹/₄ × 17″
Tate Gallery, presented by the executors of the
artist's estate, 1980
Illustrated p.140

55.
Maquette for Winged Figure 1957 (BH 227)
Brass with strings
height 558mm, 22″
Trustees of the Barbara Hepworth Estate
Illustrated p.138
UK only

56.
Torso I (Ulysses) 1958 (BH 233)
Bronze
height 1320mm, 51¹/₂″
Art Gallery of Ontario, Toronto. Gift of Friends
of Sculpture, 1964
Illustrated p.99

57.
Maquette (Variation on a theme) 1958 (BH 247)
Bronze
440 × 227 × 180mm, 17 × 9 × 7″
Art Gallery of Ontario, Toronto. Gift of Marian
Moore, Toronto 1985
Illustrated p.139

58.
Sea Form (Porthmeor) 1958 (BH 249)
Bronze
768 × 1137 × 254, 30¹/₄ × 44³/₄ × 10″
Tate Gallery, presented by the artist 1967
Illustrated p.87
UK only

59.
Sea Form (Porthmeor) 1958 (BH 249)
Bronze
768 × 1137 × 254mm, 30¹/₄ × 44³/₄ × 10″
Art Gallery of Ontario, Toronto. Gift of Sam
and Ayala Zacks, 1970
USA and Canada only

60.
Holed Stone 1959 (BH 257)
White alabaster
270 × 198 × 192mm, 10 × 7³/₄ × 7″
Art Gallery of Ontario, Toronto. Gift of Mrs
O.D. Vaughan 1985
Illustrated p.108

61.
Reclining Form (Trewyn) 1959 (BH 262)
Bronze
300 × 700 × 190mm, 11³/₄ × 27¹/₂ × 7¹/₂″
Trustees of the Barbara Hepworth Estate
Illustrated p.128
UK only

62.
Corymb 1959 (BH 270)
Bronze
276 × 330 × 240mm, 10⁷/₈ × 13 × 9¹/₂″
Trustees of the Barbara Hepworth Estate
Illustrated p.148

63.
Figure (Nyanga) 1959–60 (BH 273)
Elm
908 × 571mm, 35³/₄ × 22¹/₂″
Tate Gallery, presented by the artist, 1969
Illustrated p.78

64.
Figure (Chûn) 1960 (BH 279)
Polished bronze
355 × 216 × 152mm, 14 × 8¹/₂ × 6″
Art Gallery of Ontario, Toronto. Gift of Sam
and Ayala Zacks, 1970
Illustrated p.108

65.
Single Form (Chûn Quoit) 1961 (BH 311)
Bronze
1130 × 680 × 430mm, 44¹/₂ × 26³/₄ × 17″
Trustees of the Barbara Hepworth Estate
Illustrated p.105

66.
Square Forms 1962 (BH 313)
Bronze
343 × 190 × 89mm, 13¹/₂ × 7¹/₂ × 3¹/₂″
Tate Gallery, presented by the executors of the
artist's estate, 1980
Illustrated p.146
UK only

67.
Two Forms with White (Greek) 1963 (BH 346)
Guarea wood with colour
1020 × 1210 × 330mm, 40¹/₈ × 47⁵/₈ × 13″
Trustees of the Barbara Hepworth Estate
Illustrated p.98

68.
Vertical Form 1962 (BH 353)
Bronze
height 671mm, 26¹/₂″
Art Gallery of Ontario, Toronto. Gift of Mrs
Arnold C. Matthews, 1976. Donated by the
Ontario Heritage Foundation, 1988
Illustrated p.121

69.
Three Personages 1965 (BH 378)
Slate on wooden base
400 × 355 × 280mm, 15³/₄ × 14 × 11″
Kettle's Yard, University of Cambridge
Illustrated p.134
UK only

70.
Two Ancestral Figures 1965 (BH 383)
Iroko wood
1260 × 910 × 460mm, 49¹/₂ × 35³/₄ × 18¹/₈″
Alejandro Freites Collection, Caracas
Illustrated p.142

71.
*Maquette for Large Sculpture:
Three Uprights with Circles (Mykonos)* 1966
(BH 413)
Serravezza marble
285 × 268 × 120mm, 11¹/₄ × 10¹/₂ × 4³/₄″
Art Gallery of Ontario, Toronto. Gift of Mayta
and Jerome Markson, 1989
Illustrated p.99

72.
Two Rotating Forms I 1966 (BH 414)
Alabaster
227 × 305 × 253mm, 9 × 12 × 10″
Art Gallery of Ontario, Toronto. Gift of Mr &
Mrs Donald B. Strudley, Stratford, Ontario 1976
Illustrated p.126

73.
Marble Rectangle with Four Circles 1966
(BH 421)
Serravezza marble
height 845mm, 33$^{1}/_{4}$″
Kröller-Müller Museum, Otterlo
Illustrated p.143
UK only

74.
Four-Square (Four Circles) 1966 (BH 428)
Bronze
600 × 355 × 310mm, 23$^{5}/_{8}$ × 14 × 12$^{1}/_{4}$″
Trustees of the Barbara Hepworth Estate
Illustrated p.107

75.
Sphere with Inside and Outside Colour 1967
(BH 445)
Aluminium with colour
440 × 360 × 341mm, 17$^{1}/_{4}$ × 14$^{1}/_{8}$ × 13$^{3}/_{8}$″
Trustees of the Barbara Hepworth Estate
Illustrated p.124

76.
Six Forms (2×3) 1968 (BH 467)
Bronze
571 × 972 × 438mm, 22$^{1}/_{2}$ × 38$^{3}/_{8}$ × 17$^{1}/_{4}$″
Marlborough Fine Art (London) Ltd.
Illustrated p.113

77.
Two Opposing Forms (Grey and Green) 1969
(BH 492)
Irish marble with colour
343 × 356 × 279mm, 13$^{1}/_{2}$ × 14 × 11″
Priscilla Beckett
Illustrated p.123

78.
Two Faces 1969 (BH 498)
White marble
heights 482 and 431mm, 19 and 17″
Trustees of the Barbara Hepworth Estate
Illustrated p.111

79.
Maquette, Theme and Variations 1970 (BH 512a)
Silver on walnut
305 × 643 × 155mm, 12 × 25$^{1}/_{4}$ × 6″
Trustees of the Barbara Hepworth Estate
Illustrated p.129

80.
Bird Flight 1971 (BH 530)
Slate
375 × 360 × 280mm, 14$^{3}/_{4}$ × 14$^{1}/_{8}$ × 11″
Trustees of the Barbara Hepworth Estate
Illustrated p.135

81.
Sleeping Form 1971 (BH 534)
White marble
210 × 360 × 230mm, 8$^{1}/_{4}$ × 14 × 9″
Private Collection
Illustrated p.116
UK only

82.
Two Rocks 1971 (BH 536)
Irish black marble
height 1168mm, 46″
Trustees of the Barbara Hepworth Estate
Illustrated p.143

83.
Rock Face 1973 (BH 560)
Ancaster stone
1022 × 473 × 229mm, 40$^{1}/_{4}$ × 18$^{1}/_{2}$ × 9″
Tate Gallery, bequeathed by the artist, 1976
Illustrated p.135
UK only

84.
Group of Three Magic Forms 1973 (BH 206)
Silver
120 × 370 × 315mm, 4$^{3}/_{4}$ × 14$^{1}/_{2}$ × 12$^{1}/_{2}$″
Trustees of the Barbara Hepworth Estate
Illustrated p.131

85.
Cone and Sphere 1973 (BH 571)
White marble
1050 × 500 × 380mm, 41$^{1}/_{3}$ × 19$^{5}/_{8}$ × 15″
Trustees of the Barbara Hepworth Estate
Illustrated p.120

86.
Fallen Images 1974–5 (BH 574)
White marble
1219 × 1302 × 1302mm, 48 × 51$^{1}/_{4}$ × 51$^{1}/_{4}$″
Tate Gallery, presented by the executors of the artist's estate, 1980
Illustrated p.110

DRAWINGS

87.
Figure Study of Crouching Woman 1929
Charcoal and wash
438 × 254mm, 17$^{1}/_{4}$ × 10″
The Board of Trustees of the Victoria and Albert Museum, London
Illustrated p.157

88.
Standing Mother and Child c1932
Ink on paper
180 × 114mm, 7 × 4$^{1}/_{2}$″
Trustees of the Barbara Hepworth Estate
Illustrated p.49

89.
Three Studies for Sculpture c1932
Pencil on paper
274 × 211mm, 10$^{3}/_{4}$ × 8$^{1}/_{4}$″
Trustees of the Barbara Hepworth Estate
Illustrated p.49

90.
Form with Hole c1932
Pencil on paper
207 × 181mm (approx), 8$^{1}/_{8}$ × 7$^{1}/_{8}$″
Trustees of the Barbara Hepworth Estate
Illustrated p.37

91.
Studies for Sculpture (Standing Figures) c1932
Pencil on paper
150 × 178mm, 6 × 7″
Trustees of the Barbara Hepworth Estate
Illustrated p.50

92.
Studies for Sculpture (Profile Heads) c1932
Pencil on paper
274 × 211mm, 10$^{3}/_{4}$ × 8$^{1}/_{4}$″
Trustees of the Barbara Hepworth Estate
Illustrated p.50

93.
Two Heads (Mother and Child) c1932
Pencil on paper
227 × 181mm, 9 × 7$^{1}/_{8}$″
Trustees of the Barbara Hepworth Estate
Illustrated p.36

94.
St. Rémy: Tower 1933
Pencil on paper
311 × 378mm, 12$^{1}/_{4}$ × 14$^{3}/_{4}$″
Trustees of the Barbara Hepworth Estate
Illustrated p.41

95.
St. Rémy: Mountains and Trees I 1933
Pencil on paper
314 × 378mm, 12$^{3}/_{8}$ × 14$^{7}/_{8}$″
Trustees of the Barbara Hepworth Estate
Illustrated p.41

96.
Red in Tension 1941
Pencil and gouache on paper
254 × 355mm, 10 × 14″
Private Collection
Illustrated p.73

97.
Drawing for Sculpture 1941
Graphite and gouache on pasteboard
281 × 381mm, 11 × 15″
Art Gallery of Ontario, Toronto. Purchased with
assistance from the Walter and Duncan Gordon
Charitable Foundation 1991
Illustrated p.81

98.
Reconstruction 1947
Oil and pencil on board
343 × 464mm, 13¹/₂ × 18¹/₄″
Arts Council Collection, The South Bank
Centre, London
Illustrated p.92

99.
Drawing for Stone Sculpture 1946
Pencil, gouache and watercolour on composition
board
227 × 421mm, 9 × 16¹/₂″
Private Collection
Illustrated p.74

100.
Drawing for Stone Sculpture 1947 1947
Oil and pencil on board
342 × 648mm, 13¹/₂ × 25¹/₂″
Priscilla Beckett
Illustrated p.96

101.
Hospital Theatre 1947
Ink and tempera on gessoed pressed paper board
385 × 459mm, 15¹/₈ × 18″
Art Gallery of Hamilton, Ontario, Canada. Gift
of M.F. Feheley 1970.
Donated by the Ontario Heritage Foundation
1988
Illustrated p.158

102.
Two Figures with Folded Arms 1947
Oil and pencil on board
356 × 254mm, 14 × 10″
Tate Gallery, purchased 1959
Illustrated p.89

103.
Operating Theatre Sketch c1947
Blue ink on paper and pencil grid
413 × 323mm, 16¹/₄ × 12³/₄″
Trustees of the Barbara Hepworth Estate
Illustrated p.158

104.
Nude Holding Mirror 1948
Graphite on gessoed pressed paper board
375 × 535mm, 14³/₄ × 21″
Art Gallery of Hamilton, Ontario, Canada. Gift
of M.F. Feheley 1970. Donated by the Ontario
Heritage Foundation 1988
Illustrated p.158

105.
Prevision 1948
Oil and pencil on board
457 × 359mm, 18 × 14¹/₈″
The British Council
Illustrated p.92

106.
Portrait of Lisa in Blue and Red 1949
Pencil and paint on hardboard
382 × 255mm, 15 × 10″
Trustees of the Barbara Hepworth Estate
Illustrated p.93

107.
Life Study, Male and Female 1949
Oil and pencil on board
464 × 610mm, 18¹/₄ × 24″
Private Collection
Illustrated p.158
UK only

108.
Self Portrait 1950
Oil and pencil on board
305 × 254mm, 12 × 10″
National Portrait Gallery, London
Illustrated p.159

109.
Standing Figures and Head: Caryatid 1951
Oil on graphite on masonite
666 × 229mm, 26¹/₄ × 9″
Art Gallery of Ontario, Toronto. Gift by
subscription, 1956
Illustrated p.91

110.
Family Group – Earth Red and Yellow 1953
Oil and pencil on board
298 × 222mm
Tate Gallery, bequeathed by Miss E.M.
Hodgkins, 1977
Illustrated p.130

111.
Group (Dance) May 1957 1957
Ink on paper
358 × 255mm, 14 × 10″
Trustees of the Barbara Hepworth Estate
Illustrated p.138

112.
Project for Sculpture (Winged Figure) 1957
Ink on paper
371 × 257mm, 14¹/₂ × 10¹/₈″
Trustees of the Barbara Hepworth Estate
Illustrated p.136

113.
Summer (Project for Sculpture) April 1957, 1957
Ink on paper (black and blue)
354 × 255mm, 14 × 10″
Trustees of the Barbara Hepworth Estate
Illustrated p.145

114.
Concave Form 1960
Oil and pencil on board
319 × 377mm, 12¹/₂ × 14³/₄″
Private Collection
Illustrated p.122

115.
Stone Form 1961
Oil and pencil on board
542 × 533mm, 21³/₈ × 21″
Alejandro Freites Collection, Caracas
Illustrated p.100

Comparative Illustrations

Barbara Hepworth and the Avant Garde of the 1920s
p. 10 Barbara Hepworth, c.1925; p. 13 John Skeaping, 'Cat' 1928, Green serpentine marble, whereabouts unknown; p. 15 Collection of G. Eumorfopoulos, at his home in London; p. 17 Barbara Hepworth, 'Goose' 1927–28, terracotta; Richard Bedford, 'Cricket' 1931 Swedish green marble, Collection Arthur Wheen; p. 18 Alan L. Durst, 'Feline' 1930, Sienna marble, Tate Gallery; Gertrude Hermes, 'Baby' 1932, Bronze, cast from chalk carving, Tate Gallery; p. 23 John Skeaping, 'Reclining Woman' 1930 Hopton wood, stone, whereabouts unknown; p. 26 Barbara Hepworth's Studio at the Mall, Hampstead c. 1932–33.

The 1930s: 'Constructed Forms and Poetic Sculpture'
p. 32 Henry Moore, 'Girl with Clasped Hands' 1930, Cumberland alabaster, British Council; p. 32 Henry Moore, 'Mother and Child' 1930, Ancaster stone, Private collection; p. 33 Barbara Hepworth, 'Carving' 1930, Iron-stone, Private collection (TGA 7247); p. 37 Barbara Hepworth, 'Pierced Form' 1931, Alabaster, Destroyed (war) (TGA 7247); p. 39 Ben Nicholson, '1932 (girl in a mirror, drawing)' Pencil on paper, Private collection; p. 39 Henry Moore, 'Two Forms' 1934, Pinkardo wood, The Museum of Modern Art, New York; p. 40 Barbara Hepworth, 'Two Forms' 1934, Iron-stone, Private collection (TGA 7247); p. 40 Henry Moore, 'Two Forms' 1943, Bronze cast from original iron-stone, Private collection; p. 44 Barbara Hepworth at St. Rémy de Provence, Easter 1933 (TGA 8717); p. 44 Ben Nicholson, '1933 (St. Rémy de Provence)' Pencil on paper, Private collection; p. 45 Ben Nicholson, '1933 (St. Rémy, Provence)' Oil and pencil on board, Private collection; p. 45 Hans Arp, 'Head with Annoying Objects' 1930–32, Original plaster, Silkeborg Kunstmuseum; p. 46 Barbara Hepworth, 'Figure (Mother and Child)' 1933, Alabaster, Destroyed (TGA 7247); p. 46 Hans Arp, 'Necktie and Navel' 1931, Painted wood, whereabouts unknown; p. 52 Ben Nicholson, 'October 2 1934 (white relief - triplets)' Oil on carved board, High Museum of Art, Atlanta, Georgia; p. 52 Barbara Hepworth, 'Holed Polyhedron' 1936, Alabaster, Private collection; p. 53 Equi-Potential Surface to Two Like Charges (upper) Barbara Hepworth, 'Two Forms' 1935, Marble, Private collection (lower), (page 127 from *Circle: International Survey of Constructive Art*, London 1927); p. 54 Alberto Giacometti, 'Model for a Square' 1931–32, Wood, Peggy Guggenheim Collection, Venice (Solomon R. Guggenheim Foundation); p. 56 Alberto Giacometti, 'Cube' 1934 (with incised self-portrait, c.1936–46), Bronze, Alberto Giacometti Foundation, Zurich; p. 56 Alberto Giacometti, 'Head/Skull' 1934, Plaster, Hirshhorn Museum and Sculpture Garden, Smithsonian Institution; p. 59 Henry Moore, 'Carving' 1936, Marble, Private collection; p. 60 Alberto Giacometti, 'Suspended Ball' 1930, Metal and plaster, Alberto Giacometti Foundation, Zurich; p. 60 Barbara Hepworth, 'Cup and Ball' 1935, Marble, Private collection (TGA 7247).

Cornwall and the Sculpure of Landscape: 1939–1975
p. 81 Naum Gabo, 'Linear Construction in Space No. 1' 1945–49, Perspex with nylon filament, Art Gallery of Ontario; p. 82 Aerial photograph of St Ives, Cornwall, showing Porthmeor beach and Barbara Hepworth's Studio 1967; p. 83 'Chûn Quoit' near Morvah, Cornwall Neolithic era 4300–2100 BC; p. 83 'Mên-an-tol' (stone of the hole) near Morvah, Cornwall Beaker Period and Bronze Age 2400–800 BC; p. 84 Barbara Hepworth working on the wood carving 'Pendour' at Carbis Bay 1947; p. 86 Barbara Hepworth, 'Two Heads (Janus)' 1948, Mahogany, Hirshhorn Museum and Sculpture Garden, Smithsonian Institution, Washington; p. 95 Barbara Hepworth, 'Apollo' 1951, sculpture in steel rod for Sophocles, *Electra*, produced at the Old Vic Theatre, London; p. 104 Barbara Hepworth, 'Reclining Figure (Landscape Rosewall)' 1957, bronze, McNay Art Museum, San Antonio; p. 104 'Mên Scryfa' (stone of writing) near Morvah, Cornwall Dark Ages and Early Christian Period AD 410 onwards; p. 105 Barbara Hepworth, 'Rock Form (Porthcurno)' 1964, Bronze, Private collection; p. 106 Barbara Hepworth, 'Four-Square (Walk Through)' 1966 under construction; p. 109 Barbara Hepworth, 'Four Hemispheres' 1969, Marble, Private collection; p. 112 Barbara Hepworth, 'Conversation with Magic Stones' 1973, Bronze, Barbara Hepworth Estate; p. 114 Barbara Hepworth, 'Assembly of Sea Forms' 1972, Marble, Norton Simon Museum of Art, Los Angeles p. 115 Barbara Hepworth, 'The Family of Man' 1970, Bronze, Barbara Hepworth Estate; p. 116 Barbara Hepworth, 'Three Part Vertical' 1971, Marble, Private collection.

The Artist in Post-War Britain
p. 132 Installation shot of Barbara Hepworth exhibition at the Whitechapel Gallery, London 1954; p. 132 Barbara Hepworth in her new studio, the Palais de Danse, St. Ives 1961; p. 133 Installation shot of Barbara Hepworth exhibition at the Whitechapel Gallery, London May 1962; p. 133 Guggenheim International Exhibition, New York 1967, showing Barbara Hepworth, 'Three Forms'; p. 134 Barbara Hepworth, 'Square Forms (Two Sequences)' 1963, Sonsbeek International Sculpture Exhibition, Arnhem; p. 137 Barbara Hepworth working on the armature for 'Winged Figure' 1962; p. 144 Barbara Hepworth, 'Meridian' 1958–9, detail in situ at State House, Holborn, London; p. 145 Barbara Hepworth, 'Meridian' 1958–9, State House, Holborn, London; p. 151 Barbara Hepworth at work on 'Contrapuntal Forms' in St. Ives c.1949.

Photographers

James Austin p. 20, 24
Bob Berry p. 75
Butt p. 71, 85, 94, 105, 109, 111, 114, 116, 132, 134, 135, 137, 142, 143
Carlo Catenazzi p. 21, 71, 81, 91, 99, 108, 121, 126, 139, 148
Prudence Cuming p. 55, 113
Walter Dräyer p. 60
David Farrell p. 144, 145
De Groot p. 134
Jerry Hardman-Jones p. 29, 101, 118
David Heald p. 54 © The Soloman R. Guggenheim Foundation, New York
Errol Jackson p. 40
Laib p. 26, 158
Larkfield Photography p. 70, 101
Cornel Lucas p. 2, 94
E.H. Mason p. 13
John Mills p. 105

Roger Olney p. 154
Larry Ostrom p. 21
Anthony Panting p. 153
Alex Saunderson p. 33, 47, 74, 96, 123
Tom Scott p. 77
Gillian Selby p. 76
Michael Jay Smith p. 104
P E C Smith p. 112
Lee Stalsworth p. 86
John Vickers p. 95
Webb p. 133
Alan G Wilkinson p. 83, 104
Woodley and Quick p. 42
Photography of works owned by the Tate Gallery, the Barbara Hepworth Estate and the Barbara Hepworth Museum, St. Ives by David Clarke, David Lambert and Marcus Leith of the Tate Gallery Photographic Department.

ISBN 1-85437-141-X

Barbara Hepworth: A Retrospective

This book is published to accompany an exhibition organised by Tate Gallery Liverpool and the Art Gallery of Ontario, Toronto

Tate Gallery Liverpool
14 September – 4 December 1994

Yale Center for British Art, New Haven
4 February – 9 April 1995

Art Gallery of Ontario, Toronto
19 May – 7 August 1995

Prepared by Tate Gallery Liverpool
Published by Tate Gallery Publications, Millbank
London SW1P 4RG

Designed by Herman Lelie
Typeset by Goodfellow and Egan
Printed in Great Britain by Balding and Mansell, Peterborough, Cambridgeshire

Photographic Credits

Barbara Hepworth
All exhibited works courtesy of the lenders

'Contrapuntal Forms' in Harlow courtesy Harlow Study and Visitors Centre, Harlow Council

'Winged Figure' 1963 courtesy the John Lewis Partnership Archive Collection

'Reclining Figure (Landscape Rosewall)' courtesy the McNay Art Museum, San Antonio, gift of Tom Slick

'Single Form' 1984 at UN Headquarters, New York courtesy United Nations Archives

'Turning Forms' courtesy Marlborough School, St Albans

Laib photographs courtesy the Conway Library, Courtauld Institute of Art

Outdoor sculpture exhibitions courtesy the Greater London Photograph Library

G. Eumorfopolus house courtesy the British Museum

The front cover shows
Barbara Hepworth, 'Pelagos' 1946

The back cover shows
the stone carving workshop in
Barbara Hepworth's Trewyn studio, in St. Ives, Cornwall,
now part of the Barbara Hepworth Museum.